Philip S. Rawson
has published several books on Eastern art
and has contributed articles to numerous journals. He has
served as UNESCO expert on museology in India and has
organized a number of exhibitions on Indian art in Britain.
Formerly Dean of the School of Art and Design at
Goldsmiths' College, London, he is now retired. Among
his previous appointments he has been Senior Tutor at the
Royal College of Art, London, Keeper of the Gulbenkian
Museum of Oriental Art and Archaeology in the University
of Durham and Assistant Keeper of the Department of
Eastern Art in the Ashmolean Museum, Oxford. He is
co-author of *Tao* in Thames and Hudson's
Art and Imagination series.

WORLD OF ART

This famous series
provides the widest available
range of illustrated books on art in all its aspects.
If you would like to receive a complete list
of titles in print please write to:
THAMES AND HUDSON
30 Bloomsbury Street, London WC1B 3QP
In the United States please write to:
THAMES AND HUDSON INC.
500 Fifth Avenue, New York, New York 10110

Printed in Singapore

The Art of Southeast Asia

Cambodia Vietnam Thailand Laos Burma Java Bali

Philip Rawson

251 illustrations, 32 in color

THAMES AND HUDSON

Published in the United States of America in 1990
by Thames and Hudson Inc., 500 Fifth Avenue,
New York, New York 10110
Reprinted 1995

Library of Congress Catalog Card Number 89-52204
ISBN 0-500-20060-2

Printed and bound in Singapore

Contents

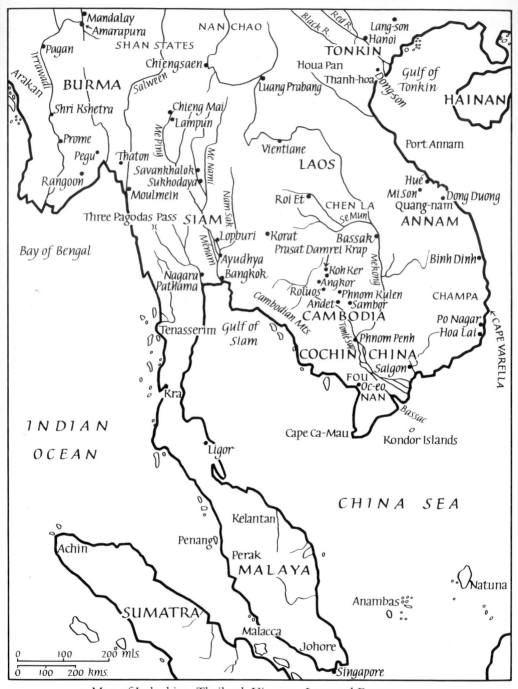

1 Map of Indochina, Thailand, Vietnam, Laos and Burma

Introduction

The culture of India has been one of the world's most powerful civilizing forces. Countries of the Far East, including China, Korea, Japan, Tibet and Mongolia owe much of what is best in their own cultures to the inspiration of ideas imported from India. The West, too, has its own debts. But the members of that circle of civilizations beyond Burma scattered around the Gulf of Siam and the Java Sea, virtually owe their very existence to the creative influence of Indian ideas. Among the tribal peoples of Southeast Asia these formative ideas took root, and blossomed. No conquest or invasion, no forced conversion imposed them. They were adopted because the people saw they were good and that they could use them. The small colonies of Indian traders, who settled at points of vantage along the sea-routes into the islands and around the coast of Indochina, merely imported with them their code of living, their conceptions of law and kingship, their rich literature and highly evolved philosophy of life. They intermarried with prominent local families; and dynasties evolved capable of organizing extensive kingdoms within which their populations could live ordered and fruitful lives.

Of course the art these Indianized kingdoms produced owes its extraordinary qualities to the genius of the native peoples. For although the modes may be Indian the expression and the content are local. What the Javanese and Balinese made springs from their own genius, just as Angkor did from the genius of the Khmer. The arts of Burma and Thailand reflect the particular genius of the Burmese and the Thai. The Indian modes provided themes and patterns for transformation, opening up before local peoples avenues of cultural and artistic development. Of course, there were regions where Indian colonies seem to have met

7

little or no response, and their settlements petered out – in the Malay Peninsula, for example, in Sumatra, and perhaps in Sarawak and North Borneo. But archaeology may yet reveal more about the history of Indian colonization in the more remote parts of the Southern Seas.

As to the special value of Southeast Asian art, the pictures in this book should speak for themselves. The best of this art combines a sensuous sweetness with a luxuriant magnificence, blending joy and delight with intense intellectual and imaginative strength. The sweetness may occasionally veer towards the febrile, the strength towards crudity. But always the virtue of each art is its own, unlike any other; each can offer us an imaginative experience which must extend our mental horizons.

Indochina

A vast series of works of art, ranging from massive architectural complexes to tiny bronzes, has been produced by the peoples of the tropical sub-continent of Indochina. This includes the modern countries of Cambodia, Thailand, Laos and Vietnam. But modern political boundaries are of little significance in tracing the history of the art of Indochina. It is usual for this purpose to divide the huge tract of land into smaller regions, which correspond with old kingdoms that sustained some sort of cultural and historical integrity. Old names such as Tonkin, Annam and Cambodia will be used in this book, because they represent more adequately the facts of history.

Three generations of French scholars have made the art of this area their special preserve – a fact which reflects traditional French political concerns. Any account of the art can only follow in the footsteps of such savants as Coedès, the Grosliers, Parmentier, Boisselier, Dupont and many others.

Indochina (*Ill. 1*) is geographically a unit, centred on the mountainous heartland of Yunnan with its dense forests. From here a number of enormous rivers flow down to the sea, spreading their alluvial plains and deltas around the curve of the coastline. The old kingdoms were usually based upon the natural divisions of this terrain suggested by the basins and plains of the major rivers. The peoples of the forest uplands have remained at a relatively primitive stage of material civilization, leading a poor and self-contained life in isolated tribal groups adapted to their hostile environment and occasionally being joined by refugees from the plains. The peoples of the fertile plains, however, have worked out the political aggression and social co-ordination that are associated with the building of empires.

The principal plains-region can be divided very clearly into two major groups – those in which Chinese influence predominated, and those in which the people looked towards India for their cultural refinements. The division lies by Cape Varella, where the inhospitable Moi highlands fall steeply down into the sea. To the north of it lie the coastal plains of Annam, and beyond them the plains of Tonkin in the lower reaches of the Black and Red rivers. Along these coasts China extended her cultural influence. To the west of the mountain range that runs northwards from the Moi highlands backing the coastal plains of Annam, lie the cradles of Indianizing civilization. The most northerly cradle is the plain of central Laos, around Vientiane on the middle course of the huge Mekong river. Westwards across the divides, in upper Siam on the Meping river, lies Chieng Mai. To the south of both and embracing the deltas of both rivers, lies the vast plain of Cambodia. Its extent includes Bangkok on the west, central Cambodia focused on Angkor, and the whole of Cochin China down to the delta of the Mekong river on the east.

This region was once the bed of the Gulf of Siam. But millennial deposits of silt from the monsoon torrents flooding down from the gorges of Yunnan have raised it to the level of an immense fertile plain. Still today the mouths of the Mekong river cannot carry the colossal volume of silt-laden water which flows down from the mountains in June. So the flow of one of its lowest tributaries, the Tonle Sap, is then reversed; the excess water flows back up to fill the lakes near Angkor and inundate the central region with its fertilizing floods. This country, including the adjacent reaches of the Mekong, was the home of the great Khmer empire. For it was far more favourable for civilization than either the westerly Siamese end of the Cambodian plain on the Menam river or the dense swamps of the Mekong delta to the southeast. The Menam river is not nearly as bountiful, and its mouths are remote from the natural sea trade-routes, which depend largely upon the monsoons and ocean currents.

The Malayan peninsula has little significance in the history of art. Certainly it must long ago have played its part in the transmission of culture from the mainland to Indonesia. And there were probably Indianized settlements near the neck of the peninsula which assisted in the transmission eastwards of Indian culture. But the environment was inhospitable to the formation of a true civilization in antiquity.

Over the whole sub-continent of Indochina the communication-routes for administration, conquest and cultural diffusion follow either the rivers or the coast, for Indochina is effectively isolated from direct overland contact with the main cultural centres of India or China by the high, deeply broken and densely forested massif of Yunnan-Szechwan. Thus, although the pattern of ethnic diffusion may have been from Yunnan down the river basins to the coast, the transmission of sophisticated culture, derived from India or China, has followed the reverse direction. Sea-borne cultural imports have been passed upwards along the river valleys, to peter out as the environment became progressively more hostile. The civilized population lived a riverine existence, and, strange as it may sound, there were no major trade-routes linking the up-river regions to one another: northern Siam to Laos, Laos to Tonkin or Annam. Only one route linked northern Siam with southern Burma. For this reason the river civilizations of Indochina flourished independently, never really fusing into a single empire. Cultural links have been provided by the sailing ships which rode the two monsoons – the south-west monsoon from June to September, the north-east from November to April.

The prehistoric phases of Southeast Asian cultural evolution are not well understood, and none of them is marked by substantial works of art. Palaeolithic tools which can be related to similar types in India have been found at many sites, probably made by people resembling surviving groups of primitive peoples, such as the Australian aborigines, the Senoi of Malaya and the Vedda of Ceylon. The end of the glacial period, about 12000 BC, probably coincides with the arrival of a later type

of man, and the final submerging of the land-bridges between Malaya, the Indonesian islands and Australia. The gradual improvement of tool-types is associated with the arrival of successive population-groups from southern China, who migrated onward by sea through Southeast Asia into the islands. People of Melanesian type were followed by two types of Indonesians. The first of these types survives among the Dayaks of Borneo and some of the tribal peoples on the highlands of Indochina. The second type of Indonesians, which probably came in by sea, has a strong Mongol inheritance and is related by tool typology to the Japanese. Its present-day representatives are the Cham, Malays and Javanese. The Thai and Vietnamese are similar, perhaps even more markedly Mongol. The Mon-Khmer people, who have representatives even in India, may constitute a fusion of Mongol and Melanesian elements.

The cultural phases through which these peoples passed culminated in a neolithic culture, marked by very fine polished stone tools: adzes and trapezoid axes, as well as basket-pottery. Bronze was imported perhaps about 800 BC into the neolithic context, and already by about 500 BC Indochina showed the cultural division into Sinizing and Indianizing cultures, based on geographical division, which was to mark its later history. The Dong-son culture of Tonkin and Annam took its inspiration from China, while to the west of the mountain spine lie many sites containing megalithic monuments, urns, dolmens and menhirs, forming part of a whole megalithic complex running from southern Arabia, through southern India, southern Annam, into modern Siam and Laos. The urns, carved from white sandstone, are often decorated with designs and animal figures. They were tombs; when excavated they often contain ashes and are surrounded by pots. These megaliths may perhaps be associated with numerous unexplored earthworks, and it has been suggested that both may be related to the early Mon people. Final dating of the megalithic culture is not possible, but it is probable that it persisted into the Christian era.

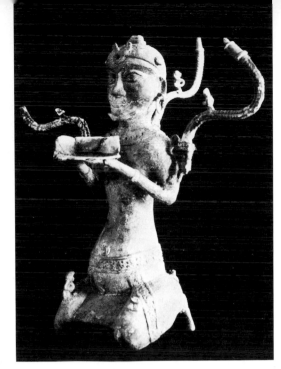

2 Lamp-holder from Lach Truong, Dong-son culture. Light coloured bronze, height 33 cm. In its own genuine style, though it has some affinities with the bronze figure sculptures of Chou China

The Dong-son culture produced the first true Indochinese works of art which we know. They are mainly items of bronze tomb-furniture or religious objects. Dong-son is the chief site in the Tonkin plain, from which the whole culture takes its name. But many sites, ranging in date from about 500 BC to the second century BC, stretch down the coast of Annam, and perhaps into Indonesia. In Tonkin it seems probable that Chinese influence, political as well as artistic, became progressively stronger, until the Chinese Han dynasty conquered Tonkin in 111 BC, making it in effect a Chinese province producing a provincial version of Chinese art. Until then the Dong-son people had been producing a wealth of idiosyncratic art, including utensils, weapons, bowls, pots, ornaments of bone and shell, and especially magnificent large bronzes. Dagger hilts were in the form of human figures. A bronze lamp was discovered (*Ill. 2*), composed of a kneeling man holding a bowl; from him three other bowls branched out, two in the form of stylized birds, while tiny human figures play at his knees

13

and hips and sit on the branch-supports. On large bronze plaques and vessels, no less than on smaller items, the characteristic Dong-son ornament appears: it is composed of spirals, Greek key-patterns, or concentric squares made of and mingled with parallel striations and rows of dots in relief. These, it seems, were produced by the standard Chinese bronze-founder's technique of incising the patterns on the negative mould into which the bronze was to be poured. Indeed, much of the ornament suggests a simplified and broadened version of Chinese ornament of the period of the Warring States.

The most interesting and important of these Dong-son bronzes are several huge drums which seem sometimes to have been buried with the dead. The famous 'Moon of Bali' (*Ills. 5, 6*) is probably another of these. They are broad, waisted cylinders with a flat disc head. On the centre of the head there is usually a radiating pattern in relief, no doubt referring to the sun (*Ill. 4*). On the rim there may be plastic figures of frogs, and other designs occupy the outer section of the disc. The drums were probably used as the magical implements of the rain-maker, an important official in that region of long, burning

3 Thunder-drum of the Dong-son people from Ngoc Lu, Tonkin. Bronze, height 63 cm, diameter of face 79 cm. Such drums can produce a tremendous volume of sound

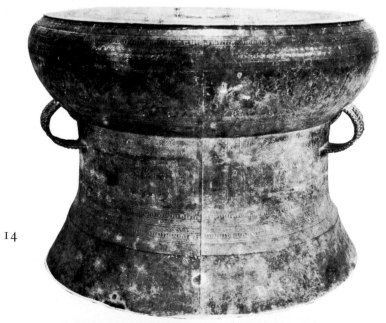

14

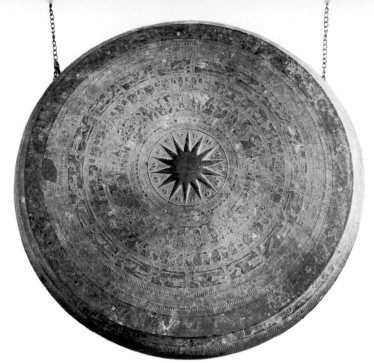

4 The face of the drum from Ngoc Lu bears an emblem of the sun surrounded by symbols of the creatures which depend upon it for their life

drought. The beating of the drums would invoke the monsoon thunder; frogs are the creatures whose joy in water makes them symbols of rain. But the iconography goes further. On some of the drums are relief designs of dancers; on at least one is a design of a boat carrying human figures. The dancers and the boat's passengers seem to be wearing head-dresses composed of large, carefully trimmed feathers, and some carry an

5, 6 The 'Moon of Bali', Pedjeng. Bronze, height 187 cm, diameter 160 cm. *Right*: sketch. *Far right*: detail of mask. The largest of the Southeast Asian bronze drums, superbly cast. The schematic masks may represent the spirits of the ancestors

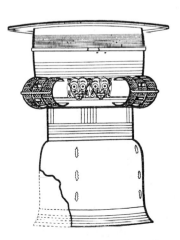

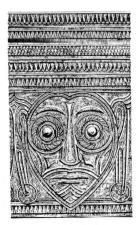

axe-like weapon characterized by a deep V-cleft in its top edge. It is interesting that some of the Naga peoples in the hills of Assam, which form the westernmost extension of the Yunnan massif, still today wear ceremonial head-dresses of trimmed toucan feathers; and until recently the Konyak Nagas used an obsolete ceremonial 'dao' (a kind of combination of axe and sword) called the *milemnok*, which also had a deep V in its top edge. Perhaps the Dong-son dancers represent the usual participants in the rain-making ceremony which introduced and encouraged the monsoon. The boat's passengers may represent voyagers to the Kingdom of the Dead – a common myth in the eastern islands. Certainly the Dong-son people, like many South Sea islanders, must have made and used large sea-going canoes similar to those used in Melanesia today.

After the Chinese conquest of Tonkin, Chinese art gradually obliterated all the idiosyncratic Dong-son elements. Tombs of Chinese type began to appear, with provincial versions of Chinese designs of the Han, T'ang and Sung dynasties. Chinese administration pushed on down the coast, where for a time it was held at bay by the Hinduized Cham kingdom in southern Annam. Mahāyāna Buddhism from China was established in Tonkin in the third and fourth centuries AD, Zen Buddhism in the late sixth century. Tonkin became the main point of departure for Chinese pilgrims bound by sea for the great holy sites of Buddhism in India. It was, in fact, in Tonkin that the Chinese learned the techniques of sea-going trade. For a time further Chinese colonization remained in abeyance, held off by the strength of the Khmer civilization. But by the sixteenth century the Sinized Buddhist Vietnamese had virtually obliterated all vestiges of the classical Indianized civilizations of Cambodia, Laos and Siam. Active coastwise settlement by Chinese colonists in pursuit of trade was under way. And by the twentieth century people who were Chinese by race, language and culture had infiltrated into all the countries of Southeast Asia.

The Chinese themselves would never have supposed that the Sinized regions of Tonkin and Annam could have made any

16

artistic contribution to the central tradition of classical Chinese culture. They were merely semi-barbarous provinces. Their art could never have been looked on as anything but a provincial, inadequate version of Chinese art. After the extinction of the Indianized kingdoms, however, Chinese elements blended with older Southeast Asian styles to produce fine and idiosyncratic art-styles, as will be seen. And the products of the potteries of Savankhalok (Sawankhalok) in upper Siam, made in imitation of Chinese Sung and Ming wares, are of very high aesthetic merit.

From the artistic point of view the Indianized parts of Southeast Asia are always regarded as the most significant. Their stone temples have survived even the ravages of tropical vegetation. Indian colonization and cultural conversion of the land to the west of the Annam mountains began during the early centuries of the Christian era. Burma was effectively Indianized; trading stations were set up farther and farther afield along the shores of Asia. And as usual Buddhism, the merchants' religion, came in the wake of trade. It is often not realized how active the Indians were as traders. The policies of many of the chief dynasties of Indian history, their conquests and drastic shifts of ground, were dominated by the exigencies of trade. As middlemen and entrepreneurs between the Far East and the Roman Mediterranean world, Indians built up immense fortunes. And although it is true that Buddhism was the prime religion of the merchants, establishing its monasteries along all the trade-routes of the ancient world, Hindu forms of religion were also established beyond the seas. A kind of Brahminism, without India's strict rules of caste and society, flourished in some of the Indian colonies, and Hindu deities supply the iconography for a good deal of Southeast Asian art. Most important of all, the highly developed Sanskrit language and literature, together with the Indian alphabets, were made available to the local people. They were thus able to write their own language, and to gain access to a world of ideas which must have seemed to them miraculous. And the royal cults of Cambodia were inspired by a strong current of Indian literary inspiration; while in Java

and Bali the old Indian epics, the *Rāmāyaṇa* especially, have long been an inexhaustible reservoir of themes for dance, drama and poetry.

The Indian colonization of Southeast Asia was actually never a conquest: there were indeed no kingdoms to conquer among the tribal peoples. The kingdoms that grew up later grew in response to Indian ideas; and it seems that no mass emigration of Indians to Southeast Asia ever took place before the European period. The nuclei of Indianization were mere trading colonies, where an Indian way of life was practised and Indian forms of religion were observed. They were seen by the indigenous population to be good, so they were adopted. Intermarriage and cultural assimilation took place. Most interesting of all, there apparently existed a fairly advanced native artistic tradition in Cambodia and Cochin China, probably in perishable materials. For when the earliest versions in stone of Indian prototypes were made there, they were far from being mere copies, or even transcriptions. The sculptures of Indian icons produced in Cambodia during the sixth to the eighth centuries AD are masterpieces, monumental, subtle, highly sophisticated, mature in style and unrivalled for sheer beauty anywhere in India. It is obvious that their style is not purely Indian; there are elements in it which were never created by Indian sculptors in India, and which must only be called local. It is not possible to say whence this style sprang. It must have developed in the region (*Ill. 7*). Attempts to identify it exactly with a specific local Indian style have failed, though certain characteristics suggest links with western rather than eastern India. It cannot have been imported, fully fledged, and there may yet be further discoveries about its evolution to be made.

The earliest of the great kingdoms brought into existence in response to Indian ideas is usually called by the name under which it was recorded by Chinese historians – Fou Nan. Its centre was the area of Cochin China to the south-west of the Mekong delta; it probably extended its sway over long stretches of the coast of the Gulf of Siam, even as far as southern Burma,

7 Lokeshvara from Ak Yum. Seventh-century bronze, height 35 cm. This superb small bronze shows the Royal Bodhisattva. The modelling is sensuous, strong but subtle. Such unity of surface is achieved only by the greatest sculptors

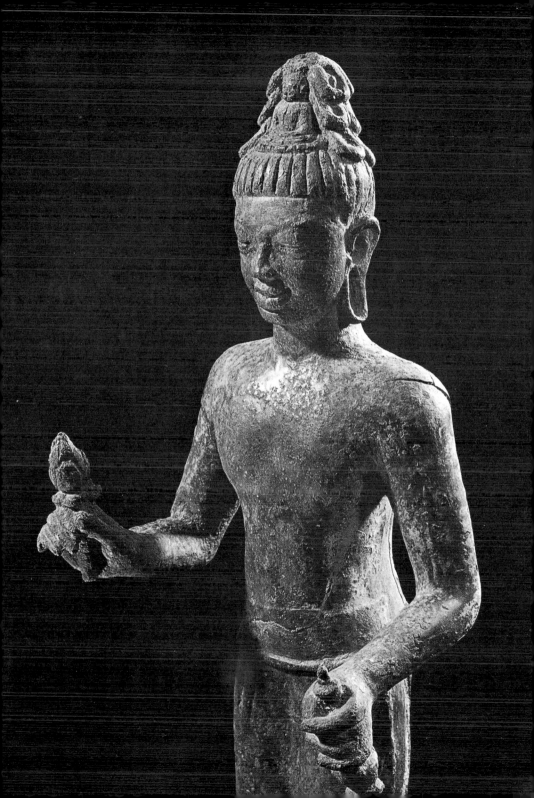

and into Indonesia as well. Its population and culture represented a combination of Dong-son and Indonesian types with the Mon-Khmer civilization of the Cambodian plain. Certainly the culture and art of Fou Nan were regarded by the Khmers as an early phase of their own evolution, and artistic traditions were undoubtedly continuous.

Fou Nan's geographical situation was ideal for the foundation of a trade-based kingdom. It lay on the natural focus of land- and sea-routes linking eastern India, southern China, and the Western world beyond. It was a kind of half-way house for the revictualling of ships and was at the centre of a region supplying many articles, especially forest and mineral products, eagerly sought by the Indian traders for their Western clients. In early times its population was probably the largest on the coast of the Gulf of Siam, and its land the best cultivated. Many small items have been found which give a key to the character of the trade and the kingdom's mercantile position. Among them are Indian jewels of gold, amulets of tin, and gems carved with small scenes of Indian inspiration. Roman objects include a gold medal of Antoninus Pius, a coin of Marcus Aurelius, and gems. From China had come a Han bronze mirror and Wei Buddhist images. There are even a few Ptolemaic Egyptian and Sassanian Persian objects.

The first historical reference to the kingdom of Fou Nan occurs in an account written by members of a Chinese embassy in the mid-third century A D. This records the local legend of its foundation – a similar legend to the one recorded of the foundation of the kingdoms of Champa and Angkor, and common enough in India too. A Brahmin, inspired by a dream, landed in Fou Nan, and married the daughter of a local serpent-deity. The Brahmin became the first king. The serpent-deity, or Nāga, is a familiar Indian representative of local native royalty. This Nāga himself then drank the floodwaters and enabled the people to cultivate the fields.

The historical facts behind the legend are not hard to decipher. Archaeology has revealed traces of an elaborate system of

ancient canals, designed with extreme subtlety so as at the same time to control the Mekong floods, to irrigate a huge area of rice paddies and to prevent the incursion of the sea when the river's flow was slack. Such elaborate waterworks were an Indian forte, upon which the wealth of Indian kingdoms and empires had long been founded. The cities were laid out on the canals, and boats could actually sail into them. The cities too were Indian in conception, with moated fortifications like many great Indian cities known to archaeology. Their houses and warehouses were built on piles, and contemporary Chinese accounts refer to the splendour of the buildings, made of wood, carved, painted and gilt. But nothing of this splendour has survived the tropical climate save a few fragmentary piles. There are a few traces of buildings made of more permanent materials, but these again suggest Indian prototypes, and were probably religious sanctuaries. The chief site where work has been done is Oc-eo, but Nui Sam has also yielded some interesting remains. Most of these more permanent objects were made, most likely, in the later stages of Fou Nan's existence.

The chronology of the kingdom is documented by inscriptions in Sanskrit. About AD 357 an Indian claiming descent from a Scythian line ruled as king. He may have been responsible for establishing the worship of Surya, the Indian Sun-god, who appears in many sculptures. A second Indian, a Brahmin, succeeded him. Then other kings with Indian names, one the son of a Brahmin who himself emigrated from India, appear in the inscriptions. One, Kaundinya Jayavarman (478–514) cultivated Buddhism, and sent a Buddhist mission complete with Fou Nanese images to the Chinese emperor. The last of the great Fou Nan kings was Rudravarman (514–after 539) who was devoted to the Hindu god Vishnu; and it was under him that the first of the Vaishnava sculptures were made.

It should, perhaps, be mentioned that there were in the same period numerous other Indianized settlements around the Gulf of Siam. Just as the Western Mon in Burma were adopting forms

of Indian culture, so the Mon peoples of the Menam plain were adopting the small culture. Perhaps the most important sites where small works of art have been found are Phra Patom, Korat and Pong Tuk.

The second kingdom which played the major rôle in the formation of both the Khmer empire and the Khmer art-style was that called Chen La. Its population were Mon–Khmer, and they had earlier lived on the upper-middle reaches of the Mekong river in what is now Laos. Later they probably lived on the Se Mun tributary. They were highlanders, tough and aggressive, whose name was Sanskritized as 'Kambuja', after which Cambodia is named.

Once more it was Indianization which enabled them to form themselves into a kingdom, probably during the sixth century AD. The process of its evolution is not clear, but certainly a major part must have been played by the example of Fou Nan. Indeed the king who finally united the kingdom of Chen La was the grandson of the last great king of Fou Nan, Rudravarman, who married a princess of Chen La. Thereafter he and his successors, who were devotees of Shiva, ruled the plain of Cochin China by the right of the old dynasty of Fou Nan. With this union of the kingdom of Chen La and Fou Nan, the centre of political power moved northwards away from southern Cochin China – which seems to have suffered an agricultural reverse, possibly due to disastrous floods – farther up the Mekong into the eastern end of the Cambodian plain. The capital of the united kingdom, which lasted into the eighth century, was first at Sambor and then, from the reign of Ishanavarman (616–35), at Sambor Prei Kuk. In this region the art-styles of Fou Nan were continued and developed through the centuries. This was the greatest phase of pre-Angkor Khmer art, and though far more survives from the Chen La than from the Fou Nan period, we can treat the evolution under these two kingdoms together as a stylistic unity. It was the foundation of classic Khmer art, just as archaic Greek sculpture was the foundation of later classical Greek art.

This art was essentially religious. At the same time it was an expression of the Indian cultural conceptions upon which the state itself was founded. The kings exercised their power of government by virtue of divine authority, and that divinity was conceived in Indian guise. Thus the deities in their temples were emblems of the highest spiritual and temporal realities combined. While the icons were not the foci of a purely personal religion, they always embody the most comprehensive and majestic image of transcendent kingship. The ordinary man had no direct access to the god in his shrine; this was reserved for the Brahmins and royalty alone.

The oldest surviving traces of Fou Nan temples show that India supplied their patterns. Most of these probably belong to the fifth century. At Oc-eo there survive the lower stages of two major shrines. The larger, which is built on an east–west axis, consists only of a vast brick foundation. It is designated 'building A'. But more interesting is that designated 'K'. It is laid out on a north–south axis and has three tiers. The lowest is a brick foundation. On this was a rectangular chamber of huge granite slabs mated by mortise and tenon – a considerable technical feat. The chamber was crowned probably by a corbelled roof-vault whose two granite pediments have survived. Near by was a brick building with rooms and a verandah. This whole complex suggests an Indian temple of the same period. For the massive volume of the stone of the shrine recalls the Indian idea of making the interior cell – the holy of holies – in the image of a cave hollowed into the body of the sacred cosmic mountain, Meru. Probably a wooden or brick-and-stucco spire completed the roof of the shrine, consummating the mountain-image. None of the surface ornament of the Oc-eo temples has survived; but at Nui Sam were found a pair of terracotta ornaments, in the form of the *chaitya* window framing a head. This is a typical Indian architectural motif.

It is assumed that during the sixth century similar temples, probably of stone, were also made. Some of the stone sculptures seem to have required a setting resembling an Indian cave-

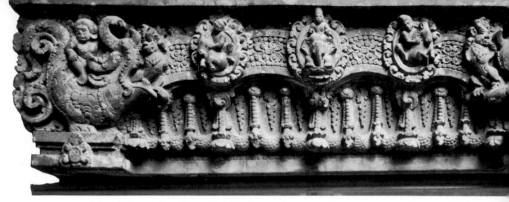

8 Lintel from Sambor Prei Kuk. Early seventh century, sandstone. Such lintels are the chief glory of early Fou Nan–Chen La architecture

temple. It has been suggested that these were 'grotto-shrines'. But nothing of them survives. It is certain that major works in stone must have been both rare and expensive, for Fou Nan itself was delta terrain, without any rock available for building. Only when access to the mountains of Chen La had made stone readily available did it become a more common building and sculptural material.

It is certain that a great deal of architecture, sacred as well as profane, must have been executed in wood. The earliest stone and brick architecture of the Chen La period actually imitates the forms of wooden architecture. This is a common phenomenon, well known in India. The prototype of the Cambodian temple is a wooden pavilion, standing on four squared-off posts at the corners, with wooden architraves, door jambs and lintels. Its roof is made of squared timber of regularly diminishing length piled into a hollow pyramid. Some Chen La sandstone buildings even used long pieces of stone as if they were wooden members, capable of bridging gaps and bearing weight like wood – although it was not conducive to satisfactory construction. Ornament was added, either stucco on brick buildings or carved on those of stone; the latter was manifestly derived from carved wood relief. The roofs were corbelled of diminishing stone courses. The method used of extending the sanctuary tower upward, giving it the height needed to symbolize the cosmic mountain, was again characteristic of wooden archi-

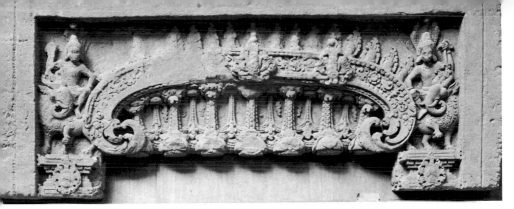

9 Lintel from Prei Kmeng. Late seventh century, sandstone. The strings of hanging jewels mark the door below as one of the gateways to heaven

tecture. A series of gradually diminishing versions of the sanctuary itself were set one above the other, each standing on the architraves of the one beneath. The whole later history of Khmer architecture was conditioned by this early pattern. It is sometimes said that the idea of repeating the basic structure in a series of tiers was suggested by the Pallava architecture of southeastern India. As a structural concept only this may be true. Visually the two styles have little in common.

The best groups of buildings surviving from early Chen La are at Sambor Prei Kuk. Two groups lay at the centre of the city, containing buildings from various periods. The main structures are typical square or octagonal brick tower-shrines, set on high brick terraces, with certain ornamented parts made of sandstone. The temple in the southern group once contained a gold lingam (phallic emblem, sacred to Shiva) and has sculptured scenes set in cartouches or ornament. Aligned with it is the tower which contained the Nandi (bull) shrine, the sandstone canopy of which is carved with magnificent relief ornament. Some of the other buildings have chaitya windows framing heads or figures to ornament their towers. The pillars and pilasters are round or chamfered, carved with rings and circlets of relief ornament, and having cushion-capitals of deeply bowed outline – like many Indian prototypes. But the chief glory of these buildings is their splendid lintel stones, carved with elaborate relief ornament (*Ill. 8*). At each end,

25

above the dies on which they rest, are fantastic beasts, whose tails are elaborate foliate curlicues, bearing riders; from the open mouth of each beast springs a fictive arch. The lintel's four lobes of ornament are textured with elaborate foliage, and punctuated by three flowery cartouches containing figures riding animals; and from the fictive arch hang fabulous looped strings of jewels punctuated by tassels. This indicates the fundamental motifs – Indian in origin – of all the later Chen La and Khmer ornamental carving which plays such an important part in the architecture. The beasts, called *makaras*, vomit forth the ornament. And the ornament itself is based upon elaborations of the hanging jewel string and the extravagantly efflorescing garland of foliage, all contained within even, orderly rhythms. The foliage in the early lintel frames shows, especially in the local style of Prei Kmeng (*Ill. 9*), the first intimations of the upward-pointing flamboyant shapes which became so characteristic of full Khmer art, sprouting everywhere from eaves and hood-mouldings.

The significance of all this ornament can be traced to Indian prototypes. The jewel strings refer back to the old Indian custom of donors literally hanging their wealth – their jewels – upon sacred trees or the railings of shrines. The foliage is derived both from the vases and garlands of flowers offered in a similar fashion, and from the imagery of the shrine as a celestial wish-granting tree through whose fabric courses the sap of divine life. The *makara* is the emblem of time, which vomits all forth, and swallows it again. And since the temple is the earthly, man-made counterpart of the heavens in which the gods dwell, the figures populating the reliefs represent lesser celestials: the courtesans, musicians and courtiers of the gods.

The Chen La style appears at several sites, and follows several phases during the seventh and eighth centuries, declining by degrees into a lesser exuberance. The phases are named after the major architectural sites where they occur – Sambor, Prei Kmeng, Prasat Andet, Kompong Preah. At Han Chei there is a small brick tower faced with sandstone, probably the last of the

pre-Angkor phase. It is small, its ornament has shrunk to pure foliage and its pillars have diminished capitals, though under the architraves are some figurative pieces of iconography. This whole somewhat unenterprising style of architecture depends on its fine relief sculpture. And indeed sculpture was the major art during the whole Fou Nan-Chen La epoch. Among the few great stone icons which have survived are some of the world's outstanding masterpieces, while the smaller bronzes reflect the same sophisticated and profound style.

No sculpture was discovered at Oc-eo, though we do know that sculpture was made at that period in Fou Nan because Buddhist statues were sent to China; and Chinese sources refer to the inhabitants of Fou Nan casting bronze statues of their gods. In the year 503, for example, King Kaundinya Jayavarman sent a coral Buddha to the emperor of China, and we hear of a queen of Fou Nan erecting a bronze image 'encrusted with gold'. We can be sure that such works were part of a flourishing tradition of art. No doubt there was much carving in wood, and probably painting too, though we know nothing of it. Where such a distinguished style of linear relief is found there must have been pictorial art as well.

The first surviving statues come from the hill Phnom Da, the 'acropolis' of the then capital of Fou Nan, Angkor Borei (*Ills. 10, 16*). They belong to the early sixth century, a period when the state of Fou Nan was coming under pressure from Chen La. The king to whose reign they belong was Rudravarman, whose patron deity was Vishṇu. The statues are Vaishṇava. Some represent Vishṇu himself in a characteristic form wearing a tall mitre, with his four or eight arms supported on a frame left in the stone of the block (*Ill. 11*). Like the great majority of Fou Nan-Chen La images they are carefully worked from the back as well as the front. The faces are markedly Indochinese. On at least one of them (*Ill. 12*) there is a striking depiction of individual muscles bulging on the shoulders, breast and arms, quite unlike the usual smooth rotundity of the limbs of most sculpture of the Indianizing tradition. To account for this, it is possible that

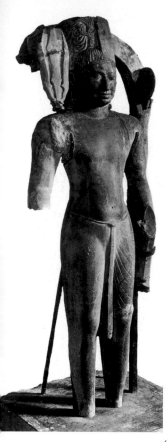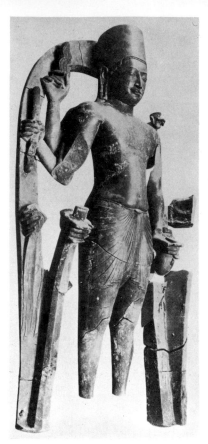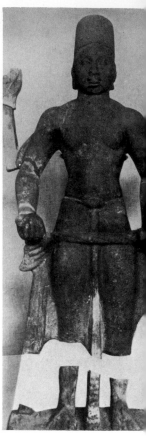

10, 11, 12 (*left*) Harihara of Phnom Da. Late sixth century, sandstone, height 175 cm. A half-and-half icon – divided down the centre – of the deity who combined the qualities of both Shiva and Vishṇu. (*centre*) Vishṇu with eight arms of Phnom Da. Late sixth century, sandstone, height 270 cm. The deity who personifies the sublime Ground of all Being. (*right*) Vishṇu of Tuol Chuk. Sixth century, sandstone, height 95 cm

Romano-Hellenic influence, already established during the second to fourth centuries AD in the north-west of the Indian sub-continent had penetrated to this remote region. A striking Vaishṇava image from the same period is that of Kṛishṇa performing one of his chief miracles, holding aloft in one hand the mountain Govardhana (*Ill. 13*). Here the image was most likely a 'grotto icon', meant to be placed in the narrow stone cell of a temple. The figure, its braced arm, and the mountain, though all

28

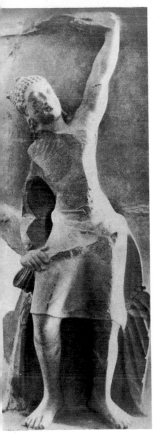
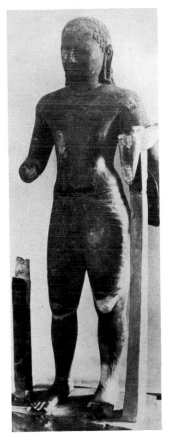
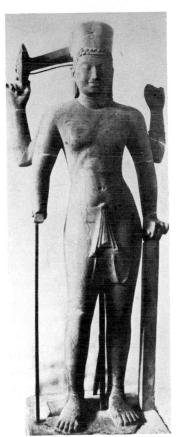

13, 14, 15 (*left*) Kṛishṇa Govardhanadhara of Vat Koh. Sixth century, sandstone, height 160 cm. (*centre*) Balarāma of Phnom Da. Late sixth century, sandstone, height 176 cm. Kṛishṇa's brother, especially reverenced by warriors. (*right*) Vishṇu of Tuol Dai Buon. Seventh century, sandstone, height 183 cm. The sensuous charm was designed to win the heart of the worshipper

standing out distinctly, are completely engaged with the background. So the sculpture is virtually a relief, but a relief of such great depth that the ground plays no rôle in the image.

This effect is characteristic and illuminating. Most Indian sculpture is in the form of massively protuberant relief, and in this the Kṛishṇa follows Indian tradition. The fact that so many of the earlier and the later Fou Nan-Chen La sculptures are carefully cut from both sides and back (*Ill. 14*) might mislead a

29

spectator into imagining that they were carved as true full-round sculpture. This is not so. Even free-standing they are still reliefs, the figures conceived on a rhomboid section, organized so as to present a clear frontal plane, with emphatically receding but distinctly visible side surfaces. The bodies show marked ridge-lines dividing the side surfaces from the frontal surface; and all the surfaces are cut as subtly undulating continuities (*Ill. 15*). The deep side surfaces give them a vivid plastic presence; the surface continuity gives them their sensuous vitality. These qualities, however much they may be overlaid by decorative schematicism in later times, are what give all of Cambodian art its special virtue.

Later the Fou Nan-Chen La sculptures become more numerous. Outstanding among them is a male deity with a horse's head probably of the sixth century, found at Kuk Trap (*Ill. 17*). The figure has a slightly *déhanché* posture, and at the side of one hip there is a big bow of drapery, which is obviously derived from a similar motif common on the sculptures of Mathura, in western India, during the second and third centuries A D. Another very Indian-like figure is the torso of a female deity, in a markedly *déhanché* posture, found at Sambor Prei Kuk (*Ill. 18*). The breasts are round, with marked cup-like top surfaces, far more characteristic of India than the sloping breasts of other early Cambodian female sculptures. The best of these is perhaps the splendid Lakshmī from Koh Krieng (*Ill. 19*), probably made in the early part of the seventh century. The majestic goddess standing in a symmetrical, frontal posture makes no attempt to seduce the mind with smiling face or a 'hippy' pose. Nevertheless, the surface of the stone is carved with an intense sensual affection, for the gods and goddesses of Hinduism are meant to be physically adored. The still later Lakshmī (*Ill. 23*), with its more decorative sinuous linear surfaces, lacks the lively monumentality of the Koh Krieng goddess.

The only masculine image which can rival this Lakshmī in its monumentality is the great Harihara – a compound icon of Shiva and Vishnu combined half-and-half – of Prasat Andet,

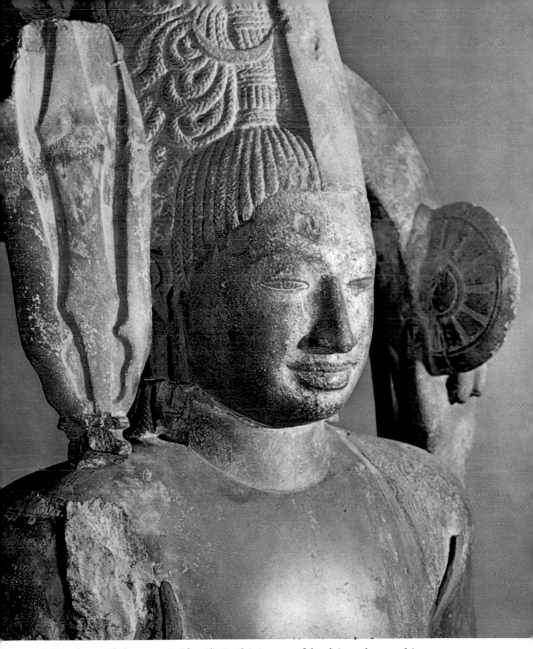

16 Harihara of Phnom Da (detail). In this image of the deity who combines the qualities of Shiva and Vishṇu the two halves of the face are subtly differentiated. The stern half is Shiva, on the proper right, with the tangled locks. The gentle, sublime half Vishṇu, wearing a mitre, is on the proper left. (See also *Ill. 10*)

dating to about 700 (*Ill. 20*). It forms the chief item of a stylistic group centred on Prasat Andet. Characteristics of the male images are incised moustaches – recalling the art of north-western India – and a forehead-peak on the mitre. This particular image has the same squared-off section with deep side recessions, and the same sensuous surface, though the general expression is far more severe. The ankles are broken; but the feet are still present and, apart from the forearms and hands, the sculpture is complete. Detail such as the brief loin-cloth held by a chain is executed in the shallowest of relief. So is the coiled hair on Shiva's side of the mitre. Jewels are carved in the same way on other stylistically similar sculptures. But most of the body is turned into clear and emphatic volumes, not bulky – slender, in fact – but fully plastic.

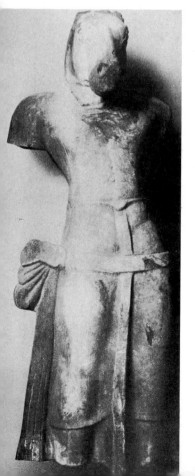

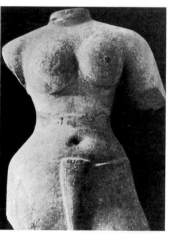

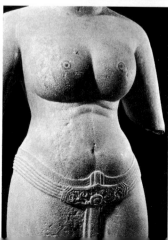

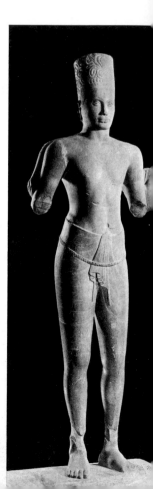

There are many more of these grandiose images, male and female, some almost complete, some fragmentary or damaged (*Ills. 21, 22*). They vary in quality, and style evolves gradually towards the recognizable Khmer style of the ninth century. Gradually the volumes of the body, so clearly defined in the style closer to Fou Nan, weaken, and submit to a somewhat decorative, sinuous silhouette that encloses the figure. Earlier the eyes, the everted Melanesian lips and the strong pectorals were defined in terms of clear planes. Later the body becomes predominantly a softly undulant surface on which features are carried out almost as linear signs (*Ill. 23*). Humps and hollows are both shallow. The folds of drapery become decorative patterns. But in spite of these changes, the original plastic inspiration remains, ready to blossom when opportunity offers.

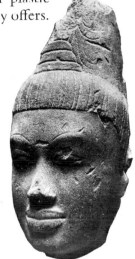

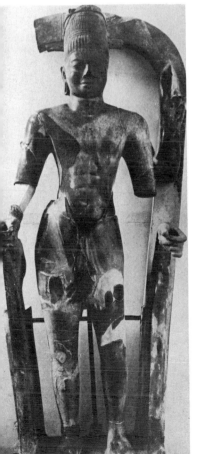

17 Vishṇu Kalkī of Kuk Trap. Sixth century, sandstone, height 133 cm

18 Indian-style female torso of Sambor Prei Kuk. Sixth century, sandstone, height 166 cm

19 Lakshmī of Koh Krieng Seventh century, sandstone, height 127 cm

20 Harihara of Prasat Andet. *c.* 700, sandstone, height 194 cm

21 Harihara of Sambor Prei Kuk. Seventh to eighth century, sandstone, height 69 cm. A strong and elegant combined Shiva and Vishṇu image

22 Head of Lakshmī of unknown provenance. Sixth to eighth century, sandstone, height 14 cm. The everted Melanesian lips and the eyebrows are emphasized by incised lines in this late pre-Khmer head

33

23 Lakshmī. Eighth to ninth century, sandstone, height 145 cm. In the figure of this goddess the whole surface has been carved as a sinuous unity. The forms of the drapery have been subordinated to the overall undulation. Sexual charm and superhuman power are reflected in the face. Such images represented the essential royalty of the earthly queen

24 (*opposite page*) Buddha of Tuol Prah Theat. Seventh to eighth century, sandstone, height 90 cm. The Buddha here takes on a majesty like that of the Hindu gods. Such images do not represent the outward appearance of the ascetic who was the Buddha, but symbolize the vigour of his spiritual nature

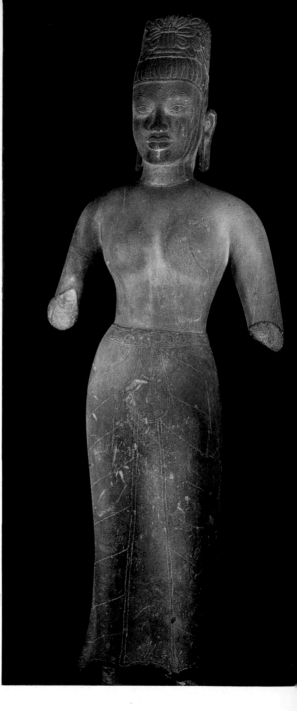

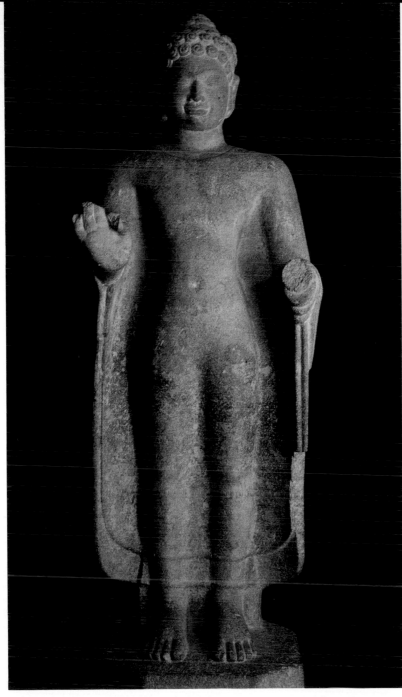

All the sculptures mentioned so far have been Hindu, but a number of Buddhist figures were carved in the same style. Once more the earliest belong to the sixth century (*Ill. 25*). The standing images of the Buddha have the same slightly *déhanché* posture as the horse-headed deity (*Ill. 28*). The seated ones have a smoothly emphatic plasticity. But whereas it is legitimate to feel a sensuous adoration for a personal deity, it cannot be correct to feel the same towards a teacher who preached the ultimate in non-attachment. None of the Buddhist images therefore attained the same sensuous suggestiveness as those of Hindu deities. The Buddhist style recalls at once something of the smooth classicism of fifth- to sixth-century Sarnath, and something of the monumentality of contemporary Ajanta (*Ills. 25, 26*). There is one Buddha head, supposed to be the earliest, from Ranlok which is often said to recall the style of the third-century Buddhas of Amarāvatī, on India's south-east coast. It is this resemblance which authorizes the assumption of its early date. There is indeed resemblance; but there are also marked differences. For this Ranlok head is a distinctively Cambodian work, with the marks of the sophisticated Cambodian style.

A number of inscriptions and temple foundations are ascribed to King Bhavavarman II who ruled from before 639 to after 656. It seems that, although the king's patron deity was probably Shiva, the religion of Mahāyāna Buddhism suddenly spread in the kingdom. A number of Mahāyāna images were made in a distinctive style, which was centred on Prei Kmeng, and was probably contemporary with that of Sambor, continuing during the Prasat Andet and Kompong Preah epoch. The most characteristic images of this Mahāyāna group are the Bodhisattvas (*Ill. 27*), and images of one type of Bodhisattva in particular, known as Lokeshvara, 'Lord of the Worlds'. It is more than likely that such images represented a *Buddhist* form of royal pattern. Where a Hindu king would derive his royal authority from a Hindu deity, a king who was a Buddhist would find it difficult to derive similar authority from the Buddha himself, who was a humble mendicant. Mahāyāna

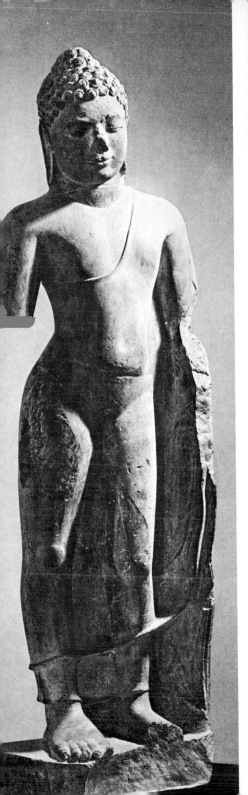

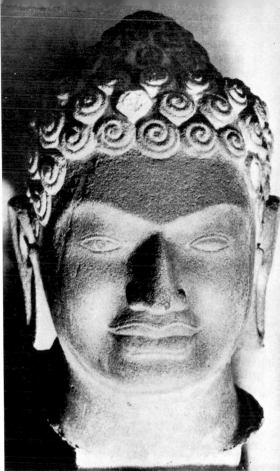

25 (*left*) Standing Buddha of Vat Romlok. Sixth to seventh century, sandstone, height 125 cm

26 (*above*) Head of Buddha of unknown provenance. Seventh century, sandstone, height 32 cm. This head illustrates the Buddha-type which served as pattern for all the Buddhas of the Eastern and Western Mon peoples of Cambodia, Thailand and Burma. But its subtle contrast of soft volume and ridge was never recaptured in later styles

37

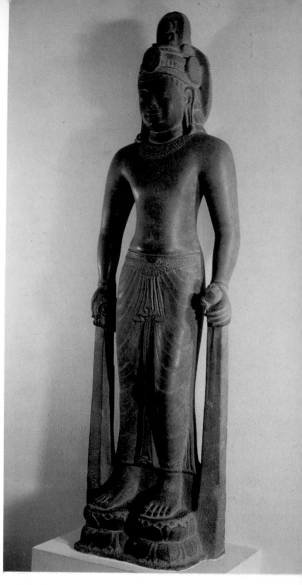

27 Bodhisattva. Eighth century. This type of Buddhist image represented the spiritual authority of a ruler Buddhist by religion

Buddhism, however, had developed doctrines in which transcendent personages played a major part. The Bodhisattvas were fundamentally beings qualified for enlightenment, but out of universal compassion had renounced Nirvāṇa until such times as all creatures were able to gain it. His spiritual status enabled the Bodhisattva to perform all kinds of miracles, and

move at will throughout the universe. But it seems likely that in north-western India the custom had grown up of allocating the title Bodhisattva to princes who protected and patronized Buddhism, and of whom images were made. These images were accorded the same kind of reverence as Hindu images, and the idea of a royal Bodhisattva, whose power extended into all corners of the world, took root; partly, no doubt, because the idea was a most convenient one for royal Buddhists who wished to remain Buddhist without renouncing their royalty. The presence in Chen La of images of royal Bodhisattvas alongside the images of Hindu deities suggests that there was more than one dynasty in the country with claims to royal sovereignty – a situation also known in India. In Khmer times the cult of Lokeshvara attained great importance.

The Bodhisattva images of Lokeshvara of Chen La exist both in stone and in bronze. Their hair is done up in a carefully arranged chignon of rope-like locks, reminiscent of the long hair of the Shiva images. At the front of the chignon is a small seated figure of the Buddha who is the Bodhisattva's spiritual authority. One fine, rather late stone Lokeshvara (fifth–eighth

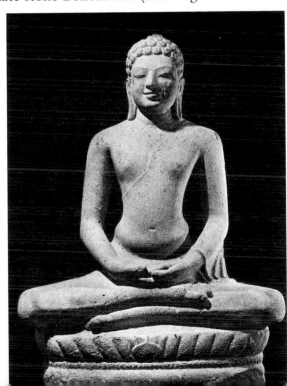

28 Buddha seated in meditation, Phum Thmei. Seventh century, sandstone, height 90 cm. The transcendent Buddha-nature is illustrated in its contemplative aspect. At the same time, it claims personal devotion by its charm

century) comes from Sra Nan Ta Sok. It stood with its four arms supported by the same kind of thick plain stone aureole that supports the arms of the Vishṇu images. It seems that its under-cutting was not completed, as it is still embedded in the stone, and the forms of the slender body are not fully disengaged. Its face is framed by hair arranged in vertical gadroons, probably supposed to represent the gathered-up roots of the chignon. Two delicate undulant lines signify creases in the soft flesh underneath the volumes of the breast.

The small Buddhist bronzes are all marked by the same ex-tremely slender figure. In some of the standing Buddhas, the drapery slung between one of the arms and the body is worked in broad, simple concave forms. The outstanding image of Lokeshvara, however, was acquired in Siam, but its exact provenance is unknown (*Ill. 29*). In this image the face and hair resemble those of the stone figure mentioned above; but the slender body and limbs are worked fully in the round, with subtle plastic emphasis.

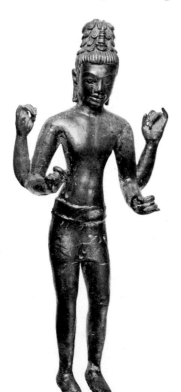

29 Maitreya from Siam, unknown origin. Seventh century, bronze, height 32 cm. The slender elegance of this figurine is achieved without any loss of plastic vigour. Its multiple arms denote the multiple powers of the divinity

Early Angkor

Some time late in the eighth century the kingdom of Chen La suffered an administrative breakdown and disintegrated into small, weak states. At the same time contact with India was lost and trade was interrupted. It is more than likely that the rising fortunes of the kingdoms of Indonesia, first at Shrivijaya, and then in central Java, eclipsed Chen La's. It is an interesting fact that the Shailendra dynasty of Indonesia claimed to be the direct heirs to the power of Fou Nan; they may in fact have been descendants of a ruling house of Fou Nan who had fled to Java as Chen La established its hegemony over the Cambodian plains. The Shailendra were a vigorous and aggressive dynasty. They ruled in Malaya, and raided as far afield as Tonkin. They are best known, however, for the large-scale works of Buddhist art they commissioned in Java, especially Borobudur. It is even possible that the sudden appearance of the Buddhist sculpture of Prei Kmeng may owe something to the Indonesians, but exactly what and how is not clear.

The establishment of the Khmer empire in Cambodia was to some extent a function of Indonesian culture. There was, however, no invasion. The success of the Khmers was a native success, and amounted to a complete reorganization of the old Fou Nan–Chen La kingdom. The fragmented regions were pulled together, and a new capital was eventually founded. The main architect of this success was Jayavarman II, who had lived a substantial part of his life in Java, at the Shailendra court. He was in some way connected with an old Cambodian royal family, and returned to Cambodia about AD 790, having been steeped in Indonesian cultural conceptions. The impetus behind his drive for power was thus the desire to emulate the Shailendra

pattern of magnificent dynastic power, supported by a strong religious cult expressed through all the resources of art.

One of his most significant acts during his campaign was to establish in 802 one of his successive capitals at Mahendraparvata on Phnom Kulen, nearly twenty miles from Angkor. He did not stay there long, for the site was unsuitable for a capital. It was a mountain, however, and its name means 'the mountain of the great King of the Gods'. The Shailendra dynasty claimed the title 'Mountain Kings', and Jayavarman clearly wished to demonstrate that he, too, was heir to this title by literally living on a sacred mountain. Like great monuments of Javanese art, the later Khmer monuments were intended to convey the image of the sacred mountain, on whose summit dwelt the king's divinity, in intimate communion with the gods, himself as one of them. Jayavarman also established the basic royal cult of the Khmers. He summoned a Brahmin learned in the appropriate texts, and erected a lingam (phallic emblem, sacred to Shiva, *Ill. 31*) with all the correct Indian ritual. This lingam, in which the king's own soul was held to reside, became the source and centre of power for the Khmer dynasty. At the same time – and by that act – he severed all ties of dependence upon Indonesia. Jayavarman died in 850, and was succeeded by his son Jayavarman III, who ruled until 877.

One of Jayavarman II's capitals was at Sambor. The temples he built with their sculptures there seem to have amounted to a revival of the old Chen La style. At Banteay Prei Nokar and Roluos (where he died) he also had old style temples constructed. But on Phnom Kulen, where the sacred lingam was set up, he seems to have ordered the first attempt to imitate the cosmic mountain in the form of the brick pyramid of his temple. In about A D 800 at another of his capitals, Amarendrapura, he seems to have made a three-tiered brick pyramid crowned by a group of five shrines, dominating the plain. Even here the shrine architecture represents a continuation of the old Chen La pattern of tiers of diminishing repeats of the basic cell. But in the elaborate sculptured ornament of his temples (*Ill. 30*) Jayavar-

31 Lingam, Phnom Kulen. Early ninth century. The phallic emblem of the power of the High God Shiva is set in the square female basin symbolic of the earth

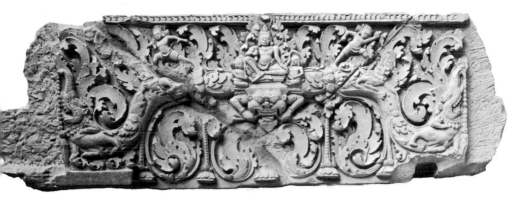

30 Lintel from Phnom Kulen. Early ninth century, sandstone. The elaborate carving with its many concave forms is characteristic of the new Khmer style in relief sculpture. Such foliage spreads from the lintel all over the temple fabric

man made a radical departure. He evidently called on artists from both Java and Champa to assist in or supervise the work of the Kulen. A form of makara-head vomiting a deer comes from Champa, as does the style and type of the pediment relief. A Javanese form of the head of the kala-monster is used. But the larger icon-figures made for Jayavarman III continue the native Cambodian traditions – somewhat stylized, perhaps. The Vishnu figures gradually dispense with the solid aureole supporting the arms. They show the Prasat Andet forehead-peak, but their eyebrows gradually lose their clear bows and condense into a single continuous line. Although under Jayavarman the Khmer 'renaissance' cannot be said to have begun, the main lines of its inspiration had been laid down.

The real emergence of Khmer art began under Indravarman (877–89). This king is represented in the inscriptions he commissioned as a scholar as well as a successful ruler. He claims to have studied the monistic Vedanta philosophy of the great Indian Shankarāchārya, with a Brahmin learned in that tradition. He pacified the Khmer kingdom and his authority seems to have been recognized in the most distant parts of Southeast Asia. But the achievement for which he is remembered today is his laying of the foundations of Angkor.

Angkor is often called a city (*Ill. 32*). In a sense it was. But at the same time it was more than a city, for its basis is an immense technological achievement. Whereas cities generally live off an already established agricultural prosperity, Angkor was originally designed to create its own prosperous agriculture. The land around Angkor is not well watered naturally. Its rivers flow violently during the monsoon season. But during the dry season, when the monsoon rain-water is gone, the surrounding plains suffer from severe drought. Angkor was a capital, filled with temples and supporting many inhabitants. But its nucleus was a splendid irrigation project, based on a number of huge artificial reservoirs fed by the local rivers and linked to each other by means of a rectangular grid system of canals. These reservoirs, called *barays*, were located at the highest point in the

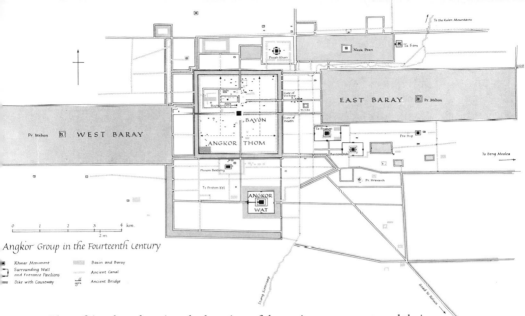

Angkor Group in the Fourteenth Century

Key:
- ■ Khmer Monument
- ⌐ Surrounding Wall and Entrance Pavilions
- ═ Dike with Causeway
- ▨ Basin and Baray
- ⋯ Ancient Canal
- ╫ Ancient Bridge

32 Plan of Angkor showing the location of the main monuments and their relationship to the grid of reservoirs and irrigation canals

river system, and were used to feed a vast chain of irrigation channels spreading out over the lower lying land. The huge acreage of rice paddy so watered was the continual support of the strength and prosperity of the Khmer empire. And since Angkor itself was the source of that support, it was regarded by the Khmers with religious reverence as a divine endowment. Its temples and palaces are thus both an expression of that reverence and at the same time an essential part of the mechanism. The continual gift of the waters of heaven, divine by origin, is ensured by continual royal intercession, and by the performance of correct ceremonial. In this the king, who was the earthly image of God, his Brahmins and later on Buddhist monks, play an essential part. The Khmer king believed himself to be united with the deity of his cult after his death, and dedicatory statues were set up in his chief temple to commemorate the divinization of the king.

Indravarman built the first colossal baray at Angkor, and laid down the basis for the irrigation system. The idea was perhaps an expansion of the concept of irrigation by means of the

45

reservoir, used by the Chen La people. The engineering involved at Angkor, however, was vaster and far more sophisticated than anything seen before in that part of the world. Indravarman's original baray, now dry, was 4,000 yards by 850 yards in extent. It is still called the baray of Lolei. Indravarman resided at Roluos, a few miles to the south-east of Angkor proper, the capital in which Jayavarman II had died.

At Roluos are the first great works of Khmer architecture. They are the Preah Ko, a temple begun in 879, south of Lolei; the king's own temple-mountain, the Bakong, begun in 881; and the ruined Prasat Prei Monti, which was the king's palace. All were surrounded by rectangular moats filled by the waters of the Lolei baray. From here the water flowed through the canals and irrigation channels and finally down to the great lake. The huge platforms of earth on which these buildings were erected probably consist of soil excavated in forming the moats and the channels which not only divided up the city, but also provided an easy means of transport.

Like virtually all Khmer buildings, and like Angkor itself, Preah Ko (*Ills. 33, 34*) is oriented east to west, with its main gates to the east. Its plan shows it to have been already a most sophisticated architecture of planned space. The moats, the terraced enclosures and the group of six shrines – in two rows of three – are subtly articulated inside their square plan. Their layout is symmetrical only along the east–west axis; the main temple-enclosure, itself square, is set back towards the west in such a way that the front walls of the first row of temples it contains lie on the central north–south axis. Gates, and pavilions whose close-set pillars seem composed entirely of turned bobbins of stone, are disposed in the area. The tower-shrines, the chief three containing stone images of deified male ancestors of the king, the second three females, were still constructed of brick, faced with stucco ornament, much of which has been lost. The shrines have evolved in such a way as to allow the lowest tier of the structure to reach a considerable height. The roof-towers are composed of four compressed tiers. The door in the face of the

46

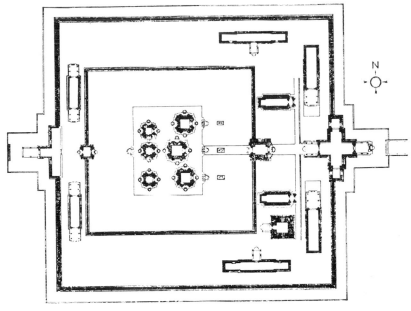

33 Plan of Preah Ko, at Roluos. Begun 879

34 Preah Ko is the earliest more or less complete example of a shrine-complex devoted to deifying the ancestors of the king

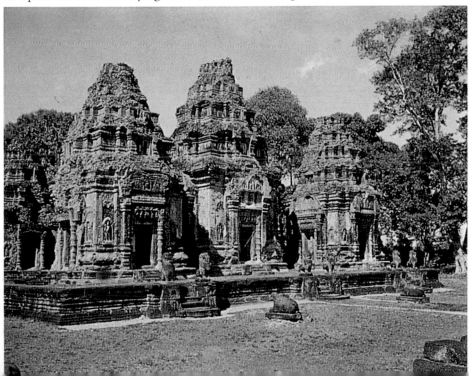

35 (*left*) Sophisticated stucco foliage from Preah Ko, an efflorescence of creation from the mouth of Devouring Time

36 (*right*) Bas-relief, ▶ Bakong: a condemned spirit falling among demons. This shows the highly characteristic formal language of Khmer art, with its deeply sinuous curves and squared enclosures

37 (*lower right*) Plan of the Bakong, begun 881; the first great temple-mountain to survive

lowest tier is the main feature, flanked by high brick pilasters with deep moulded capitals. A pair of octagonal stone pillars, with varied horizontal mouldings, support magnificent, deep, stone lintels carved with ornamental relief. In the walls are set stone images of deities carved in deep relief, set in niches crowned with flamboyant-framed arches. Clearly the stucco relief was magnificent. There must once have been an efflorescence of foliage, in which little figures of deities and animals are involved, all over these walls (*Ill. 35*).

The Bakong was a more deliberately impressive work (*Ill. 36*). It was intended to be Indravarman's own holy lingam shrine on top of its sacred mountain. The shrine (*Ill. 37*) was, like those of Preah Ko, of brick and stucco, and was replaced in the

48

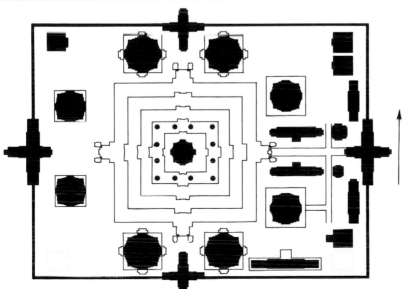

0 10 20 M

twelfth century. It stands on a series of sandstone terraces with four axial stairways and a gate-tower forty-seven feet high at the foot of each. It forms the centre of what must have been a most impressive group of eight brick shrines, set in an enclosure with gates, pavilions, and causeways over the moats lined with colossal Nāgas, and free-standing Garuḍas. There can be little doubt that the huge terraced pyramid was inspired by – if not so highly elaborated as – the great ninth-century Buddhist monument in Java, Borobudur. It is also supposed that Jayavarman II commissioned a lesser prototype, Ak Yum.

Associated with these two great monuments are a large number of magnificent sculptures. There are, of course, the figures of deities in high relief, attached to buildings, among them figures of the heavenly girls whose presence helps to demonstrate the divinity of the shrine. Their postures are far less *déhanché* and emphatically female, far more stiff and motionless than such images were earlier, when they were closer to their Indian prototypes, or than they became later. They do, however, adumbrate one interesting technical invention which became still more important in later Khmer styles, an invention which was not yet incorporated into the free-standing figures: the ring of the top edge of the waist-cloth, where it encircles the hips, is canted forwards, so as to present itself almost in plan view. This greatly enhances the three-dimensional suggestiveness of the relief.

The most important inventions of Indravarman's artists are the free-standing sandstone sculptures, especially the grouped figures. The Nāgas and Garuḍas of the Bakong causeways have been mentioned. They are, it is true, clumsy compared with later similar inventions. The Nāgas stretch like thick, serpentine rails flanking the approach roads, and the massive Garuḍas punctuate them at intervals. But this very idea – that sculptures of mythical beings should actually come down from the building and articulate into the everyday world the magical space of which the temple shrine is formed – represents a major artistic achievement.

50

The large sculptures which now stand free, such as the Bakong Shiva (*Ill. 38*) or the goddesses, must once have been enclosed in vanished brick shrines. They dispense with the stone aureole supporting the arms and hands and exhibit the same sensuous continuity of surface as the great Chen La works, but they have also become more massive. Shoulders are broad, arms and legs – especially the males' – are thick. Faces have

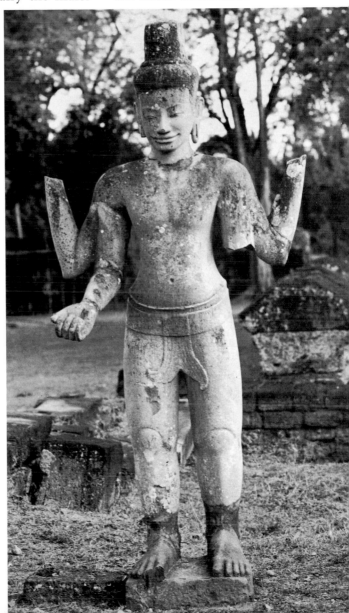

38 Shiva from Bakong. Conceived as a free-standing image of the king's patron deity. Its smooth surfaces have lost much of the vitality of earlier icons

taken on an air of complacency, and the skill of their execution has become a familiar routine. The horizontal elements of brows, eyes, nose and mouth are stressed, and the whole figure is designed on the basis of squares. Movement is almost eliminated in favour of a self-satisfied calm. The tall cylindrical mitre of the males is narrower than the head, and seated into a prominent diadem. A striking feature of the whole style is the way in which, on to the broad, sensuously massive surfaces of the images, the folds of the waist-cloth at the front of the belly and thighs effloresce into elegantly sinuous linear relief. On the Bakong Shiva a shallow fan of pleats projects on to the belly above the hip girdle, while below it extend sinuous pointed fans with rippled ends, half-way to the knees. Female images show a long, central fan of pleats running to the ankles, and a special petal-like swag of pleats folded down over from behind the girdle into a very feminine and suggestive loop, with a curvilinear pointed tail cast out on one hip. All these ornamental motifs on the figure-sculpture, like all the splendid Khmer foliate ornament, follow slowly undulant double curves slightly square in form.

The most interesting of Indravarman's sculptures is the colossal group of three figures on the Bakong (*Ill. 39*) which probably represents the king with two of his wives, one on each side, in the guise of Shiva with Umā and Gangā. The heads of all the figures are missing and so are nearly all of their arms. But it is possible to see that the whole group was originally carved from a single block. Each of the goddess-queens rests a hand on the back of one of the god-king's thighs, linking the group together. The better preserved of the female figures clearly shows the two long creases essential to canonical beauty running along the breasts. The bellies of all are broad, encircled by the girdle. The side recessions of the figures are long, running far back in depth. When whole this group must have had a splendid, monumental presence.

Yashovarman succeeded his father Indravarman in 889. His mother was herself a descendant of old Fou Nan royalty. In his

39 Indravarman with his wives, from Bakong. Sandstone, height 130 cm. Indravarman's figure commands the main stairway of his sacred mountain and was meant to awe the visitor by its massive solemnity. Opulent and hieratic, it sums up this Khmer king's conception of kingship

work he surpassed even the efforts of his father, for he moved his capital from Roluos and laid the foundations of the present complex site of Angkor. His reasons for doing this may have been a mixture of necessity, ambition and genuine far-sighted-ness. It is probable that the population of Cambodia and of the region between Roluos and the great lake was expanding fast. It may well have been obvious that it would expand still farther. Yashovarman decided to do what his father had done at Roluos, but on a vastly larger scale. He set out to capture the waters of another river, the Siemreap, and so open up a fresh tract of land for intensive cultivation. He did this in his own baray farther up the valley, away from the great lake. The baray he created, now under the western baray, was the earliest at Angkor and was four and a half miles long and over a mile wide. From it the water was led through broad canals planned on a perfect rectangular grid, down to the place he had decided on for his own temple-mountain. This was a natural hill called Phnom Bakheng. He surrounded it with a vast rectangular moat, four miles around, to form the nucleus of his new capital city and the source for his irrigation complex. On the hill he built the Bakheng temple, started in 893. It was not his first foundation, however, for earlier he had started work on a temple at Lolei, in the centre of the baray of Roluos. The Lolei temple was dedi-cated to the worship of his father, as king-divinity. Thus he was continuing one of the most important Khmer cults – the actual worship of the royal dead, a cult which Indravarman himself had pursued at Preah Ko. Yashovarman built only two other shrines in the hills, the Phnom Krom and the Phnom Bok. Each is composed of a simple row of three tower-shrines, con-structed for the first time entirely of sandstone – as is the main shrine of the Bakheng. Their sculptural style is the same as that of the Bakheng, but architecturally they are insignificant beside it.

The Bakheng (*Ill. 40*) is clearly a descendant of the Bakong (*Ill. 37*), and as such it is understandable that it should have essayed a symbolic representation of the universe somewhat on

54

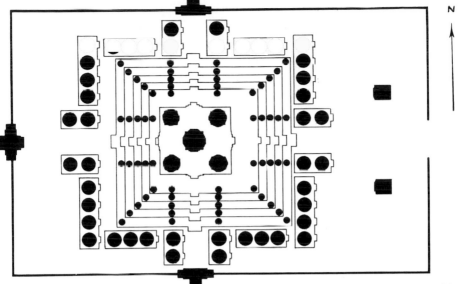

0 10 20 30 40 50 M

40 Plan of Bakheng. Begun 893. The multiple towers of this shrine were meant to illustrate a mystical conception of the cosmos

the lines of Borobudur. Once more the shrine is based on a square five-storeyed pyramid, eighty-three yards along each lower side, and forty feet high. Since it stands on a natural rock base its eminence was adequately emphasized. Once more there are axial staircases with seated stone lions flanking each flight – though they lack the gate-pavilions of the Bakong. On a raised platform on the summit stands a centralized group of five large tower-shrines. On the ground around the base stand forty-four others, while up the terraces rise rows of lesser towers. Altogether there are 108 towers set around the central tower. It has been speculated that a cosmic numerology has been incorporated into the arrangement of the towers, since 108 equals 27 (the number of 'lunar mansions') times 4 (the lunar phases). The seven levels (including the ground and summit) represent the seven heavens of Hindu mythology, and the towers are said to be arranged so that only thirty-three – the canonical number of the Hindu deities – can be seen at once from each side. Other calculations based on the seasons, the

55

planets and mythical numbers play their part as well. The implication is that the monument is a compendious image of the structure of the cosmos – at the centre of which resides the divine power of the god, whose earthly representative is the king.

From the aesthetic point of view the architecture shows two important characteristics. First, the series of compressed storeys which form the tower of each shrine, composing a series of five projecting architraves with finial, begin to take on a general

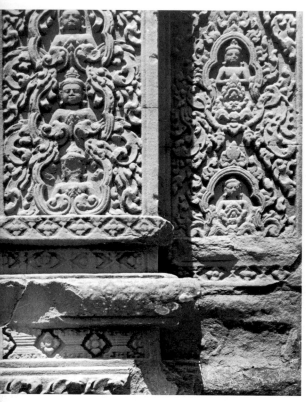

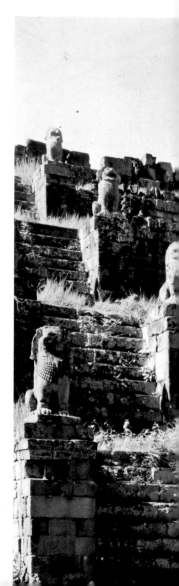

41 (*above*) Scroll decoration, Bakheng

42 (*right*) West façade, Bakheng. The towers sprouting from the terraces of Yashovarman's sacred mountain illustrate the principle of growth. The king's divinity was supposed to be the source of the fertility of the land, through the immense irrigation system he constructed and controlled

outline suggesting a sprouting shoot, one storey seeming to emerge from within the one below it, rather than simply resting on it (*Ill. 42*). This becomes highly developed in much later Khmer architecture. The second characteristic is the luxuriant, extremely fine foliate scroll relief carving which covers much of the main shrine (*Ill. 41*). It is somewhat stylized, but it creeps up pilaster faces, around hood-mouldings, even over the dies and cushions of capitals.

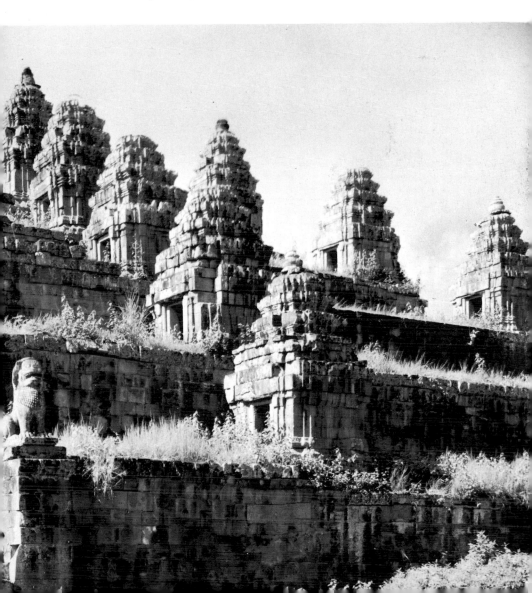

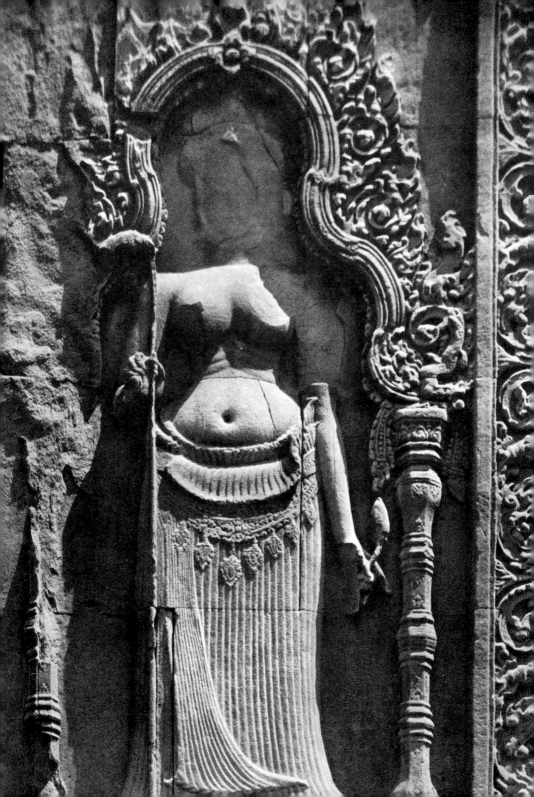

Yashovarman's sculpture is all remarkably hieratic – formal, frontal, with the figures motionless. This applies to both free-standing icons (*Ill. 44*) and the relief figures on architecture. Even the sensuousness of the flesh-carving is conventionalized, while the drapery-folds fall into hard, curved patterns, and lose the impetus of life. It is interesting to speculate whether this feature of the ceremonial sculpture reflects some spiritual aridity in court life. For the death of Yashovarman, the great ruler whose plans could have been carried out only by means of fairly drastic, even tyrannous compulsion, heralded a phase of internal conflict in the kingdom. His brother Harshavarman I reigned from 900 to 921, and built as his own temple-mountain the Baksei Chamkrong, a superbly proportioned small pyramid entirely of stone, crowned by a single tower. In 921, however, one of his maternal uncles, Jayavarman IV, split the kingdom, and set up a rival capital forty miles from Angkor, in the old Chen La country.

The site he chose, now called Koh Ker, was irrigated by a similar, though more modest baray. His son followed him as

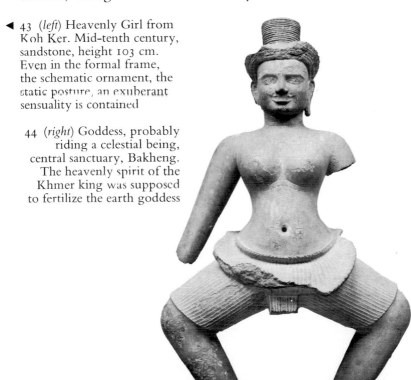

◀ 43 (*left*) Heavenly Girl from Koh Ker. Mid-tenth century, sandstone, height 103 cm. Even in the formal frame, the schematic ornament, the static posture, an exuberant sensuality is contained

44 (*right*) Goddess, probably riding a celestial being, central sanctuary, Bakheng. The heavenly spirit of the Khmer king was supposed to fertilize the earth goddess

ruler in the new capital, and a style of art evolved on the many temples there, which, though now mostly destroyed, were chiefly of brick. The sculpture (*Ill. 43*) was somewhat less hieratic than Yashovarman's work. Male figures appear, as well as female, wearing an enlarged and emphasized version of the deep petal-like loop of front drapery worn by earlier female figures. But most interesting are the free-standing sculptures found which depart from earlier canons. One of these is a four-faced Brahma, another a male divinity kneeling on one knee with the other cocked up forwards. There is a gigantic pair of mythical wrestlers, and two Garuḍa birds chasing a Nāga. It was inevitable that the Khmer genius, which conceived its architecture as situated in an ambient space, should begin to conceive its sculpture in the same way.

In the 920s for the first time temples in many parts of Cambodia were dedicated by individuals other than the king. They belonged, no doubt, to the hereditary aristocracy; their shrines are rich and beautiful, reflecting the general prosperity of the country, though the temple-mountain remained the royal prerogative. One of the earliest of these independent foundations was the Prasat Kravan, a Vishṇu temple dedicated in 921 by certain members of the nobility (*Ill. 45*). This shrine, the upper storeys of which are ruined, is remarkable especially for its reliefs carved in the baked brick of the tower. On the inner walls of the main tower are carved a series of icons of the different forms of Vishṇu, complete with attendant figures and floridly ornamental haloes. On the walls of the north tower are reliefs of forms of his wife, Lakshmī (*Ill. 46*). The main figures stand formally, with toes turned outwards on their base-lines. Their forms are simple, with only a few jewels and stylized pleats to decorate them. It is probable that these figures, indeed the whole of the shrines, were finished with a layer of fine lime and colour. Painted relief like this, based on a firm outline, comes close to the kind of painting which was practised in many countries of the Indian circle. In fact there are remains of wall-paintings on plaster in a small brick temple called Prasat Neang

60

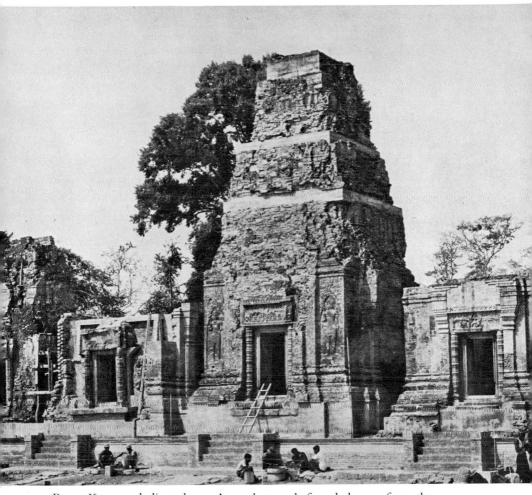

45 Prasat Kravan, dedicated 921. An early temple founded away from the capital by a private, non-royal individual. It was built entirely of brick

Khman in the south of Cambodia, dated to the late 920s. It is likely that many of the wooden buildings, which must have existed in Cambodia in their hundreds of thousands, contained painting. But it has all been destroyed along with the buildings by the deadly tropical monsoon climate of Southeast Asia.

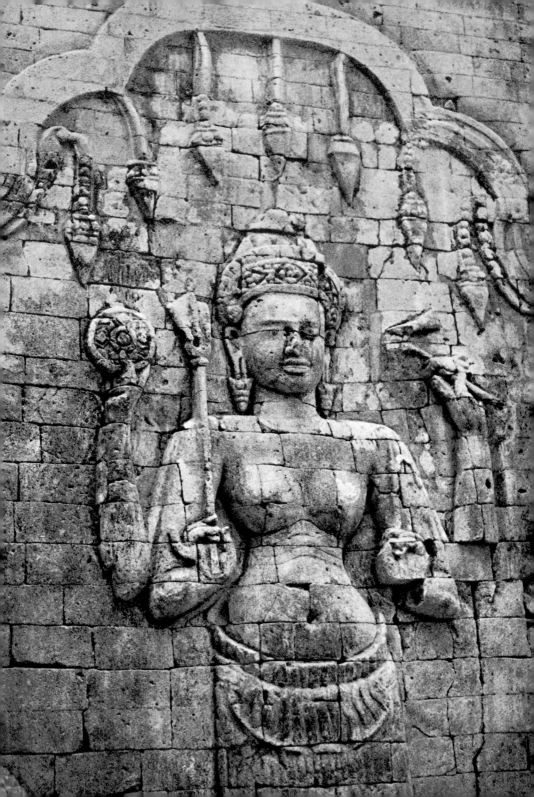

In 952 Rajendravarman (944–68) brought the court back to
Angkor. His son, Jayavarman V, succeeded him, reigning till
1001. Rajendravarman was, it seems, a learned, able and
probably tolerant king; for during his reign several Mahāyāna
Buddhist establishments were set up at Angkor, the chief of
them being Bat Chum. The custom of private individuals
dedicating temples was continued, and a number of such shrines
were built. It is probable, too, that in his reign the idea was
canonized that each king should build his own temple-mountain
which should be at the same time his own funerary shrine. After
his death he would be present there to receive worship and add
his virtue to the propitious powers watching over the empire.
Rajendravarman's own temple-mountain was Pre Rup (*Ills.*

47 Plan of Pre Rup, 961; probably the first of the temple-mountains
intended as a permanent shrine for the divine spirit of the king after his
death

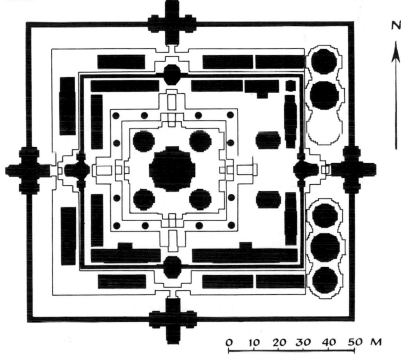

N

0 10 20 30 40 50 M

46 Lakshmī Temple, Prasat Kravan; a syncretic image of Lakshmī, a female
deity, carved in the brick surface of the temple; this is far less sensuous than the
stone carvings. The icon combines Shaiva and Vaishṇava attributes

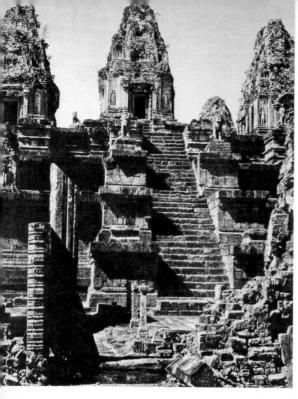

48 East façade, Pre Rup, showing the steep ascent to the summit of the mystical mountain where Rajendravarman's departed spirit was supposed to reside

49 Gate-pavilions of Banteay Srei, the most beautiful of all the early Khmer temples. 967

64

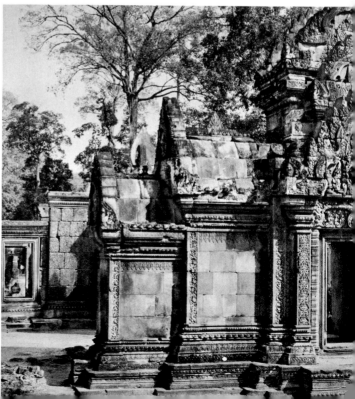

47–8) (961); he also built the eastern Mebon (952) on an island in the east baray. Pre Rup is especially impressive – a three-stepped stone pyramid, crowned by five tower-shrines of brick (*Ill. 48*). There are the usual axial staircases guarded by big stone lions. Each staircase is gained through a gate-pavilion on a cruciform plan in the outer enclosure, and through a further gate-pavilion in the inner enclosure. There is a row of six shrines on the lowest level facing east, and, most interesting, some long stone galleries once roofed with wood and tiles, a type which evolved into the long corridors of later buildings. The towers seem to revert somewhat to the old, plain convention of superimposed diminishing storeys, and not to seek the vitality of outline that began to appear in the Bakheng. Rajendravarman also established the Phimeanakas as the imperial palace – a rôle it played for all the later emperors. Its three high stone terraces with elaborate horizontal mouldings and overhanging architraves probably carried a succession of palace buildings. The present one is of a late type.

The greatest work of Khmer architecture and sculpture in the tenth century is a private foundation twelve miles north of Angkor – Banteay Srei. On this building a style was perfected which marks a high point in the art of Southeast Asia. It has survived the repeated reconstructions of Angkor only on two tiny shrines inside Angkor Thom. Everything about Banteay Srei is distinctive. It is full of inventions, and is splendidly elaborate in the best sense. The man who founded it was a Brahmin, Yajñavarāha, who was himself of royal descent, and had been tutor to Rajendravarman and his son. His temple consists of three tower-shrines in line on a single terrace inside concentric enclosures which are pierced by gate-pavilions (*Ill. 49*). Around the shrines are other buildings, some with stone-vaulted roofs (*Ills. 50, 51*), identified as libraries, and the remains of a pillared hall. On the terraces, groups of free-standing figures of mythical guardian animals are arranged. Pink sandstone was used throughout, and on the whole it is in an excellent state of preservation.

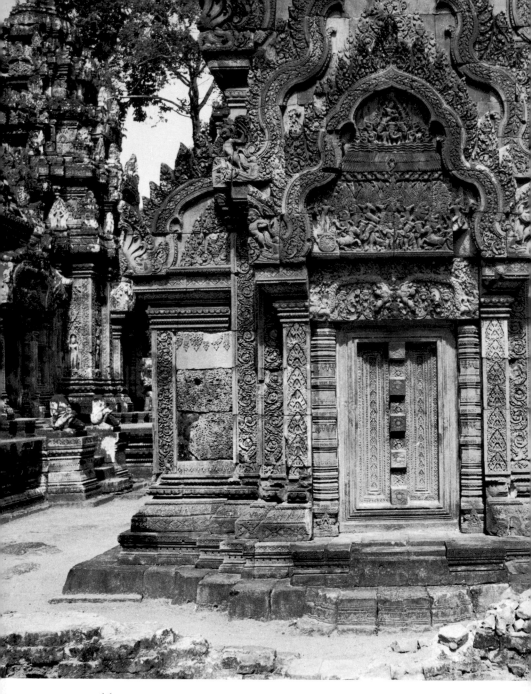

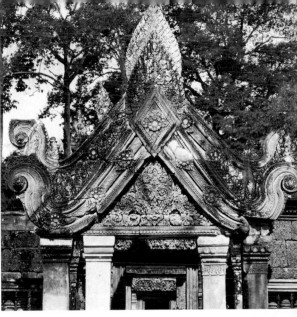

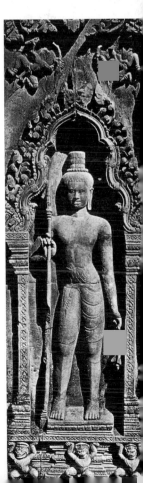

50–2 Banteay Srei: 50 (*left*) library; 51 (*above*) antefixes of library; 52 (*right*) Dvarapala, central sanctuary. This private foundation sums up the traditions of Khmer art to perfection. The lively opulence of the ornament is matched both by the architectural invention and by the sensuous vitality of the figure sculptures

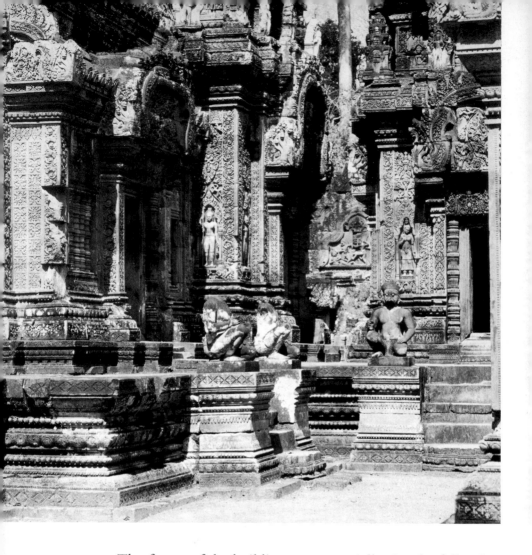

The forms of the buildings are essentially simple, following normal Khmer patterns. But to nearly all of them have been added a wealth of design, architectural and sculptural, whose purpose is to fill the mind with a sense of splendour, and invest earthly structures with an aura of divine glory. The buildings are not primarily engineered structures. They are gigantic sculptures that blossom into a tropical wealth of varied forms (*Ill. 53*). The plinth and architrave mouldings, for example,

68

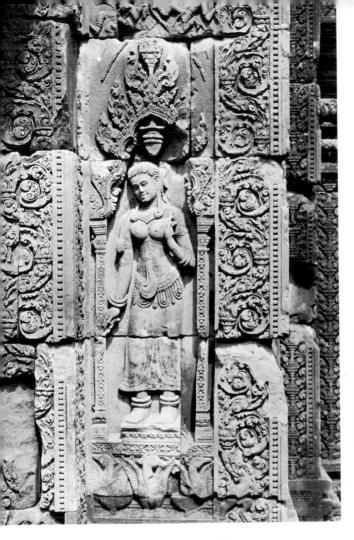

53, 54 Banteay Srei. *Far left:* the great variety of decorative forms. *Left:* Celestial girl. Banteay Srei shows an unrivalled integration of volume and enclosure in the architectural masses, vitality and order in the ornament, variety and system in the mouldings. Sculptures stand free to punctuate the space

appear as rows of petals or sprouting buds. The faces of wall panels and pilasters are covered with full foliate designs based on a wide variety of patterns – spirals, lozenges, and entered triangles, in many variations. Windows are filled with a lattice of bobbin-columns. The figures that are wall-images of deities (*Ills. 52, 54*) begin to show a fresh sense of movement, and their Cambodian faces with their everted lips take on a new, if linear, life.

69

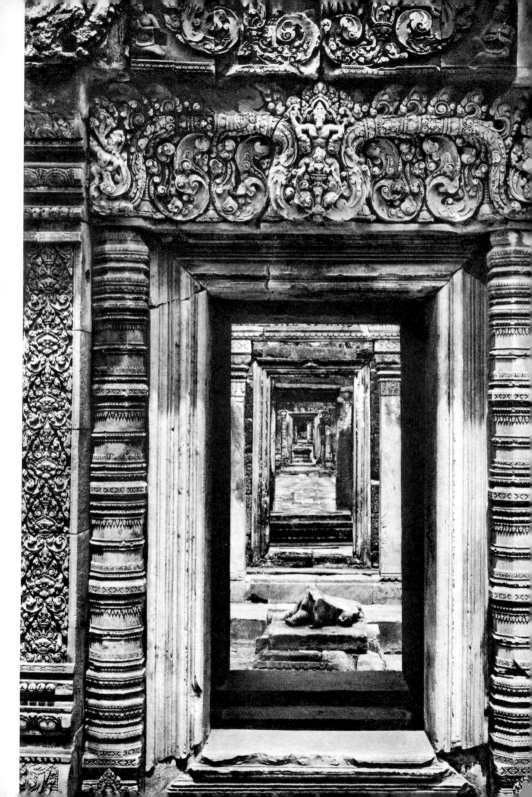

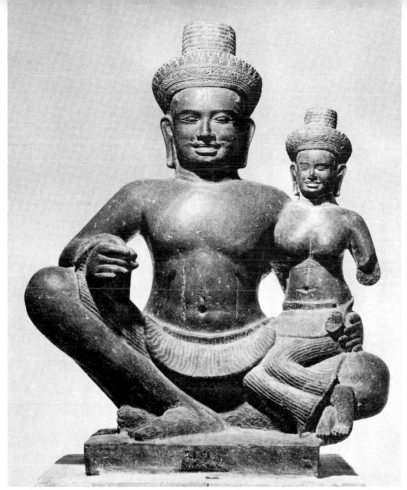

56 Shiva and Umā from Banteay Śrei. Late tenth century, sandstone.
Height 60 cm. Khmer divinity was male and female; king and queen,
earthly representatives of the deity, were both divine

The chief iconic image from the site is a splendid sculpture of
Shiva seated, holding his wife Umā on his left knee (*Ill. 56*). The
massive cubical forms give a grandiose impression of power.
But the bulk of the architectural invention was devoted to the
huge gabled doorways (*Ills. 50, 55*). These are crowned with the
usual ornate Khmer lintel. Above it usually towers a triple tier
of flamboyant double-ogival arches, whose outer ends roll up
to form Nāgas and Garuḍas, and whose deep curves erupt along

55 General view of the eastern access, Banteay Srei. The massive rectangles of
the door frames act as perfect foils for the controlled opulence of the relief
ornament. The engaged pillars articulate the two

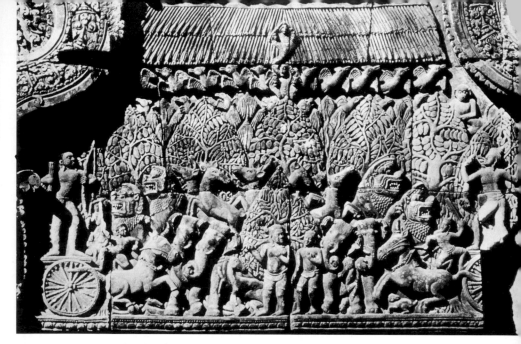

57 Pediment from Banteay Srei. The narrative relief is filled with opulent convex bodies – even the trees and birds have volume

their upper edge into a continuous row of upward-pointing hands of foliage. Inside the lowest arch is a pediment bearing a figure relief of mythical scenes (*Ill. 57*). The figures here are very lively, creating a strong sense of space. They converse or quarrel with each other recognizably. The narrative sense is strong. Sometimes the upper pediments contain figurative reliefs; here and there images of deities act as dies at the springing of the arch. The linear effect of the arches spreads beyond their termini into the ornament of roofs and façades. On the exterior gate-pavilions an entirely original pattern of double arch is used. It is triangular, crowned with a lozenge panel set in a high, pointed cartouche; its ends curl up into sinuous volutes, and it is punctuated with rosettes. Finally, on the central sanctuaries the crowning tiers, like certain south Indian towers, are people with deities, each in his halo of fine ornament.

72

The Classical Age of Angkor

During the first decade of the eleventh century, the Khmer empire was taken over by a usurper who may have originated in the Malayan provinces of the empire. He took the name Suryavarman I. His energy and skill were evidently considerable, for he annexed to the empire large tracts of territory; Champa had already been subdued, but he now dominated the whole of southern Siam as far north as Lopburi, as well as most of southern Laos. He himself adopted the Hindu royal cult of his predecessors, holding himself a representative of Shiva; but the land he came from was imbued with Buddhism. So during his long reign – he died in 1050 – he permitted or even assisted the growth of Mahāyāna Buddhism in his country. Buddhist sculpture appeared quite frequently in and around Angkor. Suryavarman's son, Udayādityavarman II succeeded him on the throne, and reigned until 1066. He expanded and consolidated the Khmer empire still further. In order to increase yet again the agricultural resources of Angkor, he built the five-mile-long western baray with its associated canals on the same pattern as the others, submerging the ninth-century city under it, and covering the old Ak Yum temple with its dyke. This king was followed by his younger brother, Harshavarman II, who ruled until 1080, but gradually lost the empire his predecessors had gained. The Cham, in particular, not only regained their independence, but sacked and burned the venerable Chen La city of Sambor on the Mekong.

Under this trio of kings the political and social fortunes of the Khmer were advancing towards a peak. The continual expenditure involved in constructing the long series of massive buildings and their associated cities indicates that the opulence of the Khmer empire was immense. For sheer size this dynasty's

73

58 Phimeanakas, *c.* 1000, showing the high plinth of the royal residence of many of the kings of Angkor. Khmer royalty had to live on a symbolic mountain

59 Ta Keo, *c.* 1000. The first of the great personal temple-mountains to be built entirely of stone

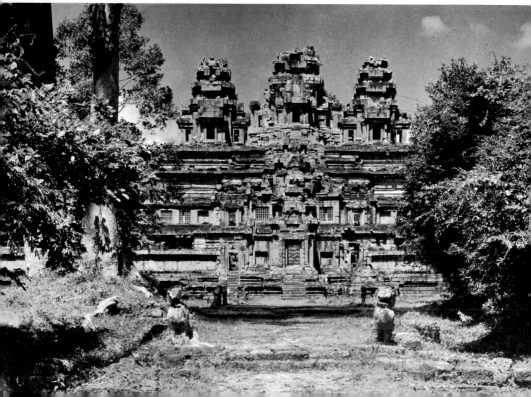

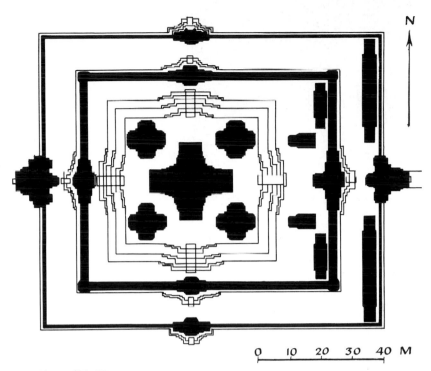

N

monuments are eclipsed only by Angkor Vat and Angkor Thom. Nothing earlier can match their ambitious extravagance. Yet the fact that the dynasty were usurpers from a distant province did not affect the character of their art at all. The builders and sculptors of Angkor continued to work for them in their own deeply ingrained tradition.

The chief work of Suryavarman's reign was the temple-mountain Ta Keo (*Ill. 59*). He continued to work on the Phimeanakas (*Ill. 58*), and did a great deal outside the capital, adding new portions to Preah Vihear, and building fine temples at Vak Ek, Vat Baset, Phnom Chisor and Chau Srei Vibol.

Ta Keo is firmly in the line of temple-mountains from Ak Yum through Bakong to Pre Rup (*Ill. 60*). Once again the five-tiered pyramid supported five tower-shrines. But this time the

75

entire structure, even the tower-shrines, was built with sand-stone. The three topmost terraces are steep and high. The two lower ones are broad, the lowest measuring 113 by 134 yards. The rims of the first terrace above the bottom one are edged with continuous pillared galleries with corner towers, while the easternmost rim of the lowest is similarly adorned. The axial approaches are through two cruciform gate-pavilions. The buildings here impress more by their spacious mass and by their form, than by their florid richness. The ornament is decidedly more restrained than in the Banteay Srei style. The lintels follow a pattern, with a monster's head in the centre from which two curled leafy branches spring. The octagonal columns are covered with more minute rings and dense, rather than opulent leafage. Pediments and tympana confine themselves to foliate ornament. Work in a similar style seems to have been continued on the Phimeanakas. Two shrines, the north and south Khleangs, which now stand within Angkor Thom, belong to the same style. Few sculptures in the style are known, however; such few as there are suggest slightly stylized versions of Banteay Srei figures, with gently smiling faces. A smile is surely appropriate on the faces of those who are supposed to dwell in heavenly bliss!

Udayādityavarman II followed the tradition which seems to have compelled ambitious Khmer kings to try to build their own temple-mountains vaster than those of their predecessors. His Baphuon (*Ill. 61*) is a colossal monument 480 yards long by 140 yards wide, approached by a 200-yards-long causeway raised on pillars. The height of the topmost of its five terraces was 75 feet, and the crown of the central tower must have been something like 160 feet above ground-level. Unfortunately, this temple has suffered much destruction, and it is difficult to form an accurate impression of what it must once have been like. It is clear that the first and second terraces were surrounded by sandstone vaulted galleries; there were towers at the terrace-corners and big gate-pavilions. There were as well four libraries on the lowest terrace. In the style of the Baphuon is the

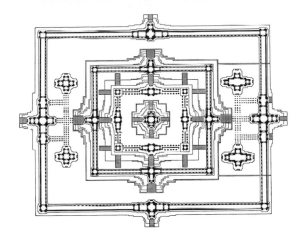

61 Plan of the Baphuon. 1050–66. Unfortunately this temple-mountain is almost destroyed. It was vast; and its plan shows it to have been the immediate prototype of Angkor Vat

western Mebon, built on an island in the king's own western baray, and also a few small shrines in other parts of Cambodia, dedicated, it seems, by the king to local deities for the benefit of the local population. They are simple towers based on shrines.

The sculptural style of Udayādityavarman's reign is both interesting and progressive. The stone relief carving, both of foliate ornament and of narrative with figures, has a beautiful classical self-sufficiency (*Ill. 62*). The ornament is never excessive, though the forms are full of life. The narratives devoted mainly to Kṛishṇa show that the artists were capable not only of infusing the old conventions with new life, but of inventing

62 Carved sandstone panel, Baphuon. The style is far more restrained and schematic than on any of the earlier Khmer buildings

entirely fresh compositions full of men and animals in vivid motion. The heads of the Brahmanical icons which come from the various sites (*Ill. 63*) show that the artists had a vision of the divine persons which included a strong sense of their physical presence. These are no routine formulae merely chopped out with skill. The correct iconic types are certainly followed, but the execution is imbued with tender solicitude for the actuality of flesh and bone. Even the linear conventions which govern the shaping of eyes and lips, derived ultimately from those of the Banteay Srei style, are carried out with modest care. The surface changes delicately from convex to concave, softly but at the same time with absolute formal accuracy. Such art can only be the result of inspiration and dedicated work in which time is no object.

One of the most interesting pieces of all is a fragmentary bronze bust, from the western Mebon, of the god Vishṇu lying asleep on the ocean of non-being (*Ill. 65*). Head, shoulders and the two right arms survive. It shows the extraordinary, delicate integrity and subtle total convexity of surface which these sculptors could achieve by modelling. Eyebrows, moustache and eyes seem to have been inlaid, perhaps with gold, silver or precious stone, though the inlay is gone and only the sockets remain. This was one of the world's great sculptures. Another magnificent bronze of Shiva, from Por Loboeuk (*Ill. 64*), suggests the wealth of metal art that once must have existed in Cambodia at the height of its power. But metal is wealth, and invaders and pillagers have melted down all but a few scattered items. Rarely indeed can such a level of artistic achievement have been attained, only to be so thoroughly obliterated.

The great invasion which destroyed the city of Angkor and ruined many of its monuments came at the close of the city's classical epoch, immediately after the culmination of Khmer art in the monument and style of Angkor Vat. The invasion was the final riposte of the hard-pressed Cham people, who suffered continuous oppression at the hands of King Suryavarman II (1113–50). The successors of Udayādityavarman II had been

65 (*right*) Reclining Vishṇu, from western Mebon. Late eleventh century, bronze, height 217 cm. This splendid figure shows the deity, the Ground of Being, asleep on the primordial ocean of non-being. Like *Ill. 64*, the face would have been inlaid

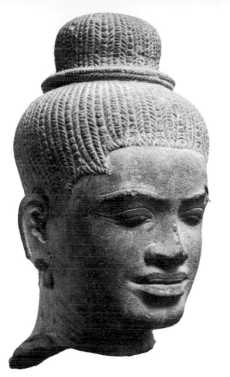
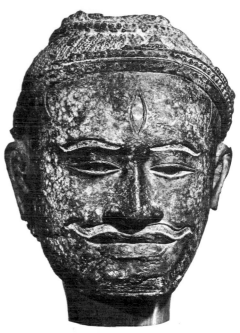

63 (*left*) Head of a god, unknown provenance. Mid-eleventh century, sandstone, height 23 cm. A typical divine head of the time

64 (*right*) Shiva from Por Loboeuk, Siemreap. Mid-eleventh century, gilded bronze, height 32 cm. This life-size head once had glazed and coloured inlays which would have given vivid expression to the face

too weak to retain control of his empire. In 1080 a new dynasty had been founded by a usurper who seized the kingdom, and called himself Jayavarman VI. He had been a northern provincial governor claiming aristocratic descent. He was not the only claimant to the throne, however, and his reign was marked by political upheavals. He never established himself at Angkor, and none of the architecture which he sponsored was there, but along the higher northern fringes of Cambodia. There are monuments at Preah Vihear, at Vat Phu and at Phimai in northern Siam, for example, where the traditions of Khmer art were well rooted. Jayavarman VI died in 1107, to be succeeded by his brothers, until his grand-nephew Suryavarman II placed himself firmly in power at Angkor in 1113.

This king was ambitious, aggressive and only at first politically successful. Angkor Vat, however, must stand to his eternal credit. His conquests extended the limits of Khmer power farther than ever before. Its western borders included Siam and rested on the eastern borders of the kingdom of Pagān. To the south Suryavarman ruled much of the Malay peninsula. It was in the east and north that his nemesis lay. In his efforts to seize control of the whole of Annam, the king of Champa refused assistance. Suryavarman simply deposed him and annexed his kingdom in 1145. The Cham were not willing to remain subservient, and regained their independence in 1149. Suryavarman died in 1150 after a further disastrous attempt to conquer Annam, when his armies were destroyed by fever on the long march through the jungle-clad mountains. His death left the kingdom exhausted, divided and weak. In 1177 the Cham seized their chance of revenge. Their fleet sailed up the Mekong river into Angkor, and sacked it. They carried off the wealth it had accumulated over the centuries, and burned the wooden city to the ground. Never before had Angkor experienced attack. It is true that a distant relation of Suryavarman's, Jayavarman VII, resurrected Angkor in a final blaze of glory but on a different metaphysical basis. The extinction of the line of god-kings in 1177 marked the end of an epoch.

Jayavarman VI built no temple-mountain. The shrines he did build in the north of Cambodia were conceived as towers· within enclosures. Suryavarman's great monument, Angkor Vat, however, is a temple-mountain conceived as a natural successor to Baphuon. It is clear that there were difficulties in finding a site for the colossal project which was to do justice to the vanity of Suryavarman the conqueror. Angkor was densely populated, filled with the monuments of the king's predecessors, and constricted by the grid of essential canals. Angkor Vat lies well to the south of the other great temples, and does not face east but west. The huge moat with which it was surrounded, two hundred yards wide and almost four miles long, was sheathed in steps the whole length of its bank. It could thus serve as the water supply for the inhabitants of the new city which Suryavarman built around it. And since the Vat is so far from the centre of the old city, it seems that this king did not live in the Phimeanakas, the old palace of his predecessors, but inhabited his own temple-mountain permanently. Although he began it almost as soon as he came to the throne, it seems to have been finished only just before he died. It is perhaps surprising that he succeeded in finishing it at all, for it has been estimated that there is as much stone involved as there is in the great pyramid of Kephren in Egypt. And what is more, the Vat's stone is carefully dressed, carved and ornamented.

The whole enclosure of seventeen hundred by fifteen hundred yards is surrounded by an external cloister (*Ills. 66, 67*). It is

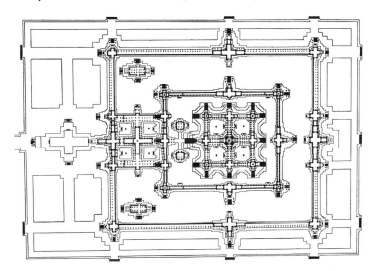

66 Plan of Angkor Vat, early twelfth century; the crowning work of Khmer architecture, carrying to their high point all the features of earlier styles

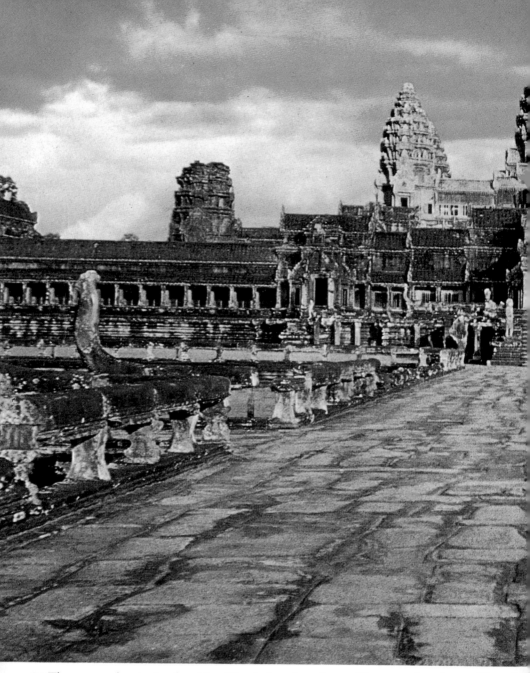

67 The approaches to Angkor Vat. The shrine pinnacles are like sprouting shoots. The who

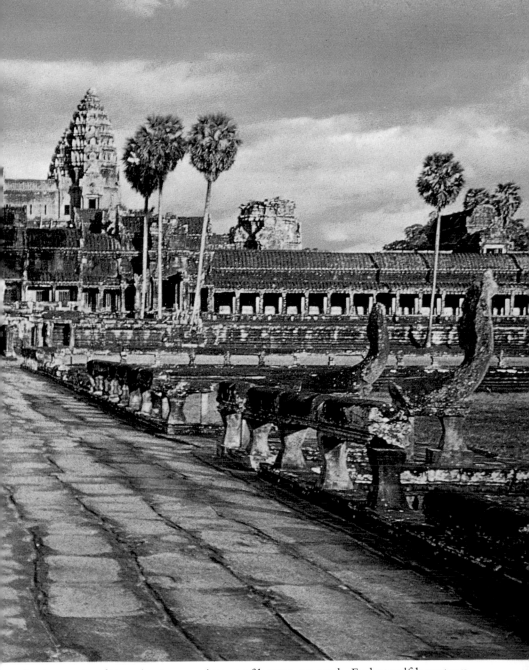

...omplex is a vast sculpture in stone, an image of heaven on earth. Early twelfth century

approached from the west by a magnificent road built on a causeway lined by colossal Nāga balustrades. Rows of lions guard the approach, and the causeway rises to a broad cruciform plateau on pillars guarded by Nāgas with raised hoods. At this level it penetrates the first of the two main rectangular enclosures which sanctify the shrine, through a towering gate-pavilion whose winged roofs ride down in steps to the level of the enclosure roof. The enclosure is formed by high walls on a plinth, cloistered and roofed with stone (*Ill. 68*). Within the first enclosure a colonnaded building joins the gate-pavilion to the façade of the inner enclosure. A transverse passage links the triple naves of the colonnaded building. At north and south lie library buildings, whose long axes run west to east (*Ill. 70*).

The inner enclosure is yet another cloistered wall, punctuated with corner towers, lesser gate-towers, and towers where the three naves meet the doors in the enclosure wall. Inside the inner enclosure, the main entry rises by a magnificent flight of steps, flanked by two further pavilions, from the ground-level to the summit of the three-terraced mountain, on which stands the quincunx of towers. All are on a cruciform plan with gabled porches extending in the four cardinal directions. But the central tower – the Shiva shrine – is the most magnificent of them all. The tower spires have eight storeys and a crown, and are square, with a series of multiple recessed profiles and centre projections that makes them look octagonal. They show the full-fledged curved outline of a sprouting bud, which gives the impression that each storey is rising out of the one beneath (*Ill. 67*). This impression, combined with the façade motifs of all the gable-ends – which have upturned corners and rise well beyond the ridges of their roofs – is responsible for the extraordinary dynamic, rising effect of the structures. Once within, the spaces of the courts, which are broad enough but dominated by the massive profiled volumes of the stonework, provide a continuously enthralling series of architectural images, no two identical. The contours of the stone roofs are convex-curved, and slightly re-curved at the eaves. Most of the pillars are square,

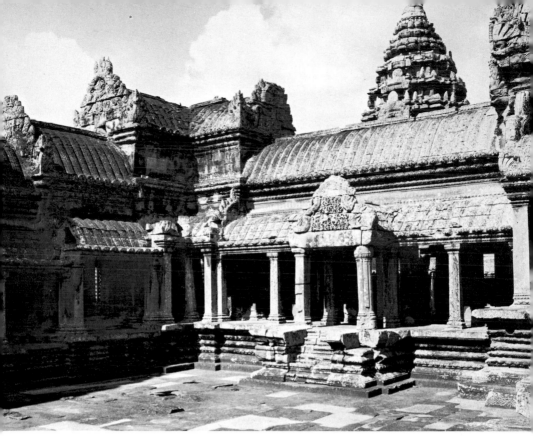

68 Courtyards, Angkor Vat.
Every corner is perfectly
articulated

69 Detail of façade, Angkor
Vat. The projections of the
building, structuring the
space around them, impose
their own image of cosmic
order

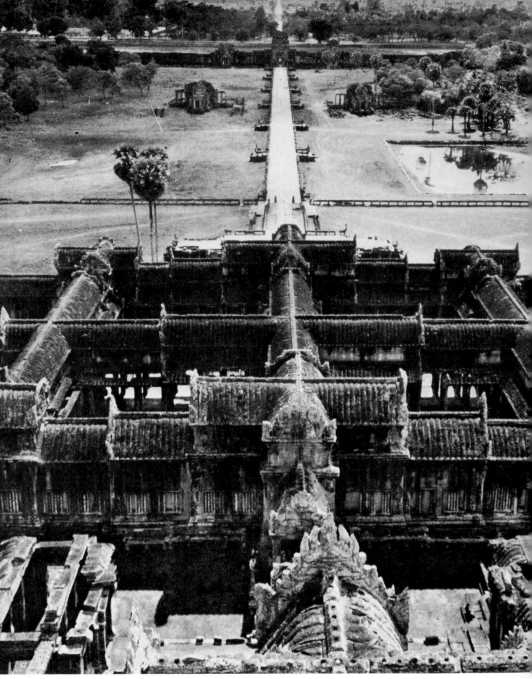

70 Cruciform courtyards, Angkor Vat. The Vat lies at the hub of its universe

with huge square-cut capitals stepped out to accept the weight of their great architraves. The salient pairs of columns, which carry the typical Khmer carved lintels, are cut to suggest quadruple compound columns. The base plinths are horizontally moulded, and under the eaves run courses of restrained ornament. Only on the towers does the accumulation of moulding and the multiplication of carved motifs become dense, with repetitions of the flamboyant gable-cartouche. The whole Vat, in fact, is a single massive sculpture. The technique of its construction consisted of erecting the plain masses, and then setting the sculptors to work to finish them *in situ*.

At Angkor Vat there are indeed numerous free-standing sculptures, including the massive guardian figures incorporated

71 Square pillars, Angkor Vat. Even the roofing surfaces are carved into their final forms

into the architecture. There are images from other parts of Angkor, including bronzes, in the style of the Vat. However, it is clear that at this time the genius of the sculptors had retreated from the full-round image. Such figures as there are lack life. The volumes of their bodies are lumpish and stilted, and the surfaces are casually worked. The ornamental elements, such as folds of garments, jewels and decorated chignons, have taken on an undue prominence. The genius of the artists of that age was for relief. Indeed one might say that the Vat is a repertory of some of the most magnificent relief art the world has ever seen. The open colonnaded gallery on the first storey contains over a mile of such work, six feet high. Elsewhere appear those occasional groups and figures of divinely beautiful female courtiers, celestial courtesans, known to Hindu tradition as *apsarases* (*Ills. 74, 78, 79*), who are an essential ingredient in the Hindu image of heaven, where all is pleasure without pain.

The style of the relief sculpture is certainly Khmer. But possibly other influences have been at work in its formation; notably the style of Borobudur in Java, which at some times in the past – at Banteay Srei for example, and at the Baphuon – perhaps contributed the overlapping series of bodies extending into deep space. But it is generally accepted that Chinese art of some kind has also made its contributions, if at a rather superficial level. Certainly we hear from Chinese sources that Suryavarman's palace, probably the Vat, had ceilings tented with Chinese textiles. The flowery ground in low relief, against which some of the apsarases are set, suggests the silk brocade for which China was always famous. The fluid linearism of the style of the figure reliefs again suggests comparable Chinese work of a slightly earlier date – though the comparative material is scanty. It would not be surprising if Suryavarman did require his artists to Sinize their style, since the emperor of China was at that time the only ruler east of India whose power and splendour were greater than Suryavarman's. But the ultimate foundations of the style remain what they always were, securely Indian, reminiscent of late Pallava and Chola art in south-eastern India.

72 Bas-relief, Angkor Vat. The march past of the army of Suryavarman II, detail of standard-bearers, with movement reminiscent of the dance

There is one further element in this relief style which is important, in a way in which it is not in the styles of Banteay Srei or the Baphuon. This is the element of expression derived from and related to the dance (*Ill. 72*). One must suppose that in common with all other Indianized courts of Southeast Asia, the Khmer court had imported and developed in its own way the traditions of the Indian dance. Even today similar traditions survive in Java, Bali, Burma, Thailand and Vietnam. The repertoire of costume, posture and significant gesture is combined at Angkor Vat with the use of the great legends of Hinduism as an immense fund of dramatic expression. But the strength of this figurative art is that it can combine into its dramatic image all sorts of additional elements such as chariots, horses, and crowds of fighting figures in a way impossible to the theatre.

The main sources for the relief subject-matter are the *Mahābhārata* and *Rāmāyaṇa*, as well as legends of Vishṇu (*Ills. 73, 75*) and his incarnation Krishṇa. The wars of classical legend, in which incarnations of the various persons of the Hindu deity triumph at length over demonic adversaries, are obvious subjects for a king who regards himself as earthly incarnation of the deity to commission. The artists' extraordinary skill is everywhere apparent. Unfortunately, we know none of their names, for the only name to be mentioned in this kind of sanctuary must be the king's. But they were capable of creating in relief

73 Bas-reliefs, Angkor Vat. Warrior chief wounded and dying on his chariot at the Battle of Kurukshetra. A vivid sense of the depth and space in which the heroic figures move is suggested by the shallowest of relief

74 (*right*) Apsarases, Angkor Vat. The king's celestial concubines

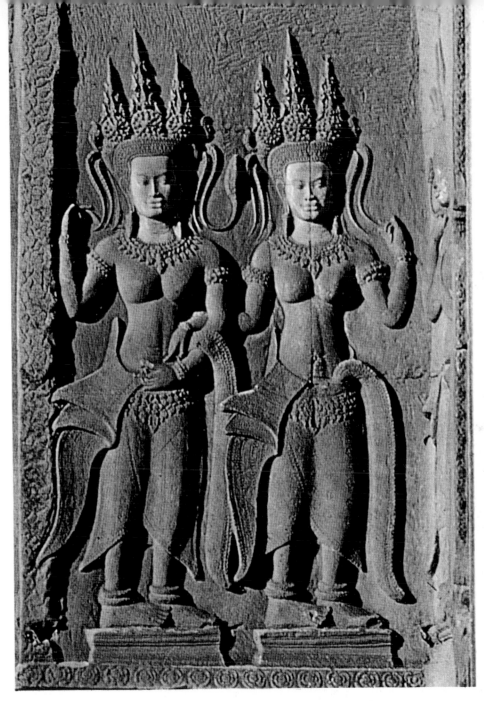

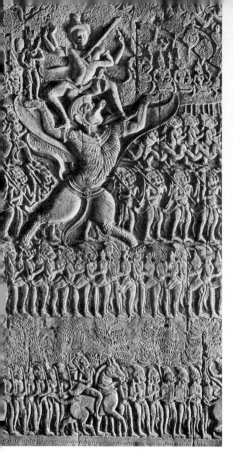
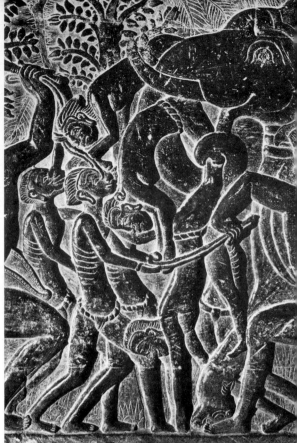

75 *(left)* Bas-reliefs, Angkor Vat. The design is hieratic: the king's divine counterpart Viṣṇu enthroned on Garuḍa

only about an inch deep an extraordinary complex of scenes: figures involved together in vigorous action, the air thick with banners, umbrellas and floating scarves (*Ills. 73, 75, 76*). It is, of course, an art of outline, where the solid bodies are created mainly out of assemblies of convex curves, with here and there re-curving pure concavities. But so skilful is the composition with its echoing and connecting curves that one has the impression that the whole relief forms part of a single massive chain of movement. The ground is filled with figures which, by their complex sequences of overlaps, produce convincing conceptions of spatial depth (*Ills. 73, 76*). Demonic faces are so characterized;

92

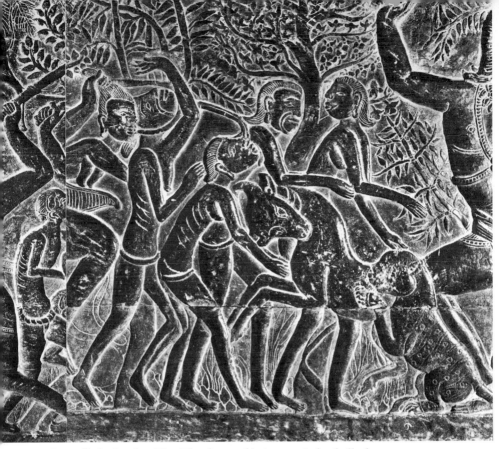

76 Bas-reliefs, Angkor Vat. The damned being carried to hell: the torments of those disobedient to the divine law of the king

but most of the other faces, as well as hands, feet and limbs, remain conventionalized, as they are in most Indianizing art. The Chinese cult of extravagant individuality did not travel to Cambodia. At bottom these sculptors were working to combine 'ready-made' forms. Their art was certainly a 'painterly' one. Indeed colour and gilt would almost certainly have completed the work.

The apsarases form an interesting special collection. They are virtually indistinguishable one from another, and stand, in postures only slightly varied (*Ills. 74, 78, 79, 80*), at the angles of buildings, by windows, framed in gorgeous floral decoration.

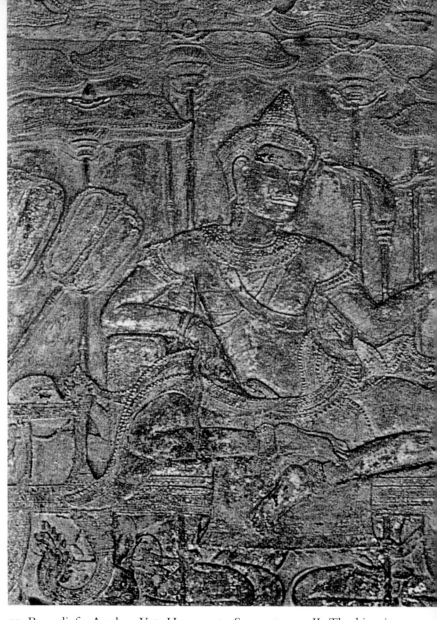

77 Bas-reliefs, Angkor Vat. Homage to Suryavarman II. The king is at his royal ease

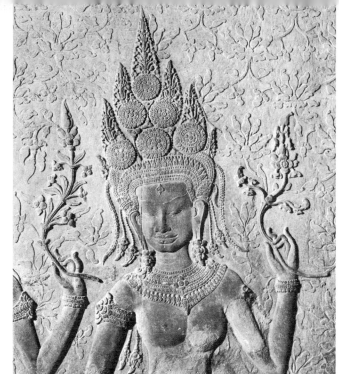

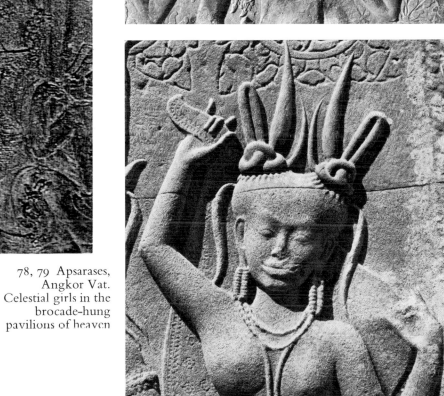

78, 79 Apsarases,
Angkor Vat.
Celestial girls in the
brocade-hung
pavilions of heaven

They represent the ultimate in Khmer ideals of female beauty; that is their rôle. They are royal–religious 'pin-ups', and though their bare torsos are certainly carved with a sinuous sensuality, the most important part of their charm is their fantastically elaborated clothing, jewellery and hairdressing. Jewels are abundant, if not very varied. It seems that the height of Khmer *chic*, however, was signified by deep, sinuous, downward–drooping lines standing far out from the body. Skirts, stoles and the long, carefully fashioned side–locks of the hair all follow this line, laid out flat on the ground of the relief. Some apsarases wear ornate, towering jewelled crowns. But the hair of many of these girls (*Ill. 80*) was divided into as many as ten separate locks, which were spread in a halo of points and loops standing out around the head.

The meaning of Angkor Vat is probably best indicated by its facing west. It is a meaning which seems, in the historical context, ironically apt: for to the west lies the region of the dead. And among the reliefs is one panel devoted to the judgment of the dead by Yama, the Hindu 'Lord of Death'. The dead are, according to their merits, punished in a hell equipped with all kinds of hideous tortures, or carried off to the mountain-peaks of heaven where the apsarases, filled with inextinguishable amorous desire, await them. It is clear that Suryavarman intended the Vat to be his own mortuary shrine; it is also clear that he intended it as a kind of premature wish-fulfilment. He had constructed his heaven, complete with apsarases, before his death, as a visible demonstration that his nature was divine. Incarnate as Vishṇu (his chosen personal deity) heaven would automatically be his after death. Could royal vanity go further? It could, and did.

It may in fact have been this hubristic royal vanity which brought Angkor to its ruin. The kings who struggled for the throne and fed their ambition by self-deification had begun to take less interest in the welfare of their kingdom and in nourishing the basis of their power. Even the irrigation canals had been allowed to silt up while the people laboured on the immense

80 Apsaras, Angkor Vat. The height of Khmer *chic*: a celestial girl

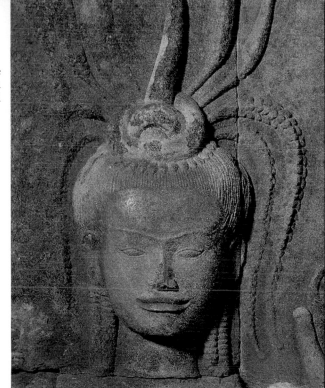

81 Jayavarman VII, Preah Khan. Twelfth to thirteenth century, stone, height 41 cm. One of the many sculptures in which the divinity of Jayavarman VII, the ambitious restorer of the glories of Angkor, was embodied

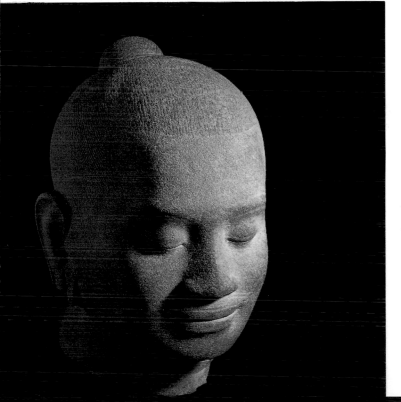

temple-mountains. As has been said, the system no longer justified the sacrifices demanded of the subjects. The ultimate phase of Angkor, however, represents a frenetic attempt not only to recapture the glory of the era before the Cham invasion, but to outdo it. It is perhaps from our point of view a pity that this phase ever took place; for as well as destroying many of the real older beauties of Angkor, it has overlaid the site with a huge number of aesthetically inferior works, produced, it seems, not for a consistent purpose, but largely to feed the vanity of the new king, Jayavarman VII. In fact his Angkor is far more remarkable as a feat of city planning and hydraulic engineering than as an aesthetic achievement.

Jayavarman VII (*Ill. 81*) was a son of Suryavarman II, but did not ascend the throne immediately on his father's death. Unaccountably he seems to have remained in retirement at Kompong Svay, forty-five miles from the capital, during the disastrous episodes that marked the end of his father's ambitious projects – even during the brief reign of a plebeian usurper. Only when the Cham had actually seized and sacked Angkor did he move. He gathered armies and defeated the invaders on land, and in a ferocious naval battle on the lakes and canals. He drove them out of the territory, and became king in the ruined capital in 1181. He then took his revenge on the Cham; he invaded their country, seized their capital, Vijaya, and made Champa a province of the Khmers. Then, at an age of over sixty, he embarked on a series of campaigns which extended the borders of the Khmer empire farther than ever before, into the south of Malaya, to the borders of Burma, and in the north as far as Vientiane and into Annam. The ruler of this empire naturally believed himself the greatest of the Khmers.

During the previous few centuries the Buddhist religion, in a Mahāyāna form, had gradually been gaining ascendancy in the whole of Indochina. The previous Khmer kings had, of course, preserved their own special cult based on the Hindu gods, who were the transcendent source of their divine royalty. But except on certain ceremonial occasions this was not a religion in which

the people participated. Buddhism, the religion of peace and salvation, was gradually winning them over. The defeat and sack of Angkor must have seemed like an adverse judgment from above on the cult of the divinized royal dead, which had come to absorb so much of the attention of the kings and of the effort of the people. The new king, Jayavarman VII, perhaps to accommodate himself to popular feeling and perhaps under the influence of two of his wives, adopted the Buddhist religion. But it was a strange form of Buddhism – a Buddhism in which the Buddha as 'victor over suffering', and especially that form of Bodhisattva known as Lokeshvara, 'Lord of the Worlds', were both adopted as divine prototypes of the human king. Just as the Hindu gods Shiva and Vishnu had been invoked, so these Buddhist principles were now invoked as the fountain of royal power and of the country's wealth. Although cults of this kind had been known in India, it is still difficult to understand how Buddhism could have been so tendentiously interpreted.

Jayavarman's inscriptions record his virtuous establishment of hospitals and Buddhist shrines complete with shelters for pilgrims. These were, no doubt, partly measures to engage the sympathy of a population by now predominantly Buddhist, whose support of the dynasty may have been shaken by the recent disastrous reverses. It may also have reflected the king's own loss of confidence in the old deities of his dynasty, and his determined quest for a more dependable metaphysical sponsorship. It is evident that there was a good deal of violent determination in Jayavarman's Buddhist cult, for he built an almost incredible number of temples both at Angkor and in the country of Cambodia. It is said that he shifted more stone than all his predecessors put together. He began to rebuild some of his own buildings even before they were finished, and during the thirty-odd years of his reign went on enlarging those he had built earlier. The general aspect that Angkor presents today is mainly due to Jayavarman VII's building activity.

Angkor Thom is his city, begun about 1200. He built it exactly over the site of Udayādityavarman II's city, centred on

99

his Baphuon. He surrounded it with a colossal moat at least a hundred yards wide and ten miles long. It became the focus of a final, huge complex of canals and irrigation, with extra barays. He walled it completely; and in the walls he built five gates marked by huge gate-pavilions (*Ill. 83*). Four gates were at the cardinal points, and the fifth gate in the east wall was there to keep open the old sacred road linking the Phimeanakas to Ta Keo, which lay slightly to the north of the east–west centre-line.

82, 83 Angkor Thom. (*below*) Porches by a gateway. (*right*) Gateway to Angkor Thom. The towers of Angkor Thom have four faces, emblems of the divine powers of Jayavarman VII surveying the four directions. His cult of the colossal obliterated many of Angkor's earlier glories

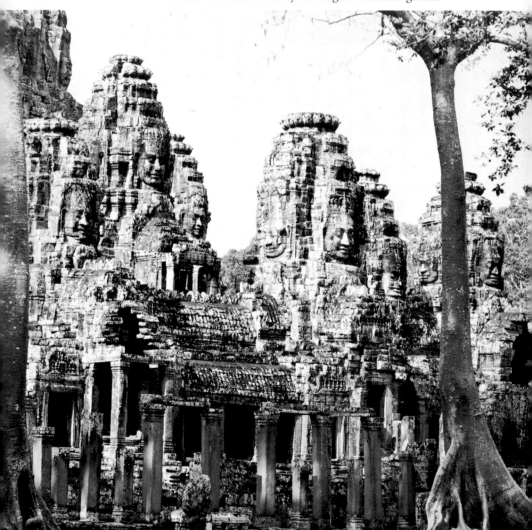

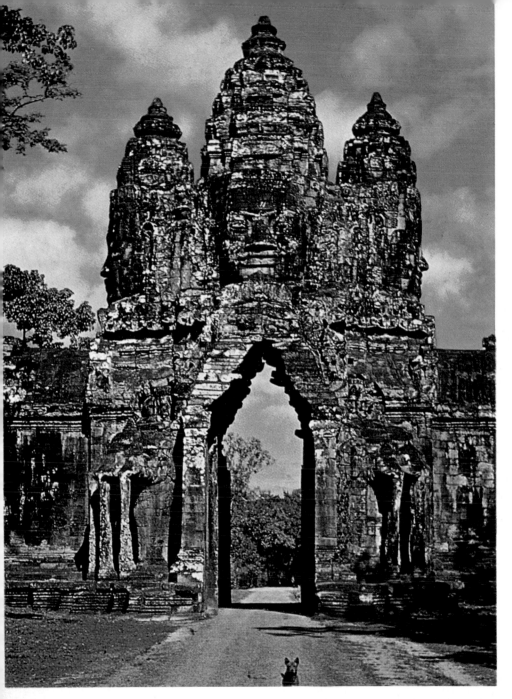

The gate-pavilions embody the outstanding architectural invention of Jayavarman's reign, which has become almost a symbol for Angkor – the tower with four colossal faces looking out in the four cardinal directions. These faces, which in some way are related to the icon of Lokeshvara, at the same time symbolize the power of the king, demonstrating his domination of the four quarters of the world. The Bayon (*Ills. 84, 86*), which was Jayavarman's own sacred temple-mountain at the very centre of Angkor Thom, is crowded with towers, most of which carry the same motif. The masks are combined with the terraced tiers of the towers, with their corner-recesses and projecting false porches, in such a way that the section becomes virtually octagonal. The elevations present both the curved and the pointed, sprouting-shoot contour. The arches of the gateways, and within the towers of the Bayon, are triangular and corbelled. Generally speaking the stonework is hasty and relatively ill-trimmed, and was carved into its final shape and surface *in situ*.

The architecture of this Jayavarman's reign at Angkor shows a certain development, though all of it ultimately springs from Angkor Vat. The chief temple complexes are: Banteay Kdei (*Ill. 85*), which may be dedicated to his religious teacher, begun the very year he arrived in Angkor (1181); then Ta Prohm (*Ill. 87*), a huge complex of towered enclosures, halls and corridors, dedicated to his mother as an incarnation of Transcendent Buddhist Wisdom, begun about 1186; Preah Khan, dedicated to his father as an incarnation of Lokeshvara, begun in 1191; and Banteay Chmar, dedicated to one of his sons who fell in battle. Angkor Thom and the Bayon followed during the first nineteen years of the thirteenth century. The ground plans of all of them are centred on a tower-shrine oriented eastwards, surrounded by rectangular roofed galleries which are punctuated by towers at the corners and at the centre of each side; the outer enclosures contain enclosed cloisters, rows of east-facing shrines on the east side, with additional enclosures and buildings at the north and south flanks of the

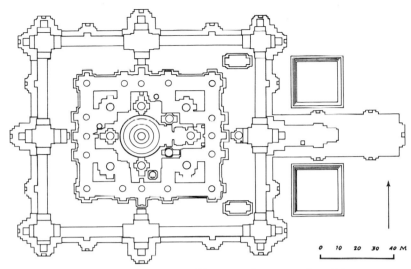

84 Plan of the Bayon, *c.* 1200. The temple-mountain of Jayavarman, which expressly claims to symbolize the cosmic Mount Meru

central complex. Many other smaller shrines were built in every available space in Angkor. Perhaps the most inventive and interesting of them is Neak Pean. This is a small tower-shrine on a circular base standing at the centre of Jayavarman's larger baray to the north-east of Angkor Thom. It is a fountain as well, its water spilling over from the basin in which it stands into four ponds before running into the baray. It represents that paradisal mountain-lake from which magic healing waters flow, supposed by Indian mythology to exist in the Himalayas.

This notion introduces us to what was, perhaps, the outstanding artistic – if not purely aesthetic – achievement of Jayavarman's architects: the working out into massive architectural symbols of a complex of mythical imagery. We have seen how the conception of the temple as sacred mountain came to be embodied in Khmer tradition. At Jayavarman's Angkor, many similar mythical concepts are worked out in visible structures – the towers with faces are one. Another is a complex of water channels representing the four sacred rivers of the world; yet another is the colossal image by Neak Pean of the compassionate Bodhisattva, Avalokiteshvara, in the form of a huge white horse, who is supposed to save sailors from drowning.

103

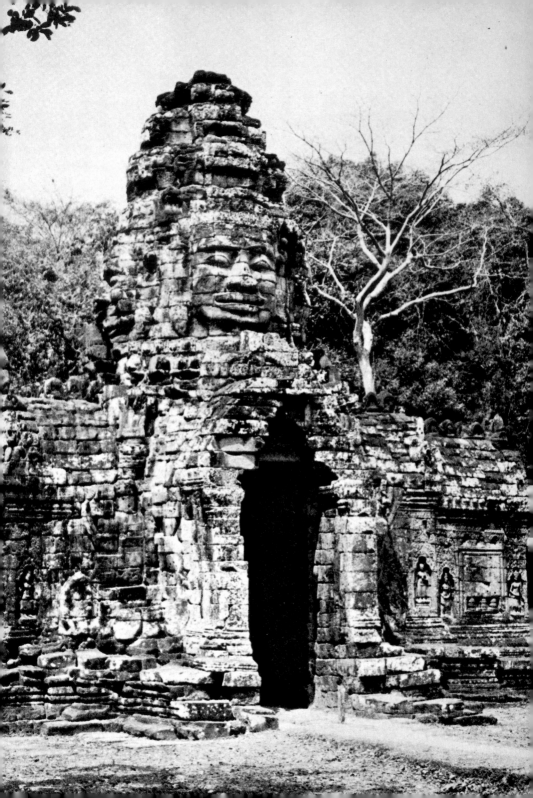

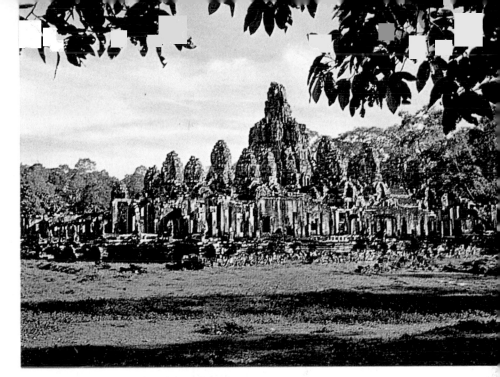

85–7 Parts of three
of Jayavarman's
colossal buildings.
85 (*opposite*) Banteay
Kdei, begun 1181;
86 (*above*) View of the
Bayon; 87 (*left*) Ta
Prohm, begun *c.* 1186

This is an allegory of the salvation of beings from suffering. The colossal stone horse is shown with human figures clinging to its body. It is not much of a work of art, though imposing as a massive image. But perhaps the most important of these realized myths is the complex of towers, terraces and colossi at the centre of Angkor Thom (*Ill. 88*).

The king built his palace in the enclosure of the Phimeanakas, and connected it with the tenth-century pools and other parts of the site, by a series of raised and carved terraces of stone. The most magnificent of these is the 'Royal Terrace' (*Ill. 90*), the front of which is decorated partly with a frieze of elephants. At

88 Aerial view of the Bayon, the only Buddhist temple-mountain in Cambodia; the new axis and creative focus of a world betrayed by its old Hindu patron deities

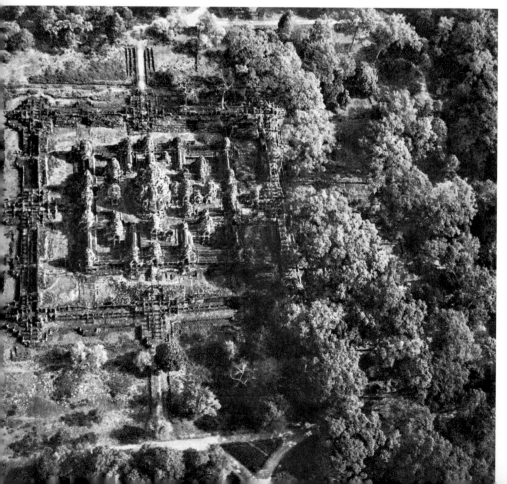

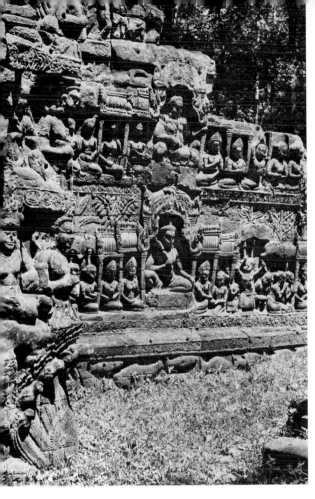

89 'Terrace of the Leper King', Bayon. The king in his palace with his servants. On this high platform the aristocracy of the Khmer were probably cremated

the centre, where the king sat at his ceremonial saluting post for the gigantic ceremonials which must often have taken place, rows of Garuḍa birds (whose normal rôle is to carry the god Vishṇu) in relief support the stages. This position looks due east along the causeway to the 'Gate of Victory' opening on the Ta Keo. To the north, the so-called 'Terrace of the Leper King' may have been the cremation-place for the aristocracy of Cambodia. Its front is carved with reliefs of serried ranks of celestials (*Ill. 89*), but the focal point of the imagery is the Bayon itself. The road to the south from the Bayon is lined with fifty-four colossal images of the gods of heaven, all pulling on the

body of the Nāga (*Ills. 91, 92*); the road to the north with the fifty-four gods of the underworld doing the same. The body of the Nāga is supposedly wrapped round the structure of the Bayon, the temple-mountain. This refers to the Hindu legend, long popular in Khmer royal imagery, which describes the creation of the world. The gods used the magical mountain Meru as the churning-stick and the body of the Cosmic Nāga as the churning-rope to churn all the worlds out of the fluid of chaos, just as the housewife churns her butter out of milk. The Bayon, Jayavarman's temple-mountain, is thus identified with Meru, the central creative focus not only of the human world but of the entire universe. Among the Khmer, the Nāga was imagined to symbolize the rainbow, the bridge of heaven; so naturally it would mark the causeways by which the Bayon – symbol itself of heaven – should be approached. The giant figures of the gods that line the causeways are not carved from single pieces of stone, but from assembled blocks, and again they are very crudely finished works. They are designed for dramatic effect, to aggrandize the king, and not as works of attentive piety.

The image of the Cosmic Nāga seems always to have been very important to the Khmers. The snake is always associated in Indian mythology both with the origin of things, and with the sources of the life-giving water upon which the whole of life, in the high tropics, depends. Angkor itself, designed as a superb irrigation system, must obviously have been under the special protection of the greatest Nāga of them all, Shesha, the emblem of infinite possibility, upon whom the god Vishnu – also long popular in Cambodia – reposes in one of his most important icons. It is therefore especially interesting that Jayavarman VII should have been responsible for so many images being carved for a number of his shrines of an otherwise rare and significant icon of the Buddha. This shows the Buddha as victor over sorrow and death, seated in meditation high upon the coils of a magical Nāga, who shelters the Buddha's head with his own seven heads and hoods spread out above him (*Ill. 96*). The original tale inspiring this icon occurs in some stories of the

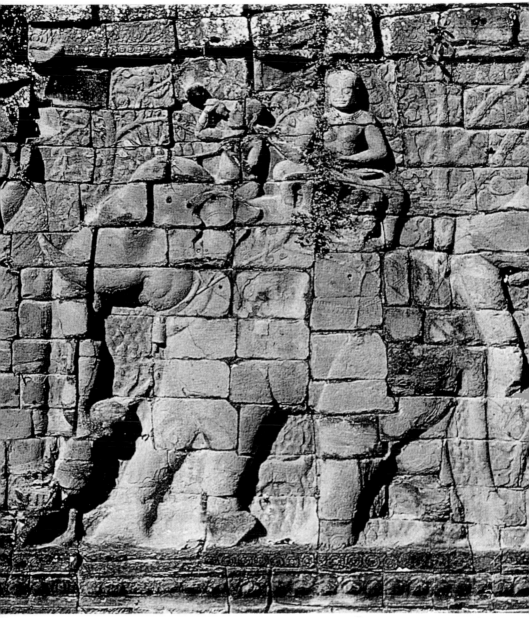

90 Detail of the Elephant Frieze, Bayon. This is part of the plinth of the
royal 'saluting base'

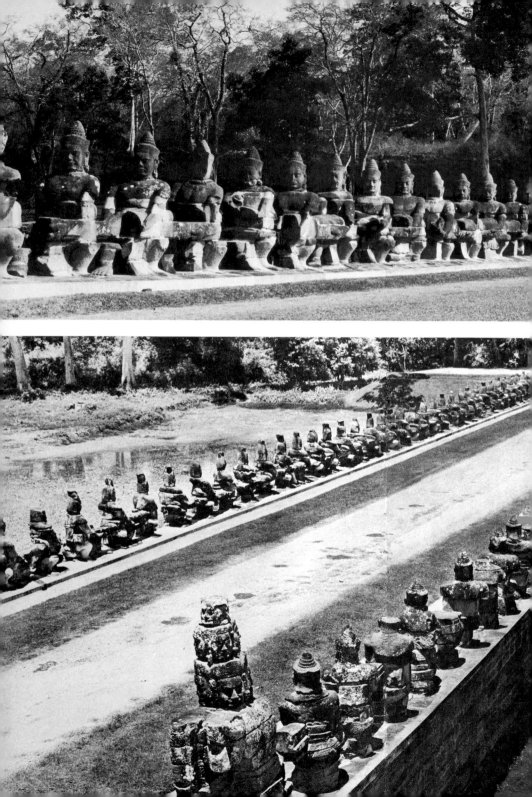

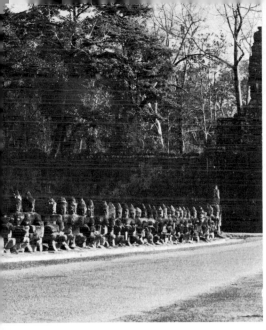

91 The road to the south, Angkor Thom; pulling the body of the Nāga. *c.* 1200

92 South gate, Angkor Thom; general view

These colossi represent the gods who pull on the body of the cosmic serpent which acts as the churning rope to churn the worlds out of the milk of Chaos

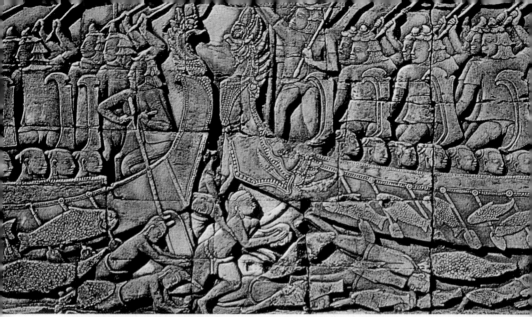

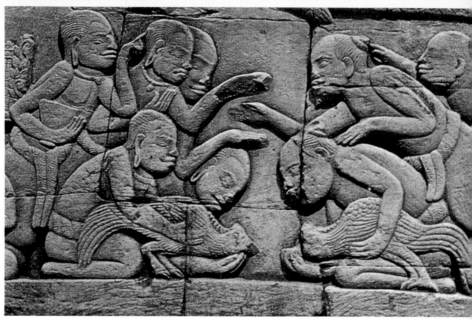

93–4 Two summary reliefs from Bayon give glimpses of Khmer life: (*above*) Cham ships, (*below*) cockfight

95 The 'Leper King', Angkor Thom. In this big work much of ▶ the old sculptural finesse of Khmer art is recaptured, without any loss of strength

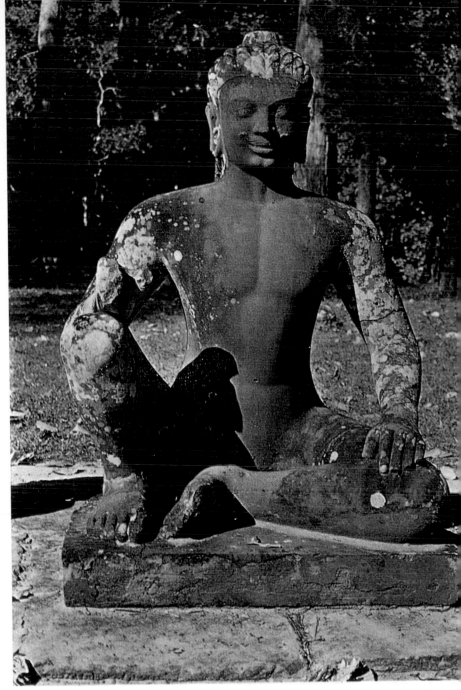

Buddha's achieving enlightenment seated under his Bodhi-Tree. Māra (Death), 'The Enemy of Man', who would be deprived of his prey by the Buddha's enlightenment, sent as many distractions as he could to divert the Buddha from his goal, including a terrible storm and flood. A Nāga crept out from his hole under the Buddha's tree to lift him above the floodwater and shelter him from the rain. Thus when he adopted the Buddha as his patron, Jayavarman made his priests seek out an image that would combine the old familiar Khmer one of the Nāga as cosmic source of existence and life, with the new image of the victorious Buddha as pattern of the king. There may also be an esoteric significance to this icon of the Buddha.

Inside the Bayon the chapels under the towers held many sculptured icons. The central one, under a tower rising 140 feet above the ground, was of the Buddha on the Nāga, the *alter ego* of the king, around whom the universe revolved. In other shrines crowded on to the terraces were images of the dignitaries of the kingdom, attending the divine king in his celestial home. Around the interior walls of the great enclosure were acres of relief carving, all of it rather hastily and roughly executed, and nowhere reaching the standard of the reliefs on Angkor Vat. These reliefs once more deal mainly with Indian classical legend. Here again there is evidence of the influence of Chinese pictorial conventions in some of the compositions, while numerous genre passages – market scenes, hunting, quarrels – have often been admired (*Ills. 93, 94*). But it is obvious that the sheer volume of work which the artists were compelled to get through prevented them from thoroughly thinking out their ideas or fully achieving their execution. This is an art of cursory extemporization on well-worn themes.

The most impressive single works of art associated with the name of Jayavarman VII are certain single iconic stone figures from various places in the Angkor Thom complex. Chief among them are the Buddhas on Nāgas, the 'Leper King' (*Ill. 95*), and the idealized 'portrait' image of the king himself (*Ill.*

81). In all of these one can feel something of the dedicated skill of the earlier sculptors of Cambodia, and it must have been that the masters who cut these important works were allowed the time they needed to mature them. Their fluent surfaces, deep plasticity and squared-off conception convey a sense of ultimate tranquillity and celestial calm. Bronze figures of deities of various kinds (*Ills. 97–100*) have been found among the ruins of Angkor Thom and at other sites. They too tend to share in the general debasement of style associated with Jayavarman, though individual pieces may recapture qualities of Suryavarman II's art.

After the death of Jayavarman VII Angkor declined. The Khmer kings retreated to the lower reaches of the Mekong river in the face of invasion by the Thai peoples of Siam. Buddhism of the Theravāda branch became the religion of the people. The

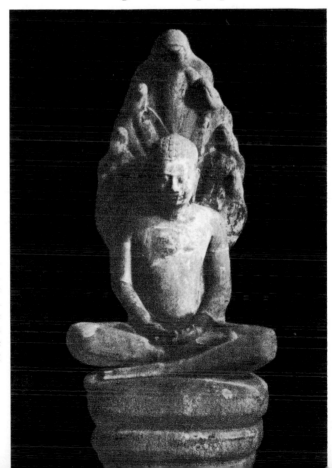

96 Buddha in contemplation protected by the Nāga. Twelfth to thirteenth century, sandstone, height 185 cm. This is the Buddhist version of the king's divine prototype. The Nāga symbolizes the fertilizing waters commanded by the king

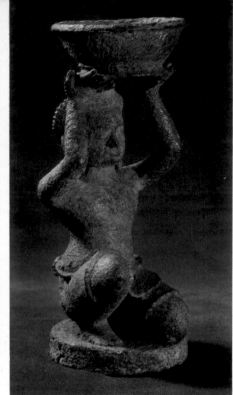

97–100 A range of small-scale sculptures dating from the last period of Khmer rule. They would have been minor altar-furnishings

97 (*above left*) Lion, late Bayon style. Fifteenth century, gilded bronze, height 24 cm
98 (*above right*) Crouching figure. Twelfth to thirteenth century, bronze, height 18·5 cm
99 Hevajra from Banteay Kdei. Twelfth to thirteenth century, bronze, height 30 cm
100 (*opposite*) Vishṇu on Garuḍa. Twelfth to thirteenth century

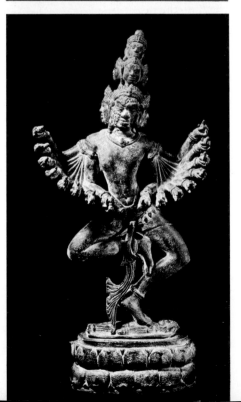

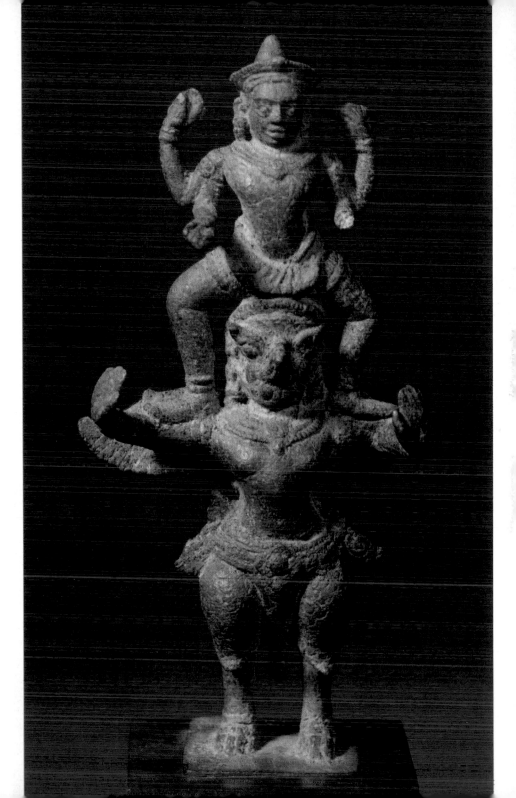

conception of a grandiose cultural unity based on sacred kingship dominating economic and political life, which had inspired the Khmer empire, disappeared. The cultural unit became the local Buddhist monastery, and the art made for such units was derived from contemporary Siamese patterns. Angkor was retaken from the Thai, and to some extent refurbished by a king in the sixteenth century. Portuguese Franciscans reached his court, and wrote the first European accounts of the incomprehensible splendours of Angkor Vat and Angkor Thom.

A few monasteries still flourish in and around Angkor – the Vat was used as one – and a few late works of art in wood, in a style often called Siamese, have been found there. At the court of Phnom Penh the Cambodian kings have retained vestiges of traditional splendour, and Cambodian craftsmen remain capable of extremely refined work, chiefly in wood. Utensils and figure sculpture of Buddhist inspiration repeat patterns of considerable beauty. It is probably true that the heritage of old traditions incorporated in the visual language of these people has enabled them to produce work in the late medieval style which is aesthetically superior to similar work made in Siam – from which the Cambodian pieces are often said to derive. In Siam the sculpture was in bronze, and much has survived, but in Cambodia, where it was of wood, almost nothing remains. The foundations of Siamese art, however, were Khmer.

Champa

The kingdom of Champa which has figured in the history of Angkor, lay in Annam, occupying part of what is now the south of Vietnam. In fact its art seems to have followed its course of evolution alongside Khmer art. But as the weaker and less fortunate neighbour of the Cambodian empire, Champa never succeeded in creating any city as magnificent as Angkor. Even so, Cham art has its own styles and great particular beauties. There remains so much archaeological investigation to be done, however, that only an outline of its development can be given.

Champa's early history runs parallel to that of Chen La. But the Chinese empire claimed much more than nominal sovereignty over Annam. The Hinduizing dynasties that ruled Champa from the early sixth century AD were thus obliged to pay heavy tribute to the Chinese, though for a short time in the mid-sixth century they threw off the Chinese yoke. Then in the eighth century the Javanese became a constant threat to the Cham; and from the north the Sinized Annamese (the Vietnamese) annexed their northern provinces in the late tenth century. The Cham were then compelled for safety to move their capital from near Mi Son to Binh Dinh in the south. Still later the Khmers were their bane, and in 1145 broke their power altogether. After this disaster the Cham still continued to live and work mainly in the south. But in 1225 the Vietnamese again pursued a policy of aggression, and in 1283 the Mongols under Kublai Khan ravaged the whole coast. After this the Vietnamese continued their drive southwards, though a brief interlude of subservient peace for the Cham kings at Binh Dinh followed while the Vietnamese were themselves threatened by the Chinese Ming dynasty between about 1360 and 1390. By 1471 the Cham were totally extinguished as a nation. It is per-

haps surprising that they succeeded in creating any kind of independent art at all. But they did.

Nothing remains of the earliest great temple built by King Bhadravarman at Mi Son, and rebuilt by Sambhuvarman (*c.* 572–629). The earliest pieces of art come from the period of Prakāshadharma (*c.* 653–86) who was a descendant in the female line of the royal house of Chen La. These works all formed part of his embellishment of the original sacred capital, Mi Son, which lies in that northern section of the country from which the Cham were driven by the Vietnamese after 980. Mi Son is set in a circuit of impressive wild hills, and its temples are oriented both east and west. The pattern of the temple did not really change throughout the whole of Cham history. Stylistic development was far more a matter of change in ornamental elements than in architectural invention. No grandiose engineering schemes and spatial conceptions like those of Angkor appear, and the Cham seem always to have remained content with the traditional Indian conception of the single-celled tower-shrine built largely of brick, but with stone elements. The only exception to this rule is the monastery complex at Dong Duong.

It will be convenient to discuss the evolution of Cham art in two main phases. The first, centred on Mi Son and Dong Duong, in the north, came to an end with the Vietnamese capture of the northern region about 980. The second is that centred on the southern capital, Binh Dinh, after the loss of Mi Son. All Cham art is based on the cult of divine kingship, somewhat resembling the Khmer cult, but far less rich, for this kingdom was fragmented, and by no means easy to unite. Kings, therefore, were the only patrons for whom temples were built. They also seem to have been the only builders of Buddhist monasteries. Like the Khmers, they were much concerned with their own postmortem deification, and the multiplicity of shrines at a site, as at Mi Son, is a function of this 'personalization' of the divine. The limited power of those kings, however, is reflected in the modesty of the shrines.

Yet there is one particular feature of Cham temples which distinguishes them. This is the pedestal altar within the cell, upon which statues of various kinds were set, sometimes – as far as we can tell – in groups. These pedestals were themselves often most beautifully adorned with reliefs, and some of the best Cham work appears on them. Usually the subjects are taken from typical Indian imagery of the celestial court. But the fact that these pedestal altars carried their sculptures in the space of the cell, away from the wall, meant that the Cham sculptors became accustomed to thinking in terms of fully three-dimensional plasticity, not only of relief. This strongly conditioned their art. It has been suggested that such a conception of the altar was derived from China, for it was quite foreign to Indian tradition. This may be true – Champa always existed in the shadow of China, often trying to cultivate good relations with the Son of Heaven as an insurance against pressure from the Vietnamese. And the coastal ports of Annam were recognized staging-posts for ships bound from China to other parts of the Orient. There can be no mistaking the Chinese inflections of the curves and scrolls of Cham ornament, especially in their fondness for the slightly squared hook or spiral in both positive and negative forms.

The temple architecture of the first epoch is represented principally at Mi Son. The groups of remains on the site have been given identifying letters by the French archaeologists who investigated them. As these are the only names they have been given, we are obliged to use them in discussing the art. From the early phases represented by the E1 group there are no complete buildings, only ground plans and fragments of sculpture. The sequence runs through towers F1 at Hoa Lai (*Ill. 101*); A1, 2, 3; F3; E1; at Po Dam, C7; to the great A1 (*Ill. 102*) and the associated Po Nagar (*Ill. 103*) at Nha Trang. Also forming part of this complex are the Prasat Damrei Krap at the Kulen in Cambodia (802), built by Cham architects while Jayavarman II was founding Angkor; and the Buddhist monastery complex at Dong Duong, built when the capital had been set up at

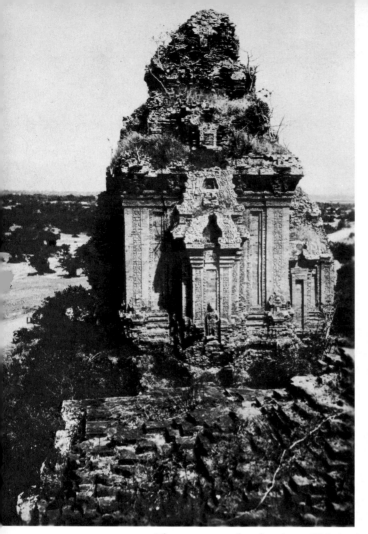

101, 102 These two modest but beautiful single-cell shrines illustrate the patterns followed by the temples of the Cham kings. 101 South façade, north tower, Hoa Lai. 102 Main tower, Mi Son A1. Mid-tenth century

Quang Nam. Unfortunately, the earliest buildings of all are not fully decipherable from their remains, and the best surviving examples of the early phase are those on Mount Kulen, on Khmer terrain, and at Hoa Lai in southern Champa.

These tower-shrines follow the same pattern. The central rectangular volume of the cell is tall, on a square or long

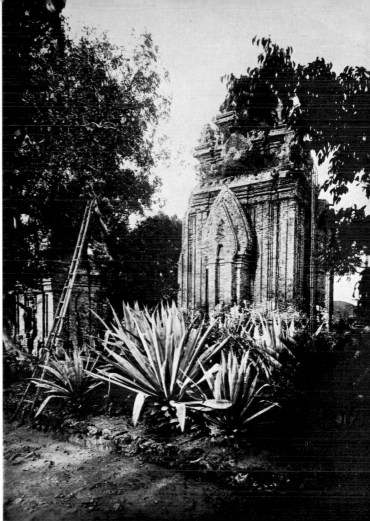

103 Main tower, Po Nagar, Nha Trang. Eleventh century. Variations in style are only minor

rectangular plan. The faces are marked with central porticos which are blind on all but the western face, where the entrance door is situated. These porticos are set in a tall, narrow frame of pilasters crowned with horizontally moulded capitals which step up outwards They support a tall double-ogival blind arch, which is crowned by another stepped in behind the first (*Ills.*

104, 105). These arches are based on the Indian toraṇa pattern, and are carved with a design of slowly undulant foliage springing from the mouth of a monster whose head forms the apex of the arch. The faces of the walls are formed of pilasters framing tall recesses, and the faces of all the pilasters are carved with foliate relief. Elaborate recessed and stepped-out horizontal mouldings mark their bases. The height of the pilasters and recesses gives a strong vertical accent to the body of the shrine. The principal architrave is carried on stepped-out false capitals to the pilasters. Three diminishing compressed storeys form the roof of the tower, each marked by little pavilions on the faces above the main porticos. Inside this tower is a high corbelled space. The blind porticos seem once to have contained figures of deities – perhaps guardians with weapons standing in a threatening posture. The chief portico was extended to include a porch, and the whole structure stood upon a plinth whose faces bore moulded dwarf columns and recesses.

When the Cham capital in the north was at Quang Nam in the late ninth century and when the monastery complex of

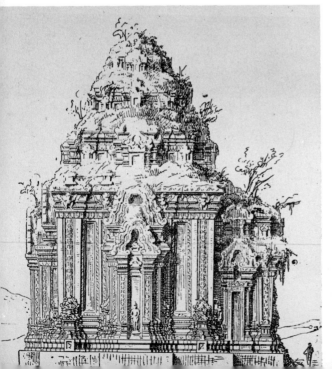

104 North tower, Hoa Lai (reconstruction). Architectural detail in some ways resembles Khmer work, but has its own individuality

106 Central tower, Hoa Lai ▶

105 Dong Duong, Quang Nam (reconstruction). Late ninth century. The Cham conception of the shrine as composed of a series of superimposed diminishing pavilions resembles that of the Khmer

Dong Duong (*Ill. 105*) was constructed, there were some divergent features to this style. First, there was a far greater emphasis upon the plasticity of many elements: the angle pilasters are deeper cut and the porticos are framed not by pilasters but by engaged pillars of octagonal section. Second, the horizontal emphasis is greater, in that the horizontal mouldings on bases

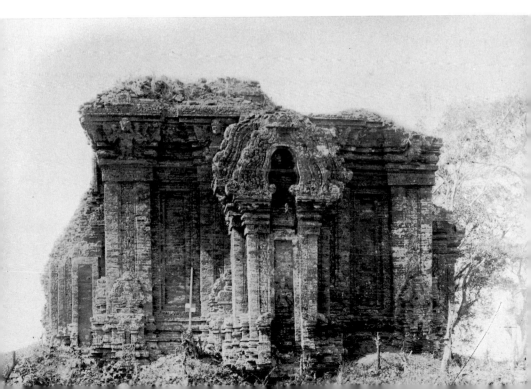

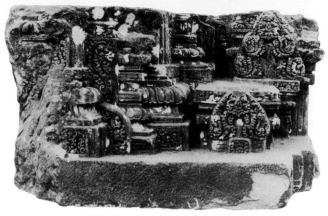

107 Fragment of an altar from Dong Duong. This is typical of the heavy, worm-like ornament of Champa

and capitals are deeper cut, those on the capitals of the porticos breaking the faces of the building most decisively about half-way up; even the engaged pillars by the door are cut by moulded rings part of the way up.

The monastery buildings must once have been most impressive. The shrines dedicated to various Mahāyāna deities were inside the circuit wall, which is about half a mile long. Brick courts, halls and gate-pavilions filled the interior. At the western-most side was a complex formed by a central tower open on four sides and surrounded by eighteen shrines. Cylindrical brick *stupas* of Chinese type lined the courts, and as well as the shrines some of the halls contained fine Buddhist images on free-standing altars. Everywhere the ornament was becoming both luxuriant and massive, losing the finesse of its earlier phase (*Ill. 107*). It proliferates even on the interiors of arches,

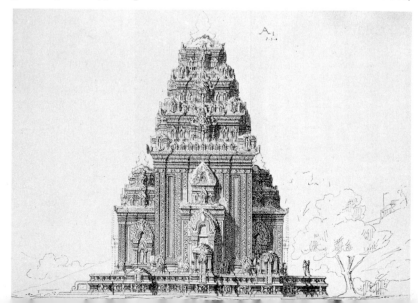

and degenerates into a worm-like pattern, which is said to owe something to the Chinese 'cloud-pattern' found as decoration on many Chinese works of art. The whole style, which is shared by some shrines at Mi Son, notably A10, gives an impression of excessive energy, scarcely under control – an impression reinforced by the sculpture, many examples of which have survived.

This epoch of building reached its apogee in temple A1 at Mi Son which is relatively well preserved and is dated *c.* 930–40 (*Ill. 108*). Here both east and west porticos contained porches and doors. The ornament is lavish, spreading on to the capitals, false capitals and interior mouldings of the wall-recesses, but is far less emphatic, exuberant and plastic than at Dong Duong. The arcades crowning the porticos are of simpler form, and the crowning, stepped-back arch has become a distinct small pavilion. The upward-curved flamboyance of the foliage relief on the portico arches has become more pronounced, and the protuberance of the members less marked. In fact the building has become more of an organic whole, the ornament having, as it were, co-ordinated the external surfaces into a more definite unity. There are additional arched niches around the foot of the structure, and all the architraves of the roof tiers are marked with continuous rows of little arched niches. The last building of this pattern is at Po Nagar (*Ill. 109*), and dates from the early eleventh century.

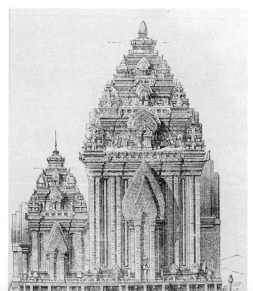

108 (*far left*) Temple A1 at Mi Son, tenth century (reconstruction)

109 Po Nagar, Nha Trang, early eleventh century (reconstruction)

These two diagrams illustrate the architectural evolution of the Cham shrine over about a century

127

The glory of Cham art is undoubtedly the sculpture of the whole of this first period, up to the end of the tenth century. Much of it consists of lesser figures that form part of the architectural décor. There are heads of makaras (*Ill. 112*), dragons and other beasts which appeared at corners on the architraves of shrines, and figures of lions which supported bases and plinths (*Ill. 110*). These share the heavy ornateness of the Cham decorative style at its most aggressive. Certain busts of celestials with joined hands served a similar purpose. They are distinguished by their crude finish, and by the deeply cut, somewhat lumpish Cham cartouches composing the crowns they

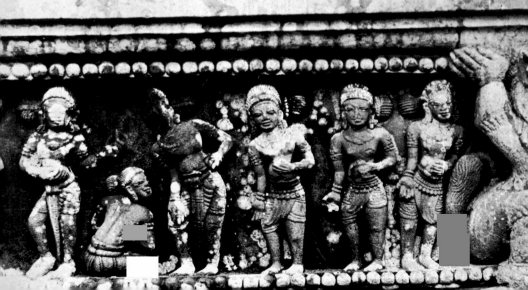

112 Head of *makara* from Tra Kieu. Seventh century, sandstone, height 52 cm. A waterspout from a temple cornice, in the form of a monster's head, in the earliest Cham style

110 (*left*) Pedestal from Ha Trung. Seventh to eighth century, sandstone, height 175 cm. An early example of Cham sculpture

111 (*left below*) Pedestal from Tra Kieu. Seventh to eighth century, sandstone, diameter of central plinth 138 cm. The figurative detail illustrates the earliest phase of Cham decorative sculpture

wear. Figures in plaques from the bases of pillars are found, such as a couple of wrestlers carved in relief. But the most striking architectural adornments have a quality all their own. The best is the capital from Tra Kieu (*Ill. 114*) which carries a musician and a couple of dancing girls – meant to be celestial apsarases, no doubt. The postures and surface of the two divine beauties have been captured with an extraordinarily sensual charm. They seem to be clothed in nothing but strings and strings of pearls, though probably they are supposed to be wearing clothes of the finest Indian gauze, which appear only in the knotted fans at their hips. The double-jointed gesture of an arm and the soft roundness of the bodies evoke a vivid response.

Of the major iconic sculptures, the great lingam icons standing on carved pedestals are the most austere. The pedestal may show

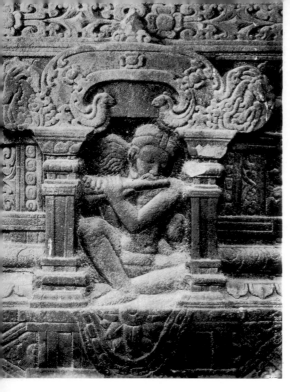

113–14 Two splendid reliefs representing the high point of the the classic Cham style

113 (*left*) Pedestal from Mi Son, ascetic playing a flute. Late seventh century, sandstone, height 60 cm

114 (*below*) Capital showing dancers, from Tra Kieu. Seventh century, sandstone, height 63 cm

115 (*right*) Shiva from Tra Kieu. Eighth century, sandstone, height 125 cm. In this deity the truly Cham characteristics are very clear, especially its somewhat barbaric severity. It seems to be stylistically related to Javanese images. cf. *Ill. 172*

116 (*far right*) Shiva from Dong Duong. Mid-ninth century, sandstone, 40 cm. The worm-like foliage ornament of the halo is characteristic of Cham art

rows of fantastic beasts, deities or dancing celestials, carved in relief. The lingam itself may emerge from discs of ornament, one of which represents an opening lotus, symbol of the feminine principle of the universe. A pedestal which probably served as an altar for icons (*Ill. 113*), from Mi Son shrine E1,

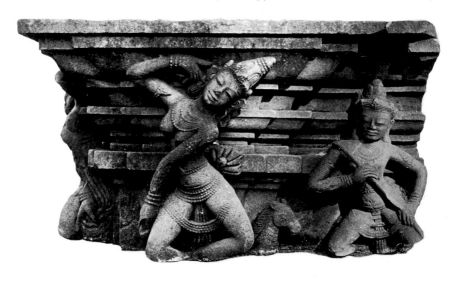

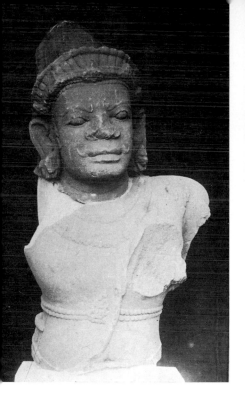
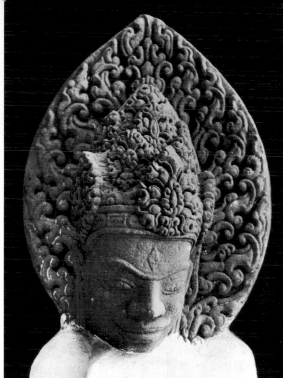

shows a series of little figures of ascetics seated, among ornament, under Cham versions of Indian toraṇa arcades, while at its two ends, celestials make expansive gestures towards the images. Several figures of Shiva survive (*Ills. 115, 116*). The bodies are relatively simplified and subordinated to a roughly cut sinuosity. The ornamental haloes feature worm-like ornament. The faces bear an expression of ferocity, with the everted Cham lips under moustaches heavily stressed, conveying an impression of unco-ordinated vigour. There seems in these to be a strong influence from Indonesian art. One Vishṇu, from Da Ngi, and certain Buddhist images of Lokeshvara (*Ill. 118*), show strong elements of Fou Nan–Chen La style. Again it is the charm of the feminine icons which is most likely to find a response today. One, of exceptional beauty, comes from Huong Qua (*Ill. 117*); others, less fine perhaps, from several sites. From Dong Duong comes a half life-size Buddha figure, and various other images, including an impressive one of Shiva (*Ill. 116*).

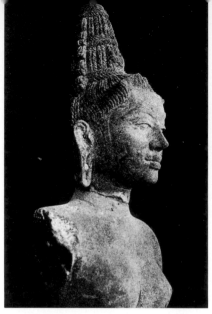

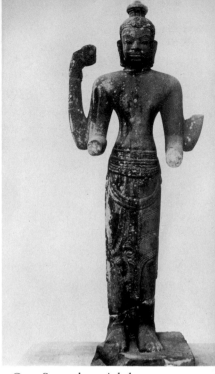

117 Female figure from Huong Qua.
Eighth century, sandstone. One of
Champa's masterpieces, at once severe,
sophisticated and sensuous

118 (*above right*) Lokeshvara from Huong Qua. Seventh to eighth century,
sandstone, height 40 cm. A barbaric contrast to *Ill. 117*

After the northern provinces of Annam had been taken over
by the Vietnamese, the Cham capital was established at Binh
Dinh. Here the kings maintained a gradually diminishing
splendour. After the Khmer attack of 1145, they could claim
little in the way of royal glory. They made a brief return to
Mi Son in 1074–80, but most of their artistic effort was spent
upon shrines at Binh Dinh and a few other sites. These form a
series of groups. Until the early twelfth century, little was done
in Champa of any artistic significance. Then a group at Binh
Dinh known as the Silver Towers was begun (*Ill. 119*). These
buildings do not have much in the way of ornament. The
multiplicity of mouldings on the tower storeys is confined to a
few miniature corner pavilions. The magnificence of the old
pilasters and architraves is suppressed into simple mouldings,
and the beauty of the buildings becomes largely a matter of
their proportions alone. This process of reduction was carried on

132

through the thirteenth century so-called Ivory Towers at Thap Mam, where a few lintels imitate the Bayon style, then through the Binh Dinh Copper and Golden Towers of the mid-thirteenth century. By the late thirteenth and early fourteenth century shrine architecture, even at Binh Dinh, had declined (*Ill. 120*), with the break-up of the kingdom, to a piling up of crudely cut stones articulated only by their reference to the classic Cham style.

Sculpture itself shows a parallel decline. At the Silver Towers there are a few examples of reliefs which convey a sense of tranquillity and splendour (*Ill. 121*). But as time goes on, a style of strange, cubical emphasis comes to dominate the iconic figures. The somewhat curlicued design of Indonesian figure sculpture is gradually converted into massive, scarcely carved blocks which convey, at their best, an impression of barbarous strength, without the special refinements of first-class 'primitive' art (*Ill. 122*).

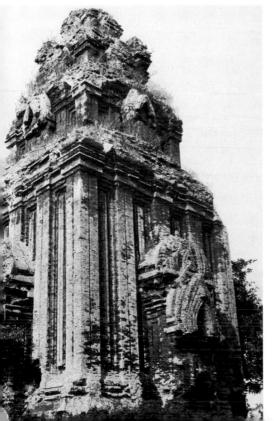

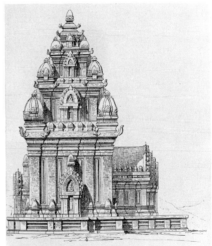

119 (*left*) Silver Towers, Binh Dinh. Early twelfth century

120 (*above*) Po Klaung Garai. Late thirteenth century

These two illustrations show the late styles of a declining Champa

The truth is that the special concept of divine kingship, with which Hinduizing shrine art was connected in Indochina, had been so far discredited that it could no longer justify its social rôle. Buddhism, as a religion for the people, was spreading all over the region. The Vietnamese, a people organized in self-contained local groups without any concept of royal divinity, found it eminently suitable to their way of life. As they gradually spread to the southern parts of Annam in response to the pressure of their own population, their form of Buddhism, with its wooden architecture of fundamentally Chinese inspiration, established itself everywhere. Faint echoes of the old Hindu style survive in the flamboyant ornament at eaves and gable. But, as in parts of Burma, it is impossible to identify any true Vietnamese art which is earlier than the nineteenth century. The imperial palace at Hue (c. 1810) consists of a series of simple, rectangular one-storey pavilions, laid out inside a group of courts among trees. The inner buildings have a bright and airy simplicity which is characteristically Chinese. The southern gate attempts a greater splendour, with a plain stone terrace and causeway approach surmounted by a tiled Chinese-style hall of wood and tiles. But the Chinese sense of pure proportion is lacking, and at the same time Hue was not sufficiently close to India and Ceylon for Buddhist inspiration to influence the art, as it still could the late Hīnayāna art of Burma.

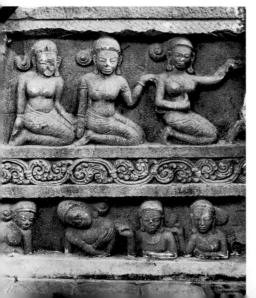

121 Bas-relief, Silver Towers. Early twelfth century, sandstone, height 83 cm. These female devotees recapture something of an older sweetness

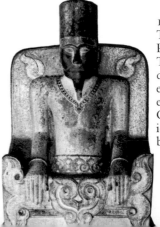

122 Icon from Thuan Dong Pagoda. Thirteenth century. The end point of the evolution of Cham art. An icon of crude, barbaric vigour

Siam and Laos

The history of Siamese art proper begins in the thirteenth century with the overthrow by Thai chieftains of the Khmer governor of southern Siam and the formation of the kingdom of Lavo. Then in 1287, the very year in which the Mongols captured Pagān, the three most powerful Thai chieftains in the central and northern part of the country combined to form an alliance. This consolidated both the kingdom of Sukhodaya, the first to create an independent cultural tradition, and a second major state whose capital was farther north at Chiengmai. The pattern for Siamese history was thus established, with two chief regions of power and culture; one in the flat rice-fields of the south, around the lower reaches and delta of the Menam river complex; the other in the mountainous, forested region of that river's northern tributaries, and including a region of certain tributaries of the Mekong itself. Between them, the central region around Sukhodaya held an uneasy balance.

The inhabitants of the southern region were predominantly Mon, and they had been for centuries one of the main sources of the intellectual strength of the Khmer empire. Works of Khmer art had been made in their territory, testimony to the Hindu royal cult of Cambodia. There survive a fair number of Siamese fragments of Khmer art (*Ill. 123*), and it is clear that Siamese art traditions take their rise from provincial Khmer prototypes. The people who formed the new states were not Mon, however, but Thai. The Thai were actually of the same racial stock as the Vietnamese, and had, during the early years of the Christian era, been forced gradually out of the regions of Canton and then Tonkin by the pressure of Chinese colonization. Whereas the Vietnamese moved south-east along the coastal strip into Annam, overran Champa, and adopted Chinese

culture and methods of civilization, the Thai crossed the hills westward into the high reaches of the Mekong and Menam. At the height of the power of the Khmer empire they were not able to make much headway down the rivers. But when Khmer fortunes declined they were free to move into the outlying provinces, make them their own, and ultimately wreck the Cambodian heart of the empire, utterly destroying its irrigation system. Siam (now called Thailand) was their most successful venture. Modern Laos is descended from another of their kingdoms.

The Thai were originally a tribal people without writing or an organized state. Although the Buddhism they eventually adopted from their contact with the kingdom of Pagān gave them an integral culture, a literature and a system of education, it could not be converted into a state-religion unifying the whole country and directing its efforts. At the same time, though they were adequate farmers, they never learned any elaborate hydraulic techniques like those of the Khmer, which would have given them the ability to amplify the resources of their land. Also, their country was far off the Chinese-Indian sea-trade routes. They therefore lived a self-contained existence, in separate city-states, and the history of the Thai kingdoms was marked by internal dissensions and shifts of power rather than by major foreign encounters. The Burmese, their co-religionists, were their chief enemies, often subjecting them to cruel invasions. Two Thai cities, Chiengmai in the north and Ayuthia in the south, remained the principal centres of foreign contact – Chiengmai because of its central position on the roads between Burma and the rest of Southeast Asia, and Ayuthia for its place on the river in the heart of the southern region.

The artistic situation in early Siam was fairly complicated. The earliest art of all in stone, stucco and terracotta – of which very little survives – is the art of a kingdom called Dvāravatī, on the lower reaches of the Menam. This kingdom survived for about six hundred years, from the sixth to the twelfth centuries A D. It was the chief of the Mon confederation, and its religion

136

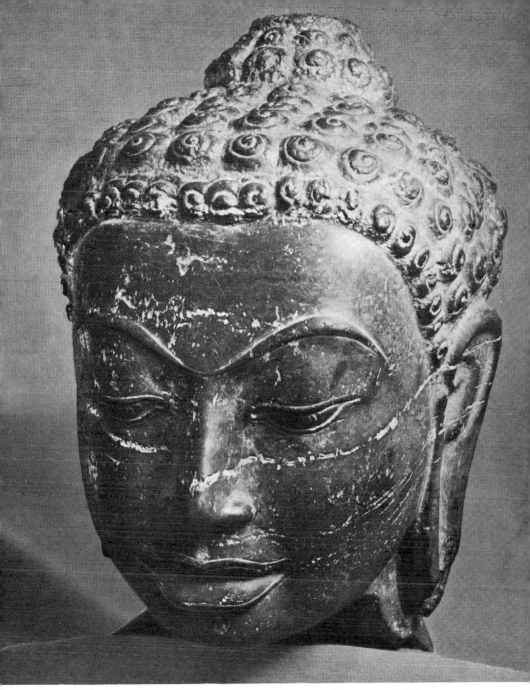

123 Head of Buddha, Dvāravatī style. Seventh to ninth century, height
23 cm. A fragment of stone sculpture of the almost vanished art of the
eastern Mon peoples. It originally belonged to a shrine icon. Its style
derives from contemporary eastern Indian art

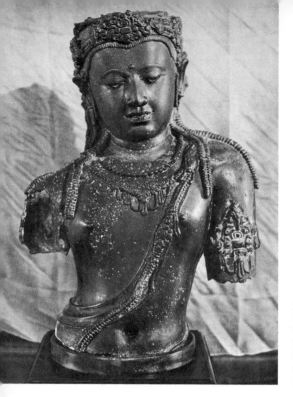

124 Avalokiteshvara from Chaiya.
Mid-eighth century, bronze,
height 63 cm. This supremely
achieved bronze shows how splendid
the eastern Mon tradition must once
have been, when its Buddhism was
of the more artistically-conscious
Mahāyāna type

was Hīnayāna, like that of the western Mon of Lower Burma.
The style of the Buddhist imagery seems to have been close to
that of post-Gupta, pre-Pāla eastern India (*Ill. 124*), slightly
cruder, but vigorous. The facial features of the figures are of
Mon type, with the everted lips emphasized by an incised line.
A number of Buddhas, more or less fragmentary, are known
from various places, including Lopburi. But the art of that
period was entirely superseded. During the eleventh century,
the kingdom of Dvāravatī lost the leadership and support of the
Mon confederation, and was open to capture by the Khmer.
The art of Dvāravatī and its Buddha types were then adopted as
canons for the growing Buddhist tradition of Cambodia,
which culminated in the art of the Bayon and Angkor Thom.
At the same time a number of Khmer shrines associated with
the Hinduized cult of royalty were built in southern Siam.
Examples are at Phi Mai, where one of the personal cult
statues of Jayavarman II has been found, and Phra Prang Sam

138

Yot, at Lopburi (*Ill. 125*), which is perhaps the best surviving example in brick and stucco of the Khmer provincial art of Siam.

During the period when the Khmer had taken over the southern Mon region of Siam, the northern region was falling under the domination of the immigrating Thai peoples, who seem, at that time, to have professed a kind of animist nature-religion, somewhat resembling the early form of the Burmese cult of the *Nats*. To the far north of Siam however, in what is now the Chinese province of Yunnan, there was a remote, Sinized kingdom called Nan Chao, in which the Thai were somehow important. The rulers of this kingdom seem to have followed a Mahāyāna form of Buddhism which may have

125 Phra Prang Sam Yot, Lopburi. Late twelfth century. A typical shrine set up under the Khmer in the provinces of their empire. It was probably a focal point for the cult of Khmer royalty, and hence a symbol of Khmer sovereignty over the Menam plain

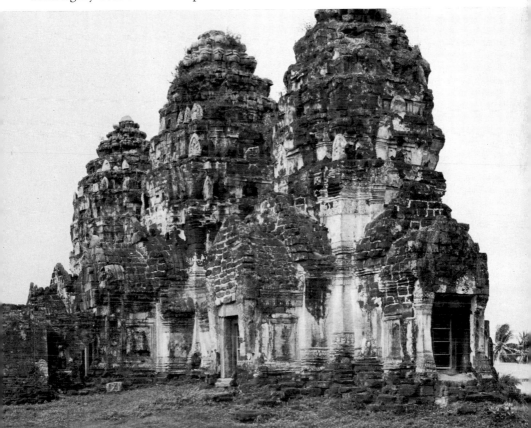

reached them *via* the Ari priesthood of Upper Burma. The worship of a Bodhisattva as a personal patron of royalty played an important part in this cult. A number of rather small bronze Bodhisattva icons are known from Nan Chao (*Ill. 126*), in a style somewhat reminiscent of the late Pallava art of the east coast of peninsular India.

From the general direction of Nan Chao the Thai seem to have moved very gradually south, establishing small kingdoms in the tropical forest lands as they went. Their social structure was based on tribal pyramids, with chieftains at the top, some of whom came gradually to acquire the idea of themselves as kings; for the concept of kingship is a cultural phenomenon, which the Thai had to assimilate, just as they assimilated Hīnayāna Buddhism. Some of the Thai gained the experience of living within the boundaries of the Khmer empire, with their own chieftains under a Khmer official. When the Khmer power was removed from central and southern Siam, the Thai moved into that region as well, intermarrying with the Mon. But even when the Thai occupation of Siam was complete, the country remained a series of small principalities, whose rulers owed, from time to time, a more or less nominal allegiance to a greater king.

All these Thai peoples had buildings of wood, chiefly bamboo; they were rice farmers, and knew how to navigate the large rivers. Their religion of the spirits gave ground only partially to Buddhism, and even today is very much alive: the guardian spirits of trees still need to be pacified, and the ancestors can be powerful helpers. Shamans can, in a state of trance, make contact with the spirit-world to work good and sometimes ill. The prevalence in Siam of this feeling for the spirits and their world is one of the reasons for the genuine affinity between certain aspects of Siamese and Burmese art. It seems probable that the Thai who settled in the northern region of Siam did not at first know anything of Buddhism, despite the contact of other branches of the Thai with forms of Buddhism in Nan Chao, Ceylon and the Khmer empire. What is probable is that

126 Bodhisattva from Yunnan. Thirteenth century, bronze. This is one of a few known bronze figurines from the remote kingdom of Nan Chao in the forested highlands of Yunnan. It represents a royal Bodhisattva

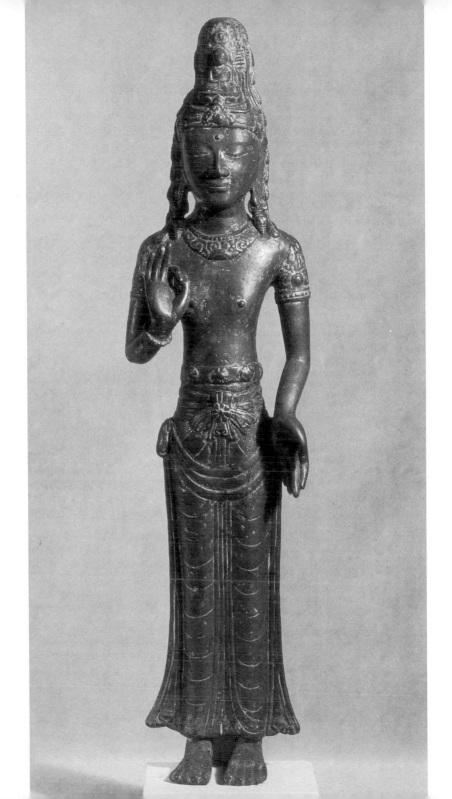

from one of these sources the Thai of Sukhodaya acquired the difficult art of large-scale bronze-casting. The earliest known reference to the art of casting bronze Buddhas in the north is to the reign of King Guṇa. By the fifteenth century the art was widely established everywhere in Siam. By this time too all the Thai as Buddhists, maintained direct links with Ceylon, the homeland of Hīnayāna Buddhism, through Lower Burma.

The early history of the northern region of Siam is mainly one of the fluctuations of power and influence between Sukhodaya and the kingdom called Lan Na, to the north, whose capital was the city which is still Siam's second largest, Chiengmai. Sukhodaya itself was in the cultural vanguard, in direct touch with Ceylon; and the first successful attempts to create a Thai Hīnayāna Buddha image seem to have been made there. In 1349 Sukhodaya was taken over and made into a dependency of Ayuthia in the south, though it retained its cultural integrity. Then, in the later part of the fourteenth century, when Buddhism and Buddhist art were at their zenith in Sukhodaya, King Guṇa of Lan Na decided to improve his strain of Buddhism by importing a body of Sinhalese-led monks north from Sukhodaya into Chiengmai.

Tiloka, a second great king of Lan Na, regarded in Siam as a saint, reigned from 1441 to 1487 and ensured the official triumph of Buddhism over the spirits. This whole period was marked in the north by a brisk conflict between the old nature-religion and the new brand of strict Sinhalese-type Buddhism imported from Ayuthia. It may well be that the old form of Buddhism, descended from Mon times, which had survived in Lan Na before King Guṇa's reform, had compromised with the spirits in some way, rather as Burmese Buddhism did. King Tiloka, by maintaining full contact between Siam and the Buddhist world of Ceylon, even India, ensured that Siamese Buddhism should be as direct an inheritor of the Truth as it could possibly be. This concern with lineage is closely reflected in the art. The fact that valuable bronze was liberally used for making huge images, and the fact that Siam has remained a

142

Buddhist country eager to conserve its sacred images, means that there is today an unrivalled continuous series of Hīnayāna Buddhas in Siam.

In the south, Ayuthia learned likewise from the Buddhism and art tradition of Sukhodaya. The styles which prevailed there in the fourteenth to sixteenth centuries were based on an amalgam of the classical Sukhodaya style with the fairly strong vestiges of Khmer traditions among a population still predominantly Mon. It is impossible at present, however, to disentangle the architectural and artistic history of the south at all satisfactorily, since the necessary archaeological investigations on the spot have not been done. It seems probable that the majority of important structures and works surviving at Ayuthia and all those around Bangkok date from a period subsequent to the wars which the Buddhist king of Burma, Bayinnaung Bayi, conducted against the Thai kingdoms in north and south Siam during the later sixteenth century. He attempted to palliate his gross human cruelty by schematic acts of Buddhist piety – feeding monks, distributing copies of the scriptures, and building pagodas (stupas) and monasteries. Thus Siamese art styles in the south were subject to a strong Burmese influence, which virtually obliterated old native forms. In the north, especially in Lan Na and the Thai kingdoms of Laos, which did not suffer so severely from this Burmese incursion, the older styles survived, developing slowly, into modern times.

It must be said that, like the Hīnayāna art of Burma, the Buddhist art of Siam is interesting chiefly in its early formative stages. Once the canonical patterns were laid down, artistic invention virtually ceased. Standard types were repeated again and again, *ad nauseam*, and architecture made no attempt to organize and articulate space. There was a positive religious reason for this state of affairs. In the Buddhist world there was long a belief, erroneous but potent, that an authorized image of the Buddha had been carved during his lifetime. Following primitive conceptions which are, strictly speaking, abhorrent to

well-educated Buddhists, this image was supposed to have absorbed much of the Buddha's own magical potency. All the major images of Buddhist shrines were supposed to contain their own share of this magical potency of the original image by virtue of their exact likeness to the great original. To ensure this likeness, immense care was taken to adhere as closely as human craftsmen could to the iconographic pattern, which was reduced for safety to a series of diagrams, measurements and canonical proportions. Such differences of style as do occur between the Buddhas of different times and places are unintentional and unavoidable, the natural consequence of craftsmen working in their own artistic idiom. They were only cultivated intentionally when an attempt was being made to capture the likeness of a famous magical image in a style which had already evolved its idiosyncrasy.

In countries of the Mahāyāna with vital art traditions, such as China, Japan and even Tibet, the rôle of creative artistic invention was admitted to be important in the development of religious imagery. In countries of the Hīnayāna, art was expected only to preserve and repeat old patterns. The whole tendency of Hīnayāna Buddhism is conservative and fundamentalist, sticking so far as possible to the strict letter of ancient canons. Neither in religious literature nor in art was there any incentive to explore the resources of words or forms. The Truth had been expressed once and for all in the old formulae. To change them would be to lose the Truth. Buddha images in Siam were popularly meant to be repositories of power; even today the famous Emerald Buddha of Bangkok is one such. Therefore it was of the greatest importance to keep the images *like* each other, avoiding change. Once local canons were established, as close as possible to Indian originals, they were never intentionally altered.

Only in the early stages of Hīnayāna development in Siam was there any scope for adjustment. Even the slight variations in type which appeared early on were themselves perpetuated and converted into canonical patterns by Buddhist piety. As

144

time went on the various great Buddhas of Siamese shrines acquired their own special local prestige, and later patrons commissioned images following the type of one or other of the early masterpieces. It was a work of great merit to commission a Buddha image. The larger and richer the image the greater the merit. So for many centuries Siamese craftsmen have been hard at work producing replicas, large and small, of most of the old prestigious images. Some were for private use. Some were merely to be stored in shrines as permanent testimony to the piety of the donor. Of all the mass of works thus fabricated only certain pieces in northern Siam are dated. It is therefore impossible to write a true art-history of Siam, for all the different types have been continuously imitated with more or less success, ever since they were first made. The imitations have been preserved without date, context or document.

The classical Sukhodaya type of art as we know it follows the limited canon of Hīnayāna Buddhism. Monasteries seem to have been constructed chiefly of wood, and however beautiful they may have been we know nothing of them. There must have been a substantial tradition of decorative art as well. But the only art of which we really do know anything is the art of the icon – the Buddha image. The Sukhodaya type represents an early attempt to establish the Sinhalese icon in Siam. The Mon Buddhas of previous centuries had followed canons derived from the Buddhist art of eastern India – Bihar and Orissa. For this was indeed the true homeland of Buddhism, and its images might have been supposed to adhere most closely to the great original pattern. But by the time the kingdom of Sukhodaya was established, the Moslems had obliterated Buddhism in that part of India, destroying monasteries and – according to their religious prejudice – all icons. In the thirteenth and fourteenth centuries, when the rulers of Sukhodaya sought to re-establish their connexions with the fountainhead of Buddhism, since Moslem India was closed to them, they had recourse to Ceylon. The distant prototypes of the Sukhothai images are at Anuradhapura, not Bodhgaya.

Characteristically the Sukhodaya Buddha (*Ills. 127, 130*) is conceived in the full-round, with continuously curved, smoothly developed surfaces. The contours are sinuous, elegant but somehow unsensuous. They lack any clear definition of plane. The smooth, oval head has elongated features. Lips, nose and eyebrows are marked by dry, smooth ridges in high loops and curlicues; the head is crowned by a skull protuberance which has taken on a long pointed shape, like a flame. The drapery has been reduced to nothing but marks at wrists and ankles, plus a single stole-like fold-pattern, with a decorative tail, running forward over the left shoulder down to the navel. The true Sukhodaya image has a vivid, linear life of its own, which many of the copies of all dates entirely fail to capture. The Buddha either sits in the 'earth-touching' attitude, or stands, one foot forward, right hand raised to the middle of the chest; this latter type evolved a boneless sinuosity all its own.

These Sukhodaya (Sukhothai) types of Buddha image were subject to two major stylistic developments, one in the southern region of Siam, the other in the northern region, following the trends of history. Ayuthia, in the south, took over Sukhodaya in 1349, and adopted many aspects of Sukhodaya culture; for it was recognized that through Sukhodaya's link with Ceylon flowed the genuine milk of Buddhist tradition. In the southern region there had survived clear vestiges of Khmer and old Mon traditions, where Buddha types were marked by a strong sense of squared-off design and cubic volume. The Sukhodaya image combined with this type to produce what is known as the U-Tong type (*Ill. 128*). In many ways this is aesthetically the most successful of all the Siamese types. For the excessive febrile elegance of the Sukhodaya type is strengthened by the Mon-Khmer conception. The sinuous linear curves, loops and dry ridges of the pure Sukhodaya originals are suppressed, and genuine modelling appears.

In the northern region the Sukhodaya type was probably first taken over when the brother of King Guṇa, in the late fourteenth century, acquired by means of a military campaign

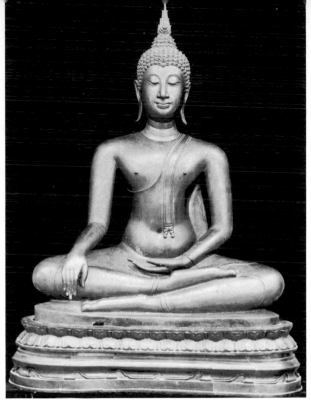

127 Buddha calling the earth to witness, Sukhodaya high classical style. Fourteenth century, bronze, height 94 cm. Its hauteur and elegance mark it out as one of the major works of Thai art

what he thought was a genuine, mystically authenticated Sinhalese Buddha from the ruler of Gampengpet, to the south of Sukhodaya. It seems in fact to have been a Sukhodaya classic image. The bronze imitations were then begun in the north, and they continued for some eighty years, in the style A. B. Griswold has called Tai Yuan – a crude version of classic Sukhodaya originals. When Tiloka came to the throne of Lan Na in 1441, he made his determined effort to purify northern Thai Buddhism, and actually imported monks, texts and art direct from Ceylon. A new image or images straight from Ceylon must have showed clearly how distant from the Sinhalese traditions the Sukhodaya type of image had grown. A new pattern was now established, called by Griswold the 'Lion type' (*Ill. 129*), which is a far more accurate representation

147

128 The 'Sinhalese' Buddha. Fourteenth century, bronze. A major example of the U-Tong style, combining the qualities of the Sukhodaya style with traces of influence from Mon art, and from Ceylon

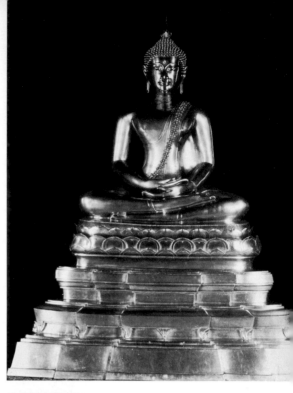

129 The Lion Lord (Pra Sing). Fifteenth century. This style represents the attempt of the northern Thai sculptors to capture the plastic vigour of the Buddhist art of Ceylon

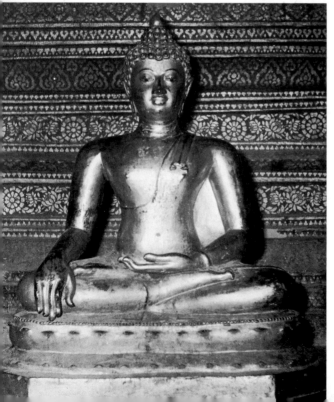

130 Head of Buddha, ▶ Sukhodaya style. Fourteenth century, bronze. The features are marked by deep curves and sharp ridges. The peak of the hairline and the tall, flame-like skull protuberance are marks of the Sukhodaya style

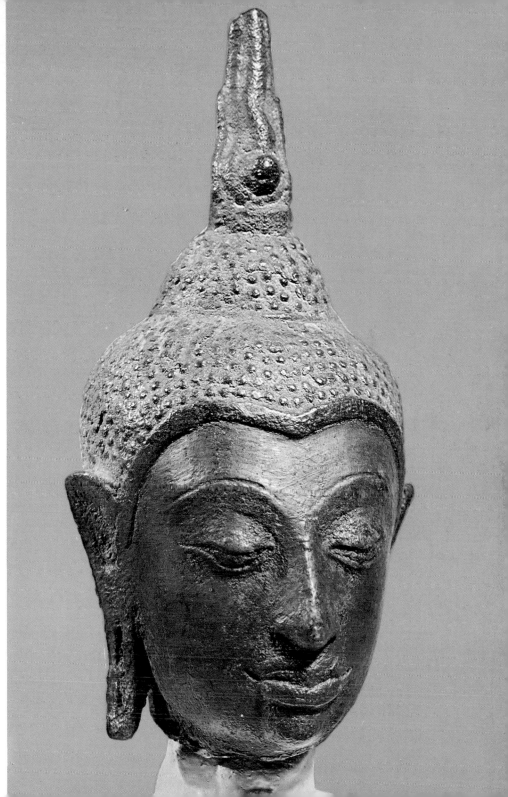

of the then current Sinhalese type of Buddha. In it the body loses its sinuous softness and takes on a greater massiveness and cylindrical strength. The features are not marked by linear ridges and curves but modelled plastically. It seems, however, that the native Thai genius is always for the sinuous and unplastic curve. And so in the later examples of the Lion type of image the curvilinear patterns of the Sukhodaya style reasserted themselves with more or less emphasis. The type persisted between about 1470 and 1565. But it must be stressed that, since images in other and earlier styles were already in existence, revered and imitated at the time the Lion type was established, the Lion type cannot be said to have superseded the others entirely. Its imitations may have preponderated in the northern cities, but elsewhere in Siam other types survived, their characteristics imperceptibly blending as the centuries wore on. The Sukhodaya type especially became the dominant formula.

One type of early structural monument has survived in the north. This is a brick-built shrine for a Buddha image. For example, Vat Chet Yot, Chiengmai (*Ill. 131*), consists of a wide rather low chamber with a portico and recessed corners, on the faces of which stand two tiers of identical Buddha figures in low relief. The roof carries at its centre a tall, four-sided pyramidal tower, crowned by a bell stupa. Smaller versions of the tower stand at the corners of the roof. As architecture such a shrine has little serious claim to attention, since the volumes and spaces are not at all articulated or developed. It is quite likely that such structures, some of them quite large, may have been the original shrines at many of the major northern monasteries. But continuous restoration has mostly obliterated them.

In the south there are a number of imposing medieval buildings. The oldest building to survive in Ayuthia, from early in the thirteenth century, is the Vat Bhuddai Svarya. This is a towered shrine, approached by a columned hall. But types invented in Sukhodaya predominated from the late fourteenth century onward. These included a stupa raised upon a cylindrical shrine as its drum, surrounded by reliquary struc-

tures. In the following century it seems that the Thai kings were adapting something of the personal funeral cult of Angkor, for the custom rapidly grew of building, as their own tombs, bell-shaped stupas, each approached by a colonnaded hall and surrounded by smaller stupas or little shrines, raised on a single high plinth and enclosed within a wall. An evolutionary series of such structures can be traced at Ayuthia, beginning with the

131 Vat Chet Yot, Chiengmai. The towers of this Buddhist shrine are modelled on the great tower of the most sacred shrine of all, that at Bodhgaya, in Bihar, where the Buddha gained enlightenment

151

Vat Phra Ram (mid-fourteenth century or later), the Vat Phra Mahathat (*c.* 1374), through the Vat Rat Burana (1424) to the best and most complete, Vat Sri Sanpet, made about the end of the fifteenth century. The stupas begin to consolidate the Siamese pagoda pattern, with a convex progressive inward curve to the dome. An interesting feature of these structures is that, like some Sinhalese stupas, they each contain hidden within the dome of the stupa a small chamber, decorated inside with wall-paintings, containing a whole collection of votive objects, many of them precious, including arms and jewels. It

132 Vat Benchamabopit, Bangkok. Nineteenth century. A typical ornate Thai building. It nevertheless retains and adapts a type of structure and sense of proportion originally Khmer

is said that the style of the painting shows strong influence from China, especially in the landscapes with hills on a high horizon line, palace pavilions that frame views, and animals among natural scenery. Colours are bright, and the contours of the figures are clear and fluent, perhaps also owing something to Khmer painting, of which nothing is known. The paintings at Vat Rat Burana (c. 1424) consist mainly of overlapped rows of worshippers, with Buddhas enthroned, or, most interesting, in profile. The colours are vermilion, yellow-green and gold. At Vat Mahathat at Ratburi erected about fifty years later,

there are similar processional scenes. The only precursors of this type of art in Siam are some ruined fragments of painting in a cave at Yala, and some incised panels at Vat Si Chum at Sukhodaya, dated to the late thirteenth century.

The last phase of Siamese art reached its apogee during the seventeenth century, after the incursions of the Burmese Bayinnaung. Burmese art had made its impact, especially on the pattern of the wooden structural halls associated with palaces and monasteries. The roof pattern characteristic of modern Siam emerged (*Ill. 132*). This is a type similar to others found in other countries of Southeast Asia. It has high gables, with long, steep, tiled roofs, and overhanging eaves, the ends of the ridge-pole marked by long, pointed flamboyant finials. Diminishing sections of hall and roof are stepped-out from under each other, and the roof-slopes themselves are stepped. Similar roofing appears in Khmer monuments. Porticos with similar roofs are articulated into the sides of these roof structures. Walls are of brick and stucco, and may carry quite long stretches of rather monotonous Buddhist wall-painting. Better examples of wall-painting of the seventeenth century appear at Vat Yai Suwannaram at Phetburi, and Vat Buddhaisawan at Ayuthia. There are many wooden painted panels, and brackets are carved with figures in the Burmese manner. In all this later art the influence of the dance-drama is apparent, especially in the garments of the figures and the way painted figures are postured, light against dark background.

When the capital was moved to Bangkok in 1767, no substantial artistic development took place, though large pagodas were built. A highly ornate reinterpretation of older styles blunted the edge of their quality. Unfortunate attempts were made to imitate Khmer styles of sculpture. Much gold, lacquer and inlay of shell and glass, were applied to many of the furnishings (*Ills. 133–4*). The central hall of the pagoda and the cloister around it contained many Buddha figures, often of plaster and of most inferior quality. A special hall often housed a large image of the Buddha lying on his right side, his face on

his right palm, about to enter Nirvāṇa at his bodily death. This icon plays an important rôle in the Buddhist scheme of life and death, but no single example has any aesthetic merit.

Many of the buildings and their ornament have a strongly Chinese aspect. This is not surprising, in view of the large expatriate Chinese population of Bangkok and its environs. But there was one most important artistic factor involved. Many of the pagodas have glazed tiles. Some are certainly imported from China, but others are descendants of the fine ceramics in Chinese style produced at the kilns of Sawankhalok during the fourteenth and fifteenth centuries by expatriate Chinese craftsmen. The Sawankhalok pottery imitates in its own materials Yüan celadons, with underglaze ornament, and grey or brown painted decoration reminiscent of Tzu Chou ware. Some of these pieces are, in their own idiom, as fine as the finest native Chinese work (*Ill. 135*). Among the products of these kilns were architectural ceramic pieces, local versions of types used in China. These, in more garish hues, became very popular during the Bangkok period.

LAOS

The art of Laos is a provincial version of the art of Siam. The Thai kingdoms of Laos, the first of which was founded about 1360, were all, in that inhospitable region of narrow river valleys and jungle-clad mountains, small, unco-ordinated and not very prosperous. The primitive Mon people upon whom the Thai imposed themselves had not made in that hostile environment any substantial cultural advances as other Mon peoples had done in Cambodia, Siam and Burma. Hīnāyana Buddhism came in from Siam, but it came without any substratum of older tradition. There were no stone buildings, and the few durable structures in Laos, of brick and stucco, are provincial versions of the art of Ayuthia. The most interesting and beautiful of these is the That Luang at Vientiane (*Ill. 136*). This is a stupa formed as a low dome of square section crowned by a striking tall spire of the sinuously moulded shape found

135 Porcelain jar from Sawankhalok. The form and texture of this
Siamese pot match the beauty of the Chinese ware it imitates

133 (*left above*) Detail of a painted lacquer cabinet showing scenes of court
life. Mid-nineteenth century. A typical piece of Bangkok ornamental
painting

134 (*left*) Painted lacquer cabinet, detail

everywhere in recent Burmese and Siamese architecture, for example, the golden palace in Mandalay. Around the base of the dome stand small structural spires of similar shape, the tallest on the outer edge of the plinth on which they stand. The whole is enclosed in a tile-roofed cloister of markedly Chinese type. A few brick and stucco buildings – halls or libraries – have roofs rising in tiers as diminishing storeys (*Ill. 136*). And the walls of Korat, with their gates, might almost be in China.

136 (*opposite*) That Luang, Vientiane. 1586, restored eighteenth–nineteenth centuries. The great stupa of Laos has a very distinctive pattern of finial

137 Vat Pbraphra Kheo, Vientiane. Rebuilt in the nineteenth century. Faint echoes of Khmer style are here incorporated into a characteristic local type of wooden building

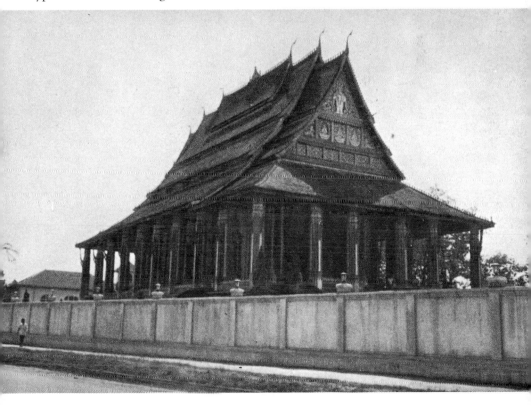

The characteristic Buddhist buildings of Laos are all of wooden construction, on wooden pillars, with long, steep, stepped-out roofs. Flamboyant finials mark the upcurved ends of the ridge-poles (*Ill. 137*), and the eaves extend to cover wide verandahs. The Buddhist images these buildings contain are all crude versions of Ayuthia types. Some bronzes appear to be fairly old, but many of the wooden figures are gilt, plated, and inlaid in base Bangkok style. Some of them are given a vigour their Bangkok prototypes do not have by the primitive directness of their carving, which states clearly conceived plastic forms.

Burma

Generally speaking, art in Burma means Buddhist art, and the Burma known to art-history is not identical with the modern geographical unity. The Buddhist culture of old Burma, however wide its general influence may have spread, was originally a product of the vast river basin of the Irrawaddy, with an extension south-eastwards along the coast to the delta of the Salween river. All the venerable city sites where major art was produced belong to this lowland region. It is not particularly surprising; since even now the higher ground is clothed in dense rain-forest, and has been inhabited for many centuries by people whose folk-religion demanded no expression in stone, bronze or fired clay – the only materials likely to survive for long in the wet monsoon climate.

Buddhism of the Theravāda or Hīnayāna branch was established as the dominant religion in AD 1056, by a fiat of the king who unified the country, Anawrahta of Pagān. This event represents a historical dateline in relation to which the whole of early Burmese history is most easily understood. But Anawrahta was setting up his state religion as a unifying force in opposition to earlier forms of Buddhism and so-called 'nature religion', which had their own history behind them, and had probably produced an art of their own. So deeply entrenched were these earlier forms of religion that they were never in fact expunged from the minds of the Burmese, but only modified and slightly adapted to fit the religious patterns of Theravāda, for Buddhism is a most accommodating religion. Its great strength is that it can fit itself very easily into almost any social and cultural framework, without losing its identity and without demanding of its followers a culturally damaging renunciation of their own customs. Thus works of art are found based on

popular non-Buddhist religious themes of considerable anti-
quity, even in the art of later times. And many Burmese of the
present day are as devoted to the worship of the Nats (see p. 163),
to astrology and even to alchemy, as they are to the doctrines of
the Buddha.

Burma lies close to India, and during the early Middle Ages,
India was a land of enterprise, sending out her merchants and
colonists to many parts of Southeast Asia. Burma received her
own groups of Indian settlers. Brahmin astrologers are known
to have been in the service of medieval kings in both Prome and
Pagān. And although Hindu images dating from the sixth to the
tenth centuries A D have been found, Hinduism never established
itself firmly in Burma. Various Indian forms of Buddhism,
however, did. The principal opponents of Anawrahta's intro-
duction of Theravāda Buddhism were a religious order known
to history as the Ari. They were probably monks of Mahāyāna
sects, for at Prome and at Pagān a number of images of Mahāyāna
'deities' have been excavated. The astrology practised in Burma
is of Indian type too, so altogether it seems that the influence of
Indian culture has always been strong, chiefly in its Buddhist
manifestations. It is probable that the social structure implicit in
Hindu theory helped to make it unacceptable to the tribally
orientated peoples of Burma. The earliest concrete evidence for
the presence of Indian influence on Burmese soil are the frag-
ments of Pali Buddhist canonical texts found at Old Prome,
dating to about A D 500.

Documentation of the early history of Burma is scant. Much
of the history is fanciful, for genuine history was not a Burmese
forte. Chinese sources refer to wild, tattooed and cannibal tribes
using bows and arrows. Ptolemy's *Geographica* identifies a
coastline, possibly around Moulmein, where cannibals lived.
To the seventh, eighth and ninth centuries A D probably belong
inscriptions from Prome and Old Prome which refer to kings
with Indian names, some of whom may have been connected
with the Pallava kings of south-east India. It seems, however,
that before Anawrahta's unification of the kingdom two

162

principal population groups divided the country between them. In the south, in the lower Irrawaddy valley, and along the coast, the Western Mon people lived. They were close relatives of the Eastern Mon, who produced a wealth of art in Siam and Cambodia, and spoke a language of their own. The Western Mon of Burma produced fine art too, most of it Theravāda Buddhist. In the upper Irrawaddy valley the Pyu people were at first dominant. They spoke a Tibeto-Burman language, and were mainly Buddhists of one kind or another – though Hindu deities were known among them. They were recorded by the Chinese, whose T'ang dynasty history gives a description of an eighth-century Pyu city. It was 160 li (c. 54 miles) in circumference, walled and moated, containing more than a hundred Buddhist monasteries lavishly adorned with colours, silver and gold. When the northern Pyu capital was captured and the people enslaved by a neighbouring kingdom in Yunnan, the way was left open for the infiltration from the Chinese-Tibetan border-country of the racially 'Burmese' people. They eventually intermingled with and came to dominate the Pyu and Mon, being converted by them to Buddhism. It seems that by about A D 1000 the process of conversion had already begun, for then a racially Burmese ruler of Pagān endowed the foundation of a Buddhist ordination hall.

These Burmese were probably the original worshippers of the Nats, and transmitted their cult in exchange to the peoples from whom they learned Buddhism. The Nats are an extraordinary mixed collection of deities, including spirits of trees, rivers, ancestors, snakes, and the ghosts of people who have met a violent or tragic death. They like a peaceful life, and they can wreak destructive vengeance on people who annoy them. Originally they were numberless. But in time a canonical number of thirty-six was fixed for them, with the Buddha included as the thirty-seventh. The Nats were worshipped with orgiastic ceremonies, and trance-rites of spiritual possession. Mount Popa, an extinct volcano near Pagān, became the sacred mountain of a group of them. Even today the Nats

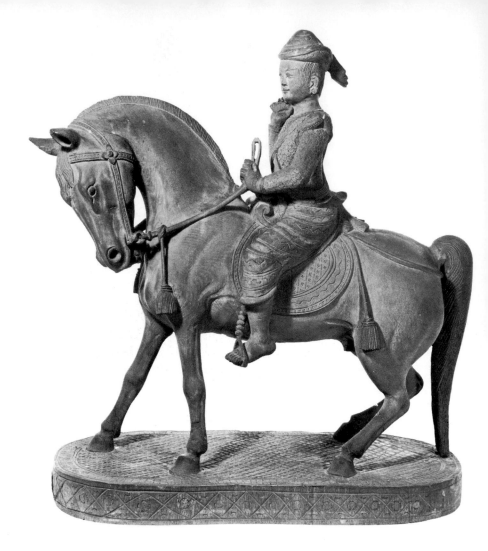

exert a powerful influence on the thought and experience of
modern Burmese.

The quality of the feeling the Burmese have for their Nats is
of the greatest importance in the whole of Burmese art; for the
expression of the best work is imbued with this feeling, even
the decoration of the huge temples of Pagān. It supplies the only
spark of inspiration in the otherwise lifeless, colossal images of
the Buddha found everywhere. The Nats themselves first

164

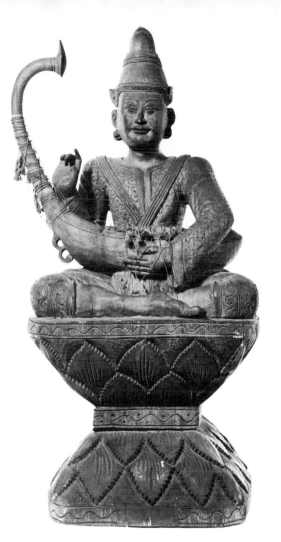

138 Burmese Nat.
Nineteenth century, teak,
height 63·5 cm

139 Burmese Nat.
Nineteenth century, teak,
height 63·5 cm

Two of the traditional
thirty-seven spirits whom
the Burmese reverence no
less deeply than they do
the Buddha

appear in the art of old Pagān. There was a collection of old
wooden Nat images in the Shwe Zigon temple at Pagān during
the late nineteenth century. Sir Richard Temple, the distin-
guished British administrator and scholar, had a set of teakwood
versions carved by Burmese sculptors which is now in Oxford
(*Ills. 138, 139*). Images of this kind must have exerted a great
influence on the course of art. For in the best Burmese art a
sense of mystery emanates from these disembodied presences,

invisible personalities inhabiting the forest trees, for whom magic is as normal a procedure as the use of hands, and who are not looked on with any excessive awe. In some districts, in every Nat-inhabited tree and in every village home there is a Nat-house, made of bamboo and grass, and decorated with bright pieces of cloth and tinsel. The undulating, flame-like pointed plaques and pinnacles which adorn Burmese architecture, and which celestial figures and court dancers wear on their shoulders, are intended to suggest the transcendent realm of magic and heavenly delight in terms peculiarly Burmese. The sensual opulence of the Indian vision of the heavens provided the original inspiration for the Burmese version. The texts of Buddhism are full of descriptions of the palaces of the gods, but in Burmese art heaven is imbued with a gentle elegance and affection, while the Indian emphasis on the physical body is discounted.

Since these people have always lived in immediate proximity to their invisible neighbours, they are as familiar to them as the inhabitants of the next village. And as the Nats are spiritual beings, and 'heaven' is the region spiritual beings inhabit, the Burmese image of heaven is of a kind of vastly enlarged village of Nat-houses.

The Buddhist temple, which according to Indian precedent may be a symbolic representation of heaven, is conceived in Burma as a hugely glorified Nat-house, for the Buddha was adopted as the greatest of the Nats. So the same symbols of supernatural splendour as adorn the Nats adorn the Buddha's images (*Ill. 140*), and a Nat-like spirituality attaches to the ubiquitous monks in whom the presence of Buddhism is experienced as an everyday reality.

King Anawrahta (Indian form: Aniruddha) was of Burmese race, and ruled at Pagān in the old Pyu kingdom. He captured the venerable Mon capital of Thaton and carried off its royal family, many skilled craftsmen and most of the Theravāda monks, to Pagān. The superior culture of the Mon captives was recognized. They were honoured, and given the task of

organizing and civilizing the new Burmese kingdom. Under Anawrahta's successors, links with the Buddhist homeland were forged. Embassies were sent to Bodhgaya in Bihar, and the great Mahābodhi temple there – marking the spot where the Buddha achieved enlightenment – was restored with Burmese money, perhaps even slightly in Burmese taste. And although Theravāda was the officially established form of religion, tolerance was extended to other forms, and it is clear that the

140 Buddha calling the earth to witness. Probably seventeenth century. Probably Upper Burma. A bronze Buddha figure decorated with the crowns and shoulder-flanges which symbolize divinity. The face contains echoes of Pyu images

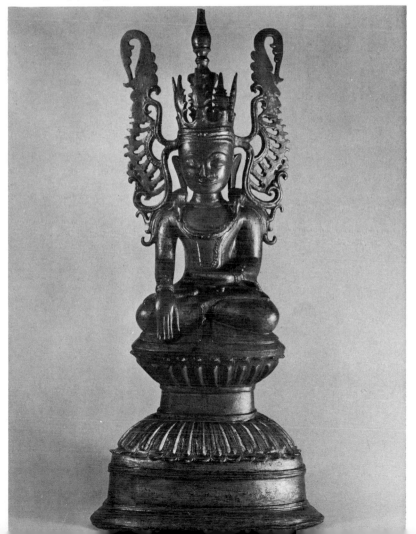

form of Theravāda adopted was itself impregnated with elements from other doctrines. The Mahāyāna had its devotees, and there are some tenth-century frescoes on a temple at Pagān suggesting that the Tantrik Buddhism (Vajrayāna) of Bengal was popular for a time. From the eleventh to the thirteenth century was the 'Golden Age' of Burmese art. In 1287 Burma was sacked and garrisoned by the Mongols. Thereafter Burmese art traditions petrified.

The art of the epoch before Anawrahta, however, in the Pyu region of Upper Burma, must have had its own splendour. The one Pyu city to have been investigated archaeologically, the old Shri Kshetra, now Hmawza, was enclosed in a massive wall. It was larger than Pagān or even Mandalay, and Mon inscriptions

141 Bobo-gyi stupa, Shri Kshetra. Ninth century. The early type of tall, cylindrical Pyu stupa, close to an eastern Indian prototype

168

refer to it as the capital even after Anawrahta's death. Near the
city are three huge ruined stupas, the largest one a hundred and
fifty feet high; a number of small, vaulted, brick chapels
probably formed part of the religious complex. The stupas (*Ill.
141*) are tall, brick cylinders, mounted on shallow, stepped
circular plinths. Their apices already have the characteristically
Burmese concave bell-like pinnacle tapering to the central
point. The later course of Burmese stupa architecture can be
described generally as the gradual elimination of what was the
main body of the Pyu stupa – the cylindrical drum – and the
progressive amalgamation of the forms of the flange-moulded
apex with the stepped plinth. The Pyu chapels follow two
patterns (*Ills. 142 3*). One is a simple rectangular hall, with

142–3 Plans of Pyu chapels, which closely resemble their Indian patterns

142 (*left*) Lemyethna, Shri Kshetra. Ninth century

143 (*right*) Bebe temple, Shri Kshetra. Ninth century

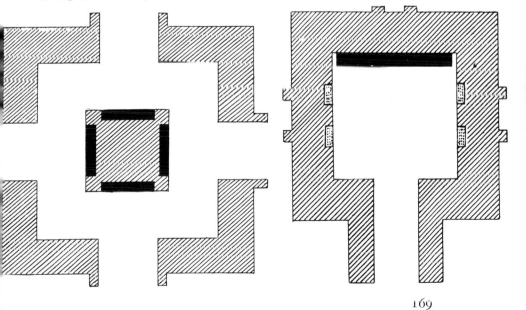

massive walls, buttresses and a single framed entrance door. The other is square in plan, set upon a square central plinth, with entrance doors on each of the four sides. This latter pattern follows a familiar Indian type.

The works of art found at Shri Kshetra are extremely varied, and little order can yet be introduced into them. There are plenty of stone images of the Hindu god Vishnu – who is, incidentally, the Hindu deity most often encountered in Southeast Asia. As he represents the central principle of existence, he travels more easily than other Hindu deities who are more closely involved with the native Indian social structure. The Ari religion is probably represented by a few works of art based on the Mahāyāna form of Buddhism. There are bronze images of Bodhisattvas, who were especially cultivated by the Mahāyāna. These are enlightened, compassionate beings, entitled to Nirvāna, who yet abstain from their own release in order to save the suffering creatures who are still in bondage to the world. They are able through their great virtue to perform miracles. They appear in art as beautiful persons, wearing the crowns and jewels of kingship. There are orthodox Theravāda Buddhist images, as well, and inscriptions.

The Pyu evidently used to burn their dead and place the ashes in pottery vessels which were kept in rows in the precincts of the shrine, sometimes on brick platforms covered with earth.

Unfortunately, little is known of the earliest phases of Western Mon art in Burma. Its achievements are known from a later phase when it was exercised in the service of Anawrahta's Theravāda Pagān, and it produced a splendid profusion of architecture and other art. At Pagān architecture is definitely the dominant art, and except for the big icons, sculpture and painting have only a subordinate rôle to play. Carving and ornament never take the prominent rôle they do in the original Indian buildings, or in other parts of Southeast Asia. The materials are brick and stucco, and they have lasted pretty well. A single Hindu temple, and a few remains of Mahāyāna inspira-

170

tion, survive among the mass of Theravāda structures belonging to the two hundred years of Pagān's greatness, before the Mongol conquest. They have, of course, suffered neglect, damage, and some – perhaps worst of all – from restoration in debased style. Even so, Pagān still contains the largest surviving group of the brick buildings which once stood in many parts of south Asia. There are thousands of remains, and the relatively dry site must have much to do with this. And, as in India, we can tell that the surviving monuments are only the relics of an immense volume of building, most of which must have been made of wood. Teak abounds in the jungles of Upper Burma, and bamboo grows everywhere – many of the reliefs represent wooden structures. The huge area of Pagān extended far beyond the limits of the known city walls, and it is likely that the surviving brick remains were surrounded by dense building in perishable materials. About these, however, it is possible only to conjecture, and assume that they supplied patterns and prototypes for what can still be seen standing in brick and stucco. From the extant inscriptions we know that royal devotees frequently turned their palaces over to the uses of religion. So it is probable that monastic architecture and palace architecture were at the very least compatible. And what is more, monasteries were – and still are – adorned with a splendour worthy of the palaces of divine kings – gilded, painted, and carved with lavish ornament. The monks are committed to a life of absolute poverty, but their laity, to whom they symbolize the saving Truth, ensure that the glory of this symbolism is made apparent in the monastic environment.

The most important early buildings at Pagān are the two shrines flanking the Sarabha gate to the city (*Ill. 144*), which contain damaged images of the Mahagiri Nats, and the early monastic library, the Pitakattaik. All are built in brick, with solid walls. The Sarabha gate shows the relics of the flat pilasters and moulded architrave which are a common feature of Burmese building, particularly at the corners of the structures. The shrines themselves are very simple, and have obviously

145 Library, Pagān. 1058. In this splendid library
with its 'flaming' roof the books of one of Pagān's
Buddhist monasteries would have been housed

144 Sarabha gate, Pagān.
Mid–ninth century. The two Nat
shrines are the oldest surviving
in Burma. They presumably
housed spiritual guardians of the
city gate

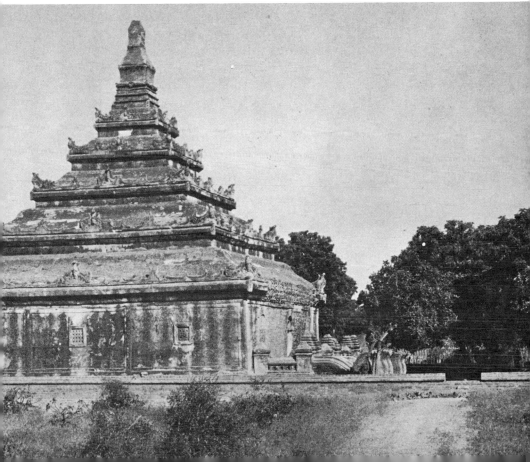

lost their original ornaments. The rectangular library (*Ill. 145*), however, retains its five-tiered roof, from which sprout flamboyant, curvilinear flanges, and which is crowned by a central spire. It is reminiscent in its proportions of Indian prototypes. A library, of course, is an important building in a Buddhist monastery, for books are vehicles of the doctrine.

The most numerous and important buildings at Pagān, however, should be classed as *cetiyas*. They have a history and line of evolution of their own, from stupa into huge structural temple. The normal stupa is a tall structure incorporating on a plinth a solid dome, which is surmounted by a member called the *harmika*. Originally, on the oldest Indian stupas, this harmika was a small railed enclosure, inside and below which the relic-chamber was set into the dome. But in Burmese stupas the harmika has become a large decorated die. Above the harmika is a circular pointed spire, flanged, in memory of its origin, as a range of honorific umbrellas of decreasing size, set one above the other, over the harmika and relic-chamber. In practice, harmika and umbrella-spire become a single architectural unit. Cetiyas based on the stupa are the true focus of the Buddhist faith. The pagoda-temple and its Buddha image is a direct functional derivative of the stupa as emblem of final Nirvāṇa.

Stupas of a pattern related to the old Pyu stupa at Shri Kshetra are found at Pagān. The earliest, the Bupaya (*Ill. 146*), was actually built by the Pyu. It stands on a high platform; its own plinth is simple, low, and octagonal. Its harmika and umbrella-spire form a single, tall concave-sided cone. The stupa type usually attributed to Anawrahta is similar to this old Pyu pattern. The main point of evolution is in the greater elaboration of the terraced plinths. These stupas (*Ills. 147, 148*) stand on a series of stepped octagonal terraces, which may themselves stand on what are virtually sacred mountains – further terraces with staircases mounting from terrace to terrace up each of the four sides. In this they resemble monuments in other parts of Southeast Asia. The domes are tall, bell-shaped cylinders, often with bands of ornamental moulding half-way

146 Bupaya, Pagān. Ninth to tenth century. A small stupa on the plinth of a stupa of Pyu pattern. It stands in a commanding position, but its plinth is relatively low

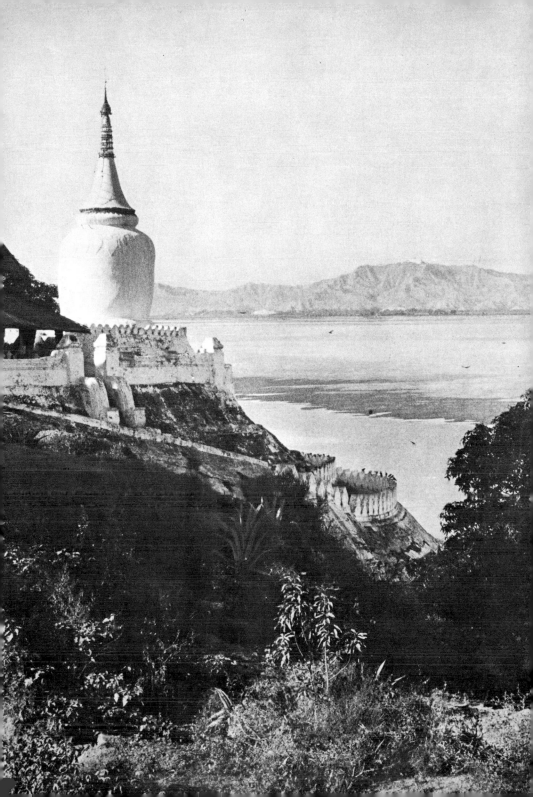

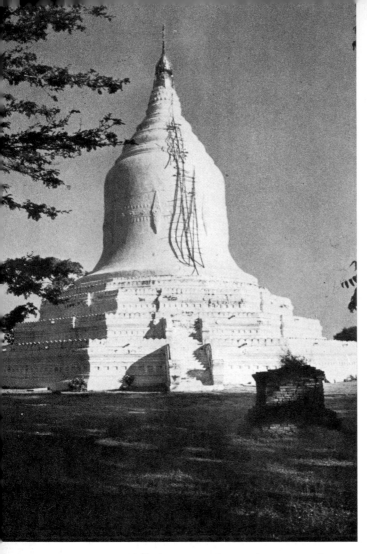

147 Lokānanda
temple, Pagān.
Eleventh century

148 Schwe Sandaw, ▶
Pagān. Eleventh
century

Two versions, both re-
worked, of the type of
majestic stupa associated
with King Anawrahta.
The high plinths which
resemble sacred moun-
tains carry terraces
around which pilgrims
can walk

up. Their crowning spires vary in pattern. Some resemble a
series of diminishing built-tiers, others more closely resemble
piled-up flanges. The most significant characteristic of some of
these stupas attributed to Anawrahta – for example the Shwe
Sandaw cetiya (*Ill. 148*) – is found on the series of rectangular
terraces forming the sacred mountain on which the stupa stands.
At the corners of these terraces replicas of the crowning harmika
combined with the umbrella-spire have been built. The terraces

176

themselves are given horizontal bands of moulding. In the earlier instances of this type of stupa at least two of the five or six octagonal plinth-terraces can be used for circumambulation. But with the development of huge rectangular terraced storeys of the sacred mountain at the end of the eleventh century, the octagonal terraces atrophy, and become no more than moulded flanges round the lower rim of the bell-shaped dome. By the twelfth century the pattern of the stupa has changed into the

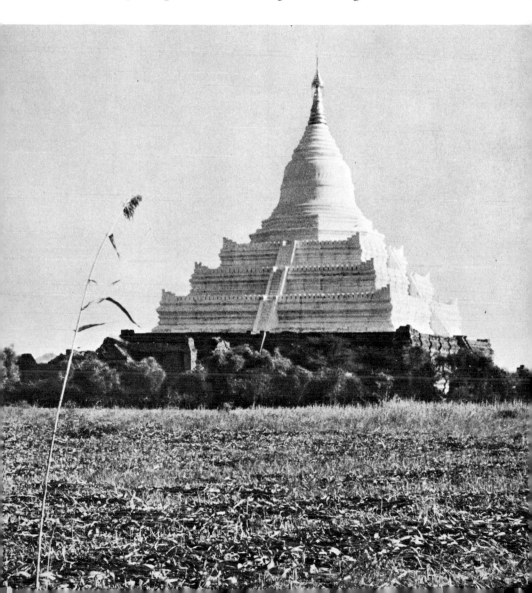

form from which the true Burmese temple was to spring. The dome has become highly ornate, the bands of ornament found on the older Pyu type having become wider and deeper, with Buddhas in framed cartouches facing out in the four cardinal directions. The old octagonal plinths have become an elaborate series of flanged mouldings round the base of the dome. The spire has become a massive conical moulded and flanged crown to the dome, while the lower, square tiers of terraces have become fewer in number and individually higher, so that each presents a tall wall surface. The miniature spires at the terrace-corners have become virtually miniature stupas. The epitome of this style is the Seinnyet Nyima cetiya at Myinpagān (*Ill. 150*).

On monuments of this last type, decorative figure sculpture comes very much to the fore. There can be little doubt that in this respect – and in the actual form of the stupa, notably in the new weight of the conical spire – there is a strong reassertion of Indian influence. For it was about the time when this development was taking place that the Burmese, on their own account, established relations with the heartland of Buddhism in Bihar. There the late Pāla style was flourishing, and it would be entirely natural for the Burmese to wish to attach themselves to the expressive modes of the country which was the source of their religious inspiration. It is likely that at the same time the Burmese were prompted to a further architectural development

149 (*left*) Development of cetiya into temple. This diagram illustrates how the originally solid mass of the Burmese stupa on its high plinth was opened up, and converted into a temple. The drum of the stupa extending up through the undercroft could still serve as focus for devotion

150 (*right*) Seinnyet Nyima temple, Myinpagān. Late eleventh century. The ornate summit of a stupa-become-temple ▶

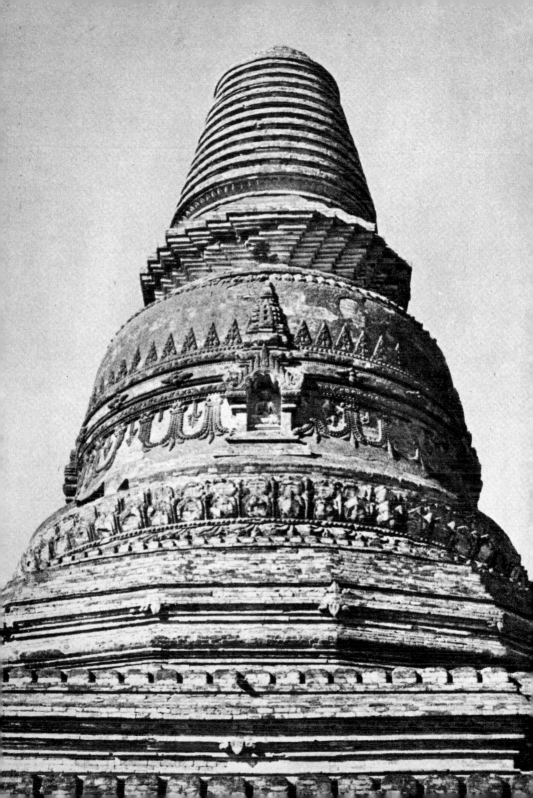

by what they saw in contemporary India. This involved the opening up of the terraced base of the stupa into a temple interior. The sacred mountain was a piece of natural Burmese symbolism, for Mount Popa was the home of the great Nats, and hollow Nat shrines, described above, had been made. In India the symbolism of the temple as sacred mountain had been very highly evolved, and the whole interior of the massive pile of the temple had been opened up, on the analogy of the cave in the hillside. Within the sacred mountain the germ of its sanctity could be made visible in its hollow depths. Anterooms and doorways would prepare the visitor's mind for the experience of the indwelling *numen*.

In the eastern regions of India where the Burmese were making contact under Anawrahta's successors, the centrally planned brick temple was a standard architectural pattern. It was crowned by a moulded spire, raised on a high plinth, with staircases at the centre of four sides. Under the spire was the main cell where the chief image was housed. In India, too, it had long been conventional for the rock-cut stupa within a Buddhist cave-sanctuary to bear on its face a carved figure of the Buddha. This was to demonstrate that the Buddha nature dwelt inside the monumental emblem of Nirvāṇa, the Buddhist Truth. By a combination of these two conceptions the Burmese arrived at the idea of their own cetiya-temple (*Ill. 149*). By burrowing into the undercroft of their stupas, as into the sacred mountain which the terraces suggested, they could open up an internal temple area, in which the Buddha image would occupy the central spot. The stupa-dome would serve as mountain-peak and spire. But since the association of Buddha image and stupa was accepted, the stupa would naturally be thought of as extending down into the undercroft to contain the Buddha image. The surrounding terraces of the sacred mountain could then also be interpreted as lean-to roofs, even awnings round the root of the stupa-drum. The exterior of the temple could still suggest the idea of the sacred mountain crowned by its stupa. But the new logic of the interior would add a fresh dimension

180

to the idea, as a place to be entered for a direct encounter with the true doctrine. Sculpture and painting on halls, corridors and doorways could recount the life of the Buddha, and present the example of his previous lives. The opening up of the lower terraces as buildings with internal wall faces of their own would make it unnecessary for the roofs of the tiers actually to serve as ambulatory terraces. Following the Indian symbolism of the cosmic mountain, however, what had been the terrace-corners retained their small stupas, for the cosmic mountain naturally possessed its foothills. Finally, the terraces as well as the inner rooms and passages became the heavenly habitat of all the spiritual creatures of Burmese and Buddhist mythology.

The first phase of this temple development is represented by the Abeyadana at Myinpagān, which is really a stupa, but its bottom storey is opened into an ambulatory corridor lit by latticed windows. The window-frames are set between flat pilasters, and crowned with a lobed hood-moulding worked with a row of flame-finials. The 'Tally Temple' near the Sabbannu, Pagān, is a splendid example of a twelfth-century temple. The central mountain-spire is a large, bell-domed stupa, worked with lavish stucco surface ornament, which stands clear and intact on top of the terraced structure. The terrace block has become a true building, and the terraces themselves have been reduced to a stepped roof. The four tall entrance doors are double-framed, stepped-out with porches, and crowned with high flame-finial hoods. The walls are deeply recessed and heavily pilastered; the base and architrave have deeply worked horizontal mouldings; the corner pinnacles are square in section.

Two other twelfth-century temples show the further course of the evolution. In both of them the stupa-spire has been, as it were, absorbed into the square body of the terrace block. It has become square in section, though its umbrella-pinnacle remains circular. It is clearly following the pattern of the bowed spire of east Indian temples in scale, seeming to be no more than the largest of the many spires on the terrace roofs. The first of these

181

temples is the great Sabbannu itself, built immediately before the 'Tally Temple' – the latter is said to have been built of the tally bricks put aside, one for each ten thousand bricks used on the Sabbannu. The Sabbannu itself is a typical square temple formed as an opened-up terrace block. Inside, in a domed cell under the main spire is a colossal seated Buddha figure. But this temple is itself raised on its own solid sacred mountain plinth of three square terraces, the lowest storey of which is again high, and opened up with an ambulatory corridor, lit by two tiers of flame-hooded windows. Passages and

151–2 Diagrams of the greatest of Pagān's stupas-become-temples. The plinths have become buildings. The spire, strongly Indianized, recalls the original stupa-dome. 151 Ananda temple, section. 1091. 152 Ananda temple, reconstruction of exterior

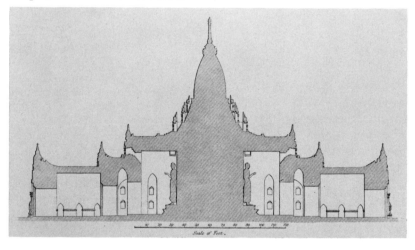

Scale of Feet.

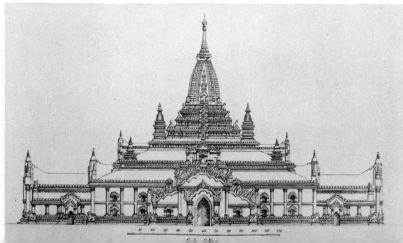

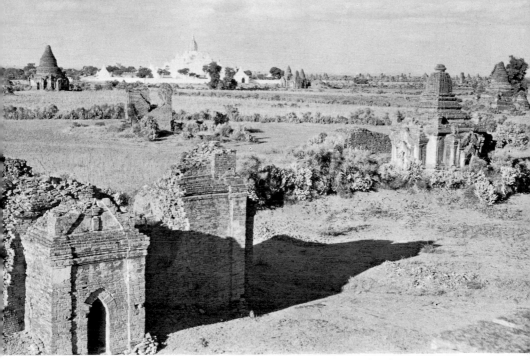

153 View of Pagān with the Ananda temple in the background. This view gives some idea of the unique architectural wealth of Pagān. There are thousands of remains, nearly all earlier than 1300

stairways run up through the massive plinth. The second of these temples is the Nagayon, at Myinpagān. This is an integral square temple, of a broader spread, and with broad, sloping roofs as terraces. But to its square terrace block and building is added a long hall, the gable-end of which is adorned with the standard double flame-finial *cum* hood-antifixes.

The crowning achievement of the Mon temple-builders at Pagān was the great Ananda temple (*Ills. 151–3*). It is still in use, unlike most of the old temples of Pagān, and so it is kept in repair, painted a blazing white with lime-stucco. It is square in plan, with a long porch-hall added to all of the four doors in the four faces of the square. The brick mass is pierced with a grid of corridors, and the terraced roofs are sloping. Its towering central spire is perhaps closest of all to the east Indian temple spire,

grooved and channelled with multiple mouldings, with a vertical band of blind windows up the centre of each face. The broadest terraced roofs have stupas at each corner. The more central, small roofs have seated lions – standard emblems of the power of the Buddhist doctrine. The faces of the lower storey are squared-off by vertical pilasters and a horizontal band. The edges of all the roofs are crenellated, and each of the magnificent doors is crowned with two huge triangular hood-antefixes of flame-finial. Inside, the spire descends through the roofs to floor-level, as a stupa-block. A colossal standing Buddha figure – of base, reworked type – faces out from it along each of the approach-halls. Inside the temple is lavishly adorned with reliefs of Buddhist subjects.

The later evolution of the Pagān temple consisted of modifications of these canonical forms, mainly by the alteration of the relative proportions of the different parts. The thirteenth-century Gawdawpalin temple (*Ill. 154*) adheres to the pattern of the rectilinear temple plus extra plinth. The ornament and flame hood-antefixes are much emphasized and enlarged. This – the Burmese style, as distinct from the Mon – tends to stress the height of the walls with its highly ornamented pilasters. Porches may be crowned not only with hoods, but even with tiered pinnacles, as in the Sembyoku. One temple at least – the Obelisk of Wet-kyi-in, Ku-byauk-ki – was built as a direct imitation of the square, straight-sided pyramid-tower of the great temple at Bodhgaya, called the Mahābodhi. This had been restored by Anawrahta's successor, Kyanzittha, in the early twelfth century. The Burmese version has little roundels, each containing a relief figure of a celestial, on each of the many partitions on the faces of the tower.

As time went on, Burmese brick-and-stucco architecture developed principally through the elaboration and often the coarsening of its ornament. It is, however, impossible to form an adequate idea of the older styles of temple architecture used, for example, at the sites of the great temples of Rangoon or Mandalay. Pagān's temples were mostly abandoned, so that

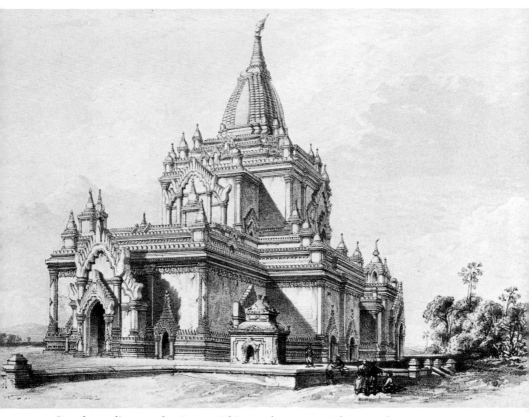

154 Gawdawpalin temple, Pagān. Thirteenth century. This temple must once have contained many paintings, and perhaps reliefs

even though they may be ruined, they show their original characteristics. But temples which have remained in continuous use have been continually and drastically restored. Stupas may have been sheathed in as many as eight successive casings of brick and stucco. Temple walls and doors are constantly torn down and rebuilt, and stucco may be renewed almost annually. Applying fresh gilding and glass inlay is popularly regarded as an act of merit, so revered architectural monuments suffer from it continually.

155 Variety of size of pagodas. Such a Buddhist ceremony justifies the extravagance of the stupas

Among the more recent pagodas there is only a little variety. In fact they can be built at a great pace and there may be hundreds of many sizes (*Ill. 155*), with many variant patterns of moulding, around a Buddhist monastery. The most expensive kind are covered quickly with extravagant and gross stucco ornament, but simpler examples can be beautiful. Occasional interesting combinations of Buddhism and Nāga cult are found in pagodas with an open cell containing an image of the Buddha, the plinth of which is composed of a Nāga coiled round the structure (*Ill. 156*). This is possibly an echo of the Khmer Bayon type of Buddha or Nāga. Among monastic buildings of wood are many derived partly from Chinese patterns, and then Burmanized by their ornamental treatment.

There are in the Shan states a number of purely Chinese administrative and monastic buildings. But at the great pagoda sites of southern Burma, such as the large Shwe Hmaw Daw at Pegu, the Mingon, Arakan or Mahā Myatmuni of Mandalay, there are numerous wooden buildings in which Chinese forms are

156 A Nāga encircling a pagoda. An extraordinary echo of the Buddhist snake-cult, originally Indian, which was carried to a high point by Jayavarman VII at Angkor

157 Schwe Dagon pagoda, Rangoon. The terrace, built 1460. This
photograph gives some idea of the extravagance which overtook Burmese
decoration during recent centuries

buried under Burmese modifications and ornament (*Ill. 157*). At the great Shwe Dagon at Rangoon, for example, where numerous extremely sacred relics are enshrined, the 'Southern Shrine' (*Ill. 158*) is based on the Chinese many-tiered pagoda. The base-storey is cruciform in plan, however, with porch-gables overriding each other, reminiscent of old Pagān, but the wooden pillars that support the porches are Chinese in conception. Yet all the angles of pillar and architrave are filled with pierced wood-panels of scroll and flower ornament, and every roof gable, tier and terrace effloresces with flamboyant pointed cartouches of similar pierced work, so that the whole building is smothered in repetitive ornament, lavishly gilded (*Ill. 157*).

Similar structures, or long halls with double- or triple-tiered gabled roofs at other pagoda sites, where less merit-money has been spent, have less ornament, and may be extremely beautiful, with only a few flamboyant antefixes pointing the gables and punctuating the eaves. Such buildings abound all over Burma. They have never been listed, surveyed or studied. In the Shan states, at the town of Kengtung, for example, beautiful examples of rustic wooden monastery architecture may be seen, where the entire effect is achieved by a multiplicity of plain tiled roofs set into and against each other, or riding over each other in terraced gables. Hardly any paint or gilt mars the simplicity. At the present time, financial stringency and a few cases of enlightened patronage have produced wooden architecture, either for monasteries or for official buildings, which succeeds in capturing the virtues of the most chaste monastic architecture. Usually in the past, however, the royal palace, and the palaces of princes and chieftains, have always been disfigured with an incrustation of extravagantly pierced and gilt antefixes, barge-boards, finials and balcony-rails, the design of which is merely monstrous, however rich.

Burmese figurative art shows the Buddha as a golden or white icon, in a blandly attractive person, unmarked by his asceticisms or suffering; the image is meant to show his spiritual not his physical nature. Buddha images, which can be miniature

158 The shrines of the Schwe Dagon pagoda, Rangoon. Fourteenth to fifteenth century. Impressive wooden buildings surround the great central pagoda, which has been replastered and redecorated countless times

159 The Palace, Mandalay. Nineteenth century. The flame-finials suggest that this is a pavilion of the immortals

or colossal, are generalized. It is part of their function to display absence of 'personality' and individualism, and they are thus monotonous. It has been described how Buddhists believe that all Buddha images, if they are to have any effective virtue or magical power, must be careful copies of the earliest images. Buddha images in Burma, which is a conservative Theravāda country, are therefore made according to a systematic proportional scheme which the craftsmen have handed down for centuries. At the same time it is believed that to make, or to pay for the making of a new Buddha image is a virtuous act, helping the donor on the way to enlightenment by creating merit for him. Thus there has always been an incentive in Burma, as in Siam, for people to multiply identical Buddha images in all sorts of materials, not because they were needed, but because it was a good thing to do for its own sake. At its lowest, this belief has led people to go to temples and spend an hour or two stamping out clay Buddhas with a metal stamp. This custom was no less prevalent in Burma than in Siam, and temples often have rooms containing thousands of this kind of Buddha.

There are only three principal iconic positions in which the Buddha appears in Burmese art. The first is in the 'earth-touching' attitude. The Buddha sits cross-legged, his body upright, his left hand is laid palm up in his lap, his right hand stretched forward over his right knee so that the tips of the fingers touch the ground. This refers to the moment of the Buddha's enlightenment, when he called the earth itself to witness that he was entitled, by the virtue he had accumulated over the ages, to the supreme insight. The second shows the Buddha standing with his right hand raised in the gesture of protection, his left held down, palm out, giving blessings. The third principal icon of the Buddha represents him lying on his right side, his cheek resting on his right hand, in the act of dying into Nirvāṇa.

The rest of the Buddhist representational iconography of Burma is based mainly on stories dealing with the life of the Buddha, and with his lives in earlier incarnations. Charac-

teristically, these stories are all represented as reliefs or paintings in an abbreviated form, containing only the principal figures, and without any expressive or dramatic interest at all (*Ill. 161*). They serve only as schematic reminders of stories that everyone knows, and do not have to tell the story. Sometimes the representations contain figures of the celestials (*Ill. 160*), who are often mentioned in Buddhist texts as listening to the Buddha's sermons, or attending him. Burmese art always represents them as delicate, elegant creatures, garlanded with scarves. Certainly these Indian celestials were conceived by the Burmese in the image of their Nats.

Figurative sculpture as represented in the colossal Buddha images enshrined in the temples, has never been a highly successful art form in Burma. The oldest images at Pagān were often built of brick and finished in stucco. Many huge modern images are made in the same way. The technique is not a flexible one, and the Burmese had no particular incentive to develop expression in the figures. They remain faithful and monotonous centrepieces for the devotions of the Buddhist faithful. They were heavily and repeatedly gilded, since paying for the application of gilding to an image was always held to be a meritorious act. This sort of pious gilding always obscured the aesthetic qualities of an image. Along the borders of the robe an inlay of precious or semi-precious stones was often set, again as a testimony to the piety of a donor. Just as it is impossible to study the evolution of the architecture of living temples, so it is not possible to compose a stylistic sequence for large Burmese images which have been continuously reworked. No research has been done in the field, and it is not likely that there would be much concrete result if it were.

In the case of smaller images, of bronze, stone or wood, dating is also difficult; there is no means as yet of distinguishing the work of different localities and of different times, and no inscriptions with dates are available. The most that can be done is to offer a tentative identification of certain images with an older, up-country provenance. It is possible that they contain

160–2 These illustrate the extremely schematic styles of early Buddhist relief and painting in Burma. All sensuous charm is avoided. (*above*) Terracotta at the Petleik-Matangjakata. Late eleventh century. (*below*) Painted terracotta plaque, Ananda. Early twelfth century. (*right*) Fresco of Preaching Buddha, Wet-kyi-in, Ky-byauk-kyi. *c.* 1113

vestiges of Pyu style, and certainly some overtones of Chinese form. They tend to be mounted on high lotus plinths, and to wear modelled crowns whose panels are very tall and pointed, as are the tall flame-like protuberances of the skull. From the shoulders there often rise high flanges, fretted and flamboyant. The modelling of the body and face is restrained, but it has more of the old sense of Indian volume to the limbs than the orthodox Burmese type of Buddha (*Ill. 140*).

There are traces of Khmer-Thai style in many Burmese images because after the Mongols broke Burmese power in 1287, these neighbours of the Burmese took over much erstwhile Burmese territory, and maintained continuous contact with the sources of Theravāda Buddhism in Ceylon through Lower Burma. The orthodox Burmese Buddha image is thus characterized by a bland horizontal emphasis in the features of the mask; but the forms of the body are suppressed into indeterminate volumes beneath the tent-like forms of the robe. The robe's pleats follow a simple, fan-like pattern; and end-folds appear sometimes developed into a fish-tail pattern. Extremely undemonstrative reticence, and no attempt at the expression of qualities, mark the hundreds of orthodox Buddhas in bronze, wood and white marble.

In a few of the temples of Pagān there survive relief sculptures in painted terracotta and frescoes that give some idea of the original splendour of the buildings (*Ills. 160, 161*). The style is markedly eastern Indian, very close indeed to Pāla art in Bihar and Bengal. Reliefs from the Ananda temple confine themselves to a few clearly silhouetted figures and objects disposed on the ground, scarcely developed sculpturally beyond their mere outlines. The most interesting work, however, is the brilliantly coloured fresco-painting in, for example, the Abeyadana and the Wet-kyi-in, Ky-byauk-kyi (*Ill. 162*). Frescoes in the Abeyadana represent a whole Tantrik series of divine principles ranged above each other on arcades. There are flying celestials in the fine slim-bodied sinuous style which provided the unvarying basis for the whole later art of Burma. And here and there

196

individual figures testify to a quality of invention that is no whit inferior to the Indian prototypes. Indeed it is possible that Indian Buddhist painters – at first willing immigrants, but later those expelled from their own country by the Moslem holocaust – actually painted some of the walls at Pagān.

The course followed by the later evolution of Burmese styles of relief and painting was always governed by a tendency towards schematic simplification. There is in Theravāda Buddhism a strong streak of puritanism towards the arts. Artistic expression is regarded as an indulgence flattering to the senses. It can only be tolerated if it is purged of all reference to actuality and converted into a kind of mnemonic diagram. Bright simple colours – red, yellow, green and gold – and generalized floral decoration are admitted only because they attract the simple mind, and give it an impetus towards the truth contained in the legend. The idea of developing a visual language for expressing Buddhist ideas, and exploring its resources as was done in Mahāyāna countries was absolutely excluded in Burma.

The later sculptures of auxiliary figures from Buddhist mythology occasionally makes a more substantial attempt at aesthetic expression. For example, there are figures representing Buddhist saints who are supposed to be listening to the sermons of the Buddha, sometimes placed in a reverent attitude before the main image in a shrine or hall. Most commonly they are of wood, gilded, and with stone or glass inlaid ornament along the borders of their robes. Their figures, features and shaven heads are far more typical of the Burmese people than the stereotyped Buddha images, and there is some correspondence with visual actuality. Their expression is bland, elegant and sweet, with all emotion exiled. But the forms of which they are composed are usually hesitant, undifferentiated, and made without any conceptual firmness or certainty.

The teakwood figures of the Nats, mentioned earlier, of which there is a set of copies in Oxford, belong to the same order of art as the temple furniture. They are carved in the same manner and technique (*see Ills. 138–9*). Many of the

163–4 The flat relief technique has compressed the flamboyance of the late Burmese style into a decorative and interesting design

wooden halls contain brackets or panels carved with elegant figures representing the inhabitants of the heavens. Their attitudes and ornaments are based on those of the palace dancers. They wear the usual insignia of immortals – upward-pointed epaulettes, and tall, stupa-like pointed hats, often adorned with flamboyant cartouches. The Nats are carved more or less in the full-round, without the tension of form that is produced by the more demanding sculptural modes evolved in other countries of Southeast Asia. Some ride on their canonical animal vehicles

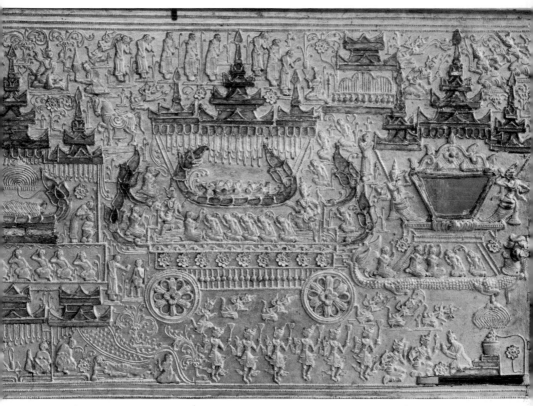

163 (*left*) Side view of *sūtra*-chest. Probably eighteenth century, wood and gesso. 164 (*above*) Front view of *sūtra*-chest

–elephants or horses – and they hold weapons or make characteristic gestures by means of which they can be identified.

One of the most important types of temple furniture, examples of which are found in some Western museums, are large, gilded *sūtra*-chests, ornamented with reliefs in gesso (*Ills. 163, 164*). Such chests were used to store the manuscripts of the sacred Buddhist texts possessed by every monastery. Since these texts contained, as it were, the essence of Buddhism, the spiritual life-blood of the monastery, the chests in which they

were kept had to be worthy receptacles, and they shared something of the reverence accorded the texts. The gilt and ornament are the visible evidence of this reverence. The chests stood backed against the walls in the library halls, and were subsidiary foci of the decorative scheme.

Their ornament is in very flat relief – true two-plane relief. And for this very reason – the strictness of the limitations of the medium – much of this relief ornament is the most aesthetically satisfying work produced by the Burmese sculptor. The top of the chest is usually plain gilt, and the back, which is not normally seen, is the same. The chest may be supported on a gilt moulded stand, perhaps with feet. Old chests were often given new stands, as it seems that their old stands often decayed, or suffered damage. The front face of the chest bears stylized representations of scenes from the life of the Buddha. Large areas of mirror may be set into the gesso to represent a lake, or the body of an ornamental chariot. The figures are few in number, laid out schematically over the surface; they tend to follow the horizontal and vertical directions, thus giving an air of repose and calm to the design. The side faces usually show figures of celestials bearing their 'insignia', in ornamental frames.

Another kind of temple furniture in which the Burmese excelled was lacquer ware. Today domestic rice bowls, either for use at home, or, more elaborate, for sale abroad, are made by stiffening a basis of fibre – often hair – with clay and lacquer-juice. They may have gilt figures or ornament on a ground of black lacquer. But the more elaborate temple 'lacquers' may be very large indeed, often compounded of as many as twenty separately formed pieces. Usually they are of red lacquer, and most have black figures and somewhat stereotyped 'rococo' scroll-like ornament. The chief items are ceremonial 'alms bowls', meant initially to receive offerings of food from the faithful for the support of the monks. But later on, of course, the kind of alms deposited in these ornate bowls and thus sanctified was no longer in the form of food, but substantial

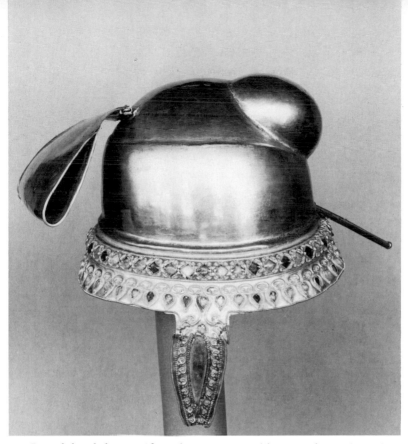

165 Royal head-dress. Fifteenth century, gold set with semi-precious stones. Part of the Burmese royal regalia, which were long preserved in London, but are now once more in Burma

wealth. Generally speaking, the forms of the bowls and related boxes are simple, with plain cylindrical or basin-shaped bodies. At the foot and lip, however, there is usually raised ornament in the form of moulded flanges. Often a highly ornate base-stand and lid are added, both with elaborate tiers of moulded flanges. Both these may be assembled out of separate pieces which fit into one another. The lid usually towers up into an elaborate conical finial resembling the pinnacle of a stupa, once more recalling the Buddhist purpose inspiring the gift of the alms – ultimate Nirvāṇa through the merit accumulated from 'giving'.

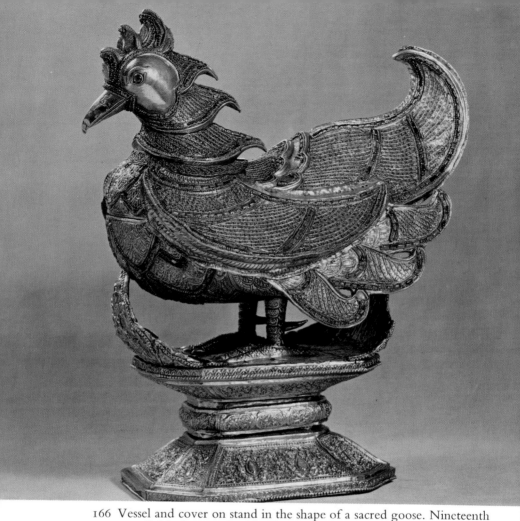

166 Vessel and cover on stand in the shape of a sacred goose. Nineteenth
century. Gold, decorated with filigree-work and inlaid with rubies and
imitation emeralds. The forms of the bird repeat the forms of flamboyant
architectural ornament. Height 41·5 cm

Gold and silver ware are another particular forte of the
Burmese (*Ill. 166*). Here again the basic forms are simple, and
the major artistic effort goes into the *repoussé* and chased orna-
ment. There are not so many flanges on these objects, but many
figures among the stereotyped floral scrolls, all of them based on
the standard Indianizing iconography. The outstanding example
of this work is the Burmese crown jewels (*Ill. 165*).

Java and Bali

The classical Indianized art of Java is possibly the greatest art produced by any of the peoples of Southeast Asia, surpassing even that of the Khmers. From the point of view of symbolism combined with formal skill, it has few rivals in the East. It represents an intimate blending of religious and artistic aims and methods, achieved by the native genius of the peoples of Indonesia. Before discussing it in detail, however, something must briefly be said of the art of the Indonesian peoples which underlay the imported traditions.

At the present time the whole group of Pacific Islands, including not only Sumatra, Borneo, Java, Bali, Celebes and the Moluccas, but all the islands of Melanesia and Micronesia, share in a complex common heritage of artistic traditions. Scholars have long been at work attempting to disentangle the various strands of tradition, basing much of their work on the assumption that waves of population-migration diffused through the islands by various routes. This fundamental group of art-styles lies outside the scope of this book. (It has been studied in Douglas Fraser's *Primitive Art* also in the Thames and Hudson World of Art series.) Among other theories, however, one theory ascribes many features of a group of island styles to the influence of Chinese Chou and Han ornament. At least it is certain that some contact was made between Tonkin and Indonesia during the Dong-son epoch: there have been found in the islands many ceremonial axes of general Dong-son type (*Ill. 168*), and ornamented ritual bronze kettle-drums cast by the *cire perdue* process closely resembling those from many parts of the mainland of Southeast Asia. The most famous of the latter is the 'Moon of Bali' (*see Ill. 5*), the largest of all the known bronze drums, found near Pedjeng on Bali. It has

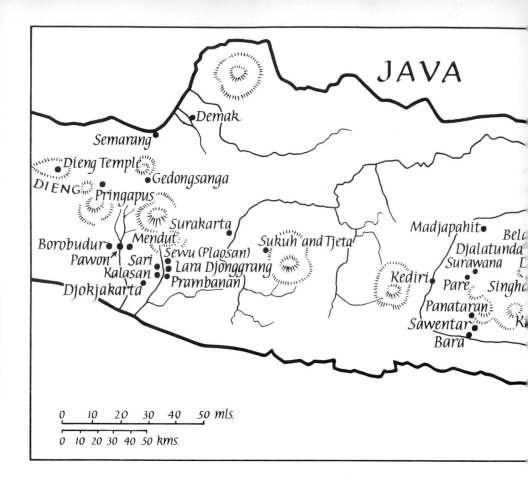

JAVA

Demak
Semarang
Dieng Temple
Gedongsanga
DIENG Pringapus
Surakarta
Borobudur Mendut Sukuh and Tjeta
Pawon Sari Sewu (Plaosan)
Kalasan Lara Djonggrang
Djokjakarta Prambanan
Madjapahit Belo
Djalatunda
Surawana L
Kediri Pare Singha
Panataran
Sawentar K
Bara

0 10 20 30 40 50 mls.

0 10 20 30 40 50 kms.

flanges and extremely elaborate relief ornament, containing stylized masks (*see Ill. 6*) with ears pierced and lengthened by large ear-rings, cast on to its faces. It has been suggested that a work so magnificent and skilful must have been imported from a mainland centre. But fragments of stone moulds for the casting of similar if smaller pieces near by suggest that the skill may have been native. It is an interesting fact – though its precise significance cannot be determined – that in relatively modern times similar though far smaller drums, some imported by Chinese, were used for paying bride-prices. The age of the 'Moon of Bali' thus becomes problematic. It could be anything

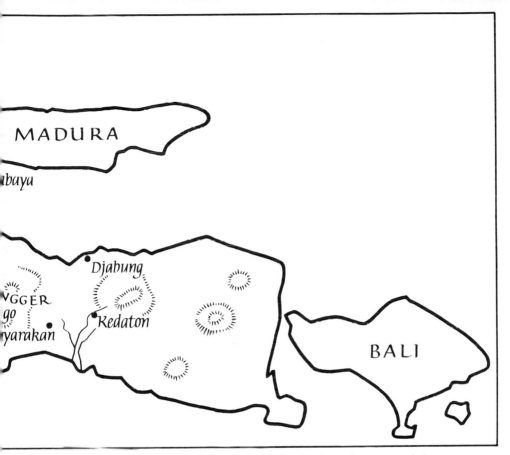

167 Map showing the principal sites in Indonesia where there are artistic remains

from roughly two thousand to one thousand years old. One particular point must be mentioned in relation to all the pre-Indian and primitive art of Indonesia: its fondness for elaborated but clearly organized schematic design. Throughout even the most complex pattern, an ordered regularity, a balance between horizontal and vertical, prevails. This characteristic mode of thought must have played some part in the formation of the Indonesian art-style, as will be seen.

The artistic achievements of this region of Southeast Asia are a direct consequence of Indian commercial exploitation. It is probable that the first Indian colonists in the islands appeared

205

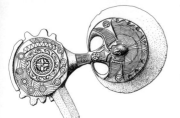

168 Bronze axe from Roti island. Dong-son culture. This ceremonial weapon is a fine piece of ornamented bronze casting in the same style as the great drums

sometime between the third and sixth centuries A D; at any rate, by the seventh century a number of Indianized principalities existed in Java. In Sumatra there existed the important but enigmatic Indianized kingdom of Shrivijaya, which exercised such a powerful artistic influence on the whole region. At Palembang, too, by the end of the seventh century there was a renowned Buddhist centre of learning. Indian traditions were extremely attractive to the agricultural populations of these countries. Indian learning, besides offering a script and an administrative system, also offered systems of law, politics, meta-physics, mathematics and astronomy, medicine and practical magic. No doubt the various chieftains who lived in their *kratons* – fortified villages – in the different parts of Java derived great inspiration, prestige and practical assistance from these imported ideas. The local 'dynasties' of the kratons competed for power among themselves, dominating more or less of the countryside as their fortunes rose or waned. No doubt their assimilation of Indian ideology was a major factor in the success of those dynasties which were responsible for the erection of the great stone monuments of central and eastern Java.

Religion, in the sense of earning the patronage of the divine or spiritual forces of the world, is always of prime importance to an ambitious ruler or dynasty. As at Angkor, whose kings learned much from the great kings of Java, the dedication of a finely executed monument is at once a testimony to the faith of the royal patron, and a transcendent source of his power. It is not certain to what extent the rulers of successful Indianized dynasties were of direct Indian stock. But it is more than likely that many ruling families traced their descent to Indian colonists who married native women. In addition, Brahmins from India would

206

have migrated to perform their essential religious functions in a new colony.

Bearing in mind that Javanese traditions – the only ones with any claim to historical interest – are notably vague, the relevant art-history of Indonesia is roughly as follows: The oldest art-works in permanent materials date from a Shiva-worshipping dynasty in central Java, whose last ruler, Sanjaya, retreated to a kraton in the east of Java in the face of the rising power of the central Javanese Shailendra dynasty (AD 778–864). The earliest major cultural assimilations from India took place probably during the seventh century, when the Pallava form of south-east Indian script was adopted for Javanese inscriptions in west Java. It is clear from the style of the earliest monuments, however, that the merchants of the western Deccan and Gujerat were no less active in Indonesia than those of other parts of India. By the time the Shailendra dynasty came on to the scene in central Java, Hīnayāna Buddhism, after having flourished for a while without leaving any substantial artistic remains, was finished in Indonesia. The Shailendra were followers of the Mahāyāna and of the Tantrik Vajrayāna forms of Buddhism. Hinduism, as the worship of Shiva and Vishnu, also remained, and in the later monuments of east Java is intimately mingled with Buddhism.

The Shailendra dynasty became extremely powerful, exercising their sway even over parts of Malaya, and influencing the politics of Cambodia. They seem on occasion to have joined with local rulers in the dedication of monuments. After their eclipse, during the second half of the ninth century, another central Javanese dynasty took over, ruling as well the region of Malang in east Java. There is then a gap in the history, bringing to an end the 'Central Javanese' period of art. By the tenth century the Mataram dynasty was ruling over both eastern and central Java, only to surrender central Java about 930. From then until the thirteenth century, apparently little art of consequence was made in eastern Java or in Bali – which formed part of the kingdom. Only a few monuments survive. In 1222, however,

the major 'East Javanese' period is inaugurated by the dynasty of Singhasāri. In 1293 the dynasty of Majāpahit succeeded, ruling constructively until about the end of the fourteenth century. The epoch of great Indianized monuments was brought to an end in Java by the arrival of Islam from western India in the fifteenth century. Thereafter, the only significant art consisted of *ad hoc* adaptations of old Javanese ornament to the meeting-hall used as a mosque, and to the tomb. There are a few fine examples. Bali, however, did not succumb to Islam. Much Hindu temple art has been continuously produced in Bali right down to the present day, and the problems of its chronology are as yet not properly resolved.

There are a few general observations which may be made about the art of Indianized Java. Stone architecture did not use pillars; nor did the major stone monuments conceptualize hollow space in the way Khmer architecture did. Javanese stone-work is fundamentally solid. As is often the case in India, such monuments are conceived primarily as vehicles for figurative or symbolic sculpture. In eastern Java and Bali, however, the shrine was more often conceived as an enclosure, a walled area of ground which was the sacred element, the buildings in it being of secondary importance. Although, of course, old wooden buildings do not survive, recent examples in Bali, and representations of wooden architecture in old reliefs, show that a tradition existed there of wooden pillared structures with tiered sloping and gabled roofs.

One particular term for a temple will often be met with. This is *chandi*. It refers to a structure based on the Indian type of single-celled shrine, with a pyramidal tower above it, and a portico. Later chandis may have additional external cells on the three walls. A chandi served as a cult focus, housing a potent icon or a group of icons. As in other countries, these were often identified with particular royal persons. The chandi was, like the temple-mountains of Cambodia, a representation of the cosmic Mount Meru, an epitome of the universe. The names Javanese chandis bear are those of popular epic heroes, but as

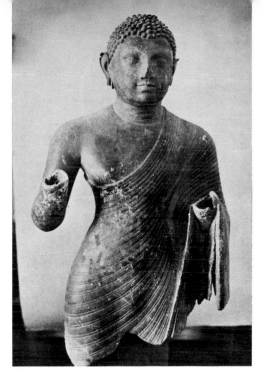

169 Buddha from Celebes. Third to fifth century, bronze, Amarāvatī style, height 75 cm. This unique Buddha may have been cast, if not in India, then in one of the oldest Indian colonies of Southeast Asia

they were only awarded in recent times they are without significance. It is sometimes said that the term *chandi* is derived from the name of a Hindu goddess who presides over the cremation-ground, or the place of the dead, of spirits. This may be recent popular usage applied to any mysterious old monument. Some of the later east Javanese chandis do appear to have been funerary monuments to royalty. But there seems to have been little connexion between the chandi as a temple and actual funeral ceremonies or burials in antiquity.

Probably one of the oldest genuine works of Indianizing art known in Java is a statue of Vishnu, somewhat crude, but distinctly reminiscent of the Pallava style of south-eastern India. Far more beautiful, however, and certainly earlier, is the bronze Buddha found in western Celebes (*Ill. 169*) in the late Amarāvatī style of about AD 300. There is little doubt though, that this work must have been imported – perhaps not from India, but from one of the greater Buddhist centres of Southeast Asia.

To begin the discussion of the Central Javanese period of art, mainly Shaiva Hindu shrines will be dealt with. First is a group of temples situated on the Dieng plateau. This is a high, volcanic region, about six thousand feet above sea-level, where there are sulphur springs and lakes. These features have made it a naturally sacred spot to people with a religion centred on the mountain image. All the Dieng temples are dedicated to Shiva. As their dates are not accurately known it cannot be claimed that they are necessarily earlier than other central Javanese monuments to be discussed later. Some are no doubt younger. Two small, single-cell shrines are Chandi Arjuna (*Ill. 170*) and Chandi Puntadewa (*Ill. 171*). They are both raised on plinths up which the single stairway rises between curved balusters. They were crowned by three stone repeated storeys. Puntadewa, the taller

170 Chandi Arjuna and Chandi Sumar. Dieng plateau. Eighth to ninth century. These early Javanese temples follow the same pattern of repeated, diminishing storeys as the early shrines of Cambodia and Champa

in proportion, is the more elegant. The niches are framed in hood-mouldings formed from the savage mask of the *kirti-mukha*, with floral scrolls at the feet of the pilasters (*Ill. 171*). The deep horizontal mouldings which punctuate the elements of the design are beautiful and simply conceived. Indeed many of the best qualities of Javanese architecture are here apparent at once. These buildings make their effect through their exquisite proportions rather than through any luxuriance of ornament, and there is a complete equality on vertical and horizontal elements. Once, certainly, they did bear a certain amount of sculpture which has since been removed. Chandi Bima, another Dieng temple, is in an entirely different style. Its plain walls do not stand on a plinth, but a plinth-effect is included in the plain mouldings of the walls of the cell. The tower is a tall pyramid, faced with rising tiers of blind arcades,

171 Chandi Puntadewa, niche. Ninth century. The characteristic Javanese door-frame. The Kāla (time) monster vomits out foliage which terminates in scroll cartouches that may also resemble monster heads in profile

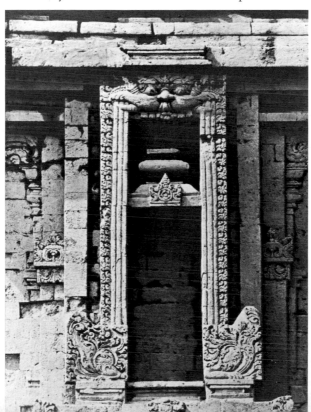

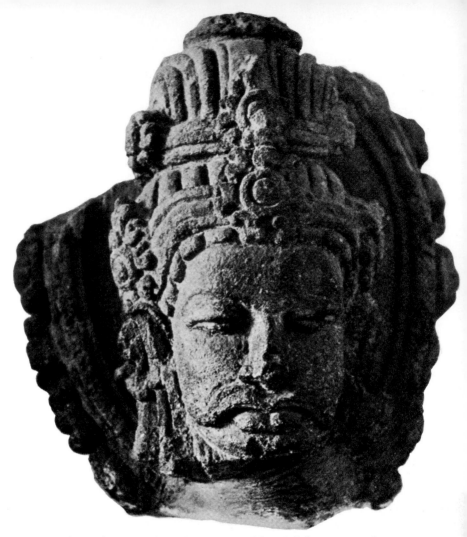

172 Shiva from Dieng plateau. Possibly eighth century, lava stone, 30·5 cm. One of the few sculptures from the Dieng. Such figures may well have been the prototypes for the Shivas of Champa (cf. *Ill. 115*)

and at the corners are engaged motifs derived from a highly ornate form of pillar–capital probably indigenous to the western Deccan. Most powerful and impressive is a statue of seated Shiva found on the Dieng (*Ill. 172*), almost intact. The Indonesian style here is highly evolved, and the figure must be close in date to Borobudur.

The few small temples from eastern Java that belong to the Central Javanese period are not fundamentally different from some of those of the Dieng, and clearly follow central Javanese traditions. They do, however, feature triangular cartouches of ornament set along the upper mouldings, rising above them, in a fashion more familiar from Indochina. The earliest probably date to about A D 732, which is the date of the earliest inscription, and the chief group is north-west of Malang, including Chandi Badut and Chandi Sanggariti.

Returning to the principal central Javanese monuments of the Shailendras, a Shaiva group on Mount Ungaran south of Semarang claims attention. Here, on the fringes of a valley with sulphur springs and looking out over the fertile plain are nine groups of temples. Perhaps the most beautiful of them is temple II of the Gedong Sanga group (*Ill. 173*). This building

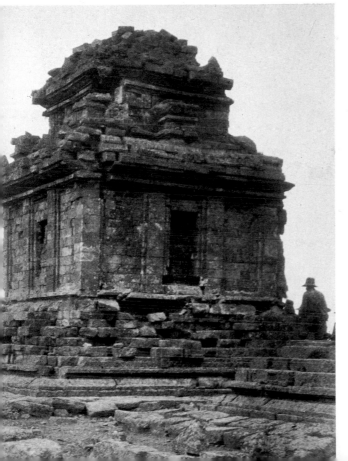

173 Temple II of Gedong Sanga. Possibly ninth century. One of several temples on a site sacred for being on a volcanic mountain at whose foot rise sulphur springs

in general resembles the Dieng temples, but there are certain marked differences in the ornamental style. First, there is more emphasis upon the raised triangular cartouches along the mouldings. Second, the horizontal bands of mouldings which mark the divisions of the monument are much simplified, not elaborately profiled as they are in the Dieng buildings. There are also passages of diaper ornament incised on to some of the faces of the tower storeys and the door jambs – a common feature of later works. And finally, the roof of the porch is fronted not by a flat triangular pediment, but by a gently bowed lintel-curve with scrolled-up ends.

In the mountainous regions of central Java there have been found remains, more or less fragmentary, of other Hindu shrines and of sculptures which originally belonged to them. Chandi Pringapus, north of Parakan, is one, which, together with the ruins of another small shrine near by, can probably be dated to about AD 850. Pringapus still contains its fine image of Shiva's bull, which is always supposed to lie facing the main cell. But the most interesting items are perhaps the beautiful, regular, scrolled arabesques on the side and rear walls, and the figures of celestials in very low relief on the walls of the porch. Among them are those most necessary ingredients of heavenly court life – musicians, one with a miniature pipe-organ from which springs, almost as if it were music, a very fine flower-scroll, and a couple of beautiful lovers, the man with his arm round the woman and holding her breast.

From another ruined Shiva temple not far from Borobudur itself, has come a group of extremely fine life-size iconic sculptures, virtually in the full-round. The Vishnu (*Ill. 175*) has the extremely smooth, faintly amorphous suavity, the absolute convexity, and the lack of definition between planes of the classical central Javanese style, while the garments he wears, with the assortment of girdles, are closely reminiscent of the Pallava–early Chola styles of south-east India. Another, the Divine Teacher (*Ill. 174*), sometimes called Agastya, represents the god Shiva taking the form of a bearded Brahmin sage with

174–5 Two of the most majestic early icons from Java. They show the Central Javanese style fully fledged: 174 Divine teacher from Chandi Banon. Ninth century, height 196 cm. 175 Vishnu from Chandi Banon. Ninth century, height 206 cm

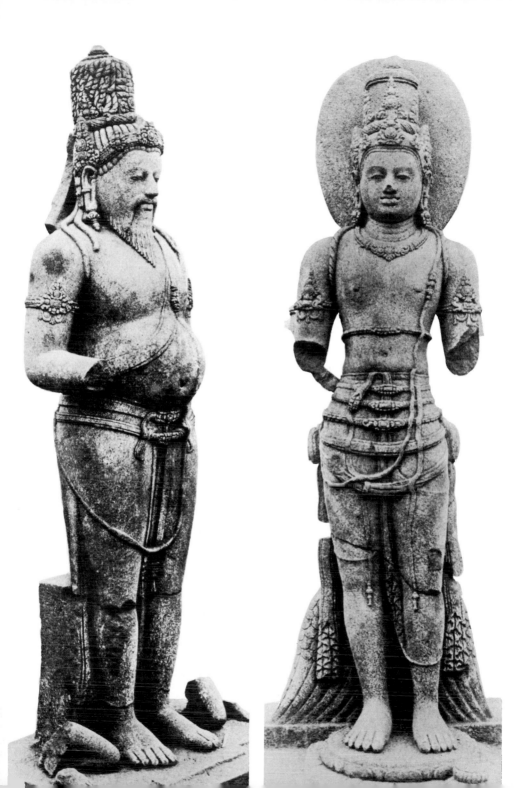

a large (and to an Oriental splendid because well-filled) pot-belly. This icon too is indigenous to south-east India. The great depth of the side recessions of these figures, although it is perhaps not so clearly defined as in the great Fou Nan-Chen La style, gives them a bland massiveness. The lack of movement, the impassive faces and the 'slowness' of the lines are part of the central Javanese conception of transcendent glory, and the regularity of the designs part of the indigenous Indonesian structure of artistic form.

The Hindu temples of central Java conform, as they must, to the general pattern of Indian shrine. It is true that in India the environment of the shrine was often vastly enlarged by the addition of porticos and ambulatories, courts, gate-towers and tanks; but the fundamental conception of the shrine itself always remained the same. The germ of divinity contained within the icon under its tower lay there as if it were radioactive, its energy radiating into the countryside. Certainly, to multiply divine images of this kind was to multiply the energy, but there was no need to complicate the structure of the main shrine. In the case of Mahāyāna and Vajrayāna Buddhism, however, art was called upon to do something more. It was required to provide a visual expression of complex metaphysical theories. In central Java we have a series of monuments based on this far broader conception of the rôle of art. The culminating work of the series, Borobudur, is a highly evolved image of a subtlety and refinement never matched, even by Angkor Thom four centuries later.

The first work of this series is Chandi Ngawen, near Muntilan. This chandi consists of five shrines standing in a row from north to south, each some twelve feet from the next. There are five shrines in the group because, according to Vajrayāna theory, there are five Buddhas, each of whom presides over one of the five major psychological categories under which ultimate reality shows itself. These five are called for convenience the Dhyāni Buddhas. This group, and their realms, are called the Vajradhātu, a term which is hardly translatable. 'Dhatu' means

'realm'. 'Vajra' has all of the following meanings, welded together – 'diamond', 'thunderbolt', 'male organ', 'unbreakably hard'. The shrines of Chandi Ngawen are based on, but more developed than, those used for Hindu deities. They stand on plinths, are more or less square in plan, and are roofed with diminishing storeys. There are pilastered projections on three faces, and a portico on the east. There are small triangular antefixes along the architrave, while reliefs of kirtimukhas vomiting floral scrolls hood the niches and portals. On plinth-level at the top of the approach stairs, stands a pair of small separate buildings flanking and supporting the gate with its decorated lintel. They must ultimately refer back to the pavilions sheltering figures of door-guardians on Indian shrines at the great sacred city of Mathura in the first to second centuries A D. At the corners of the plinth are engaged figures of lions of sub-Pallava type, whose roaring is a standard symbol for the pro-clamation of the Buddhist doctrine.

There is in old Javanese theology a further grouping of Buddhist divine principles. Whereas the Vajradhātu group may be imagined as horizontal, the Garbhadhātu group is, as it were, placed vertically above them. 'Garbha' means 'womb' or 'innermost secret'. According to Javanese Tantrik tradition, in the Garbhadhātu the Buddha nature, which is the ultimate reality of the Universe, is presented by a majestic preaching Buddha, who has two divine personalized projections. The one from his right side is Lokeshvara, Lord of the Worlds, who, as a Bodhisattva, is both compassionate and possessed of all power. Lokeshvara was employed at Angkor as transcendent *persona* of the Khmer emperor, but there he was not incor-porated into so systematic a theology as he is in Java. The projection on the Buddha's left hand is the Bodhisattva Vajrapāṇi – he who holds a *Vajra* in his hand. The symbolic Vajra resembles a double-ended trident, and is probably derived at long range from the classical Greek thunderbolt wielded by Zeus. Vajrapāṇi is the embodiment of the most secret doctrines and practices of Vajrayāna Buddhism. One of Java's greatest

176 Chandi
Mendut, view from
the north. *c.* 800.
This great shrine
was built to house a
group of sculptures
representing one of
Buddhism's most
esoteric doctrines

218

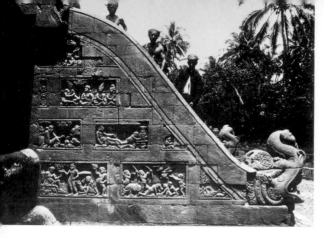

monuments, Chandi Mendut (*Ill. 176*), is a shrine expressly
created to illustrate the combined doctrine of Garbhadhātu and
Vajradhātu.

Mendut dates from about AD 800 and is thus, generally
speaking, contemporary with Borobudur. It is formed as a
single large, square chamber, roofed with diminishing storeys

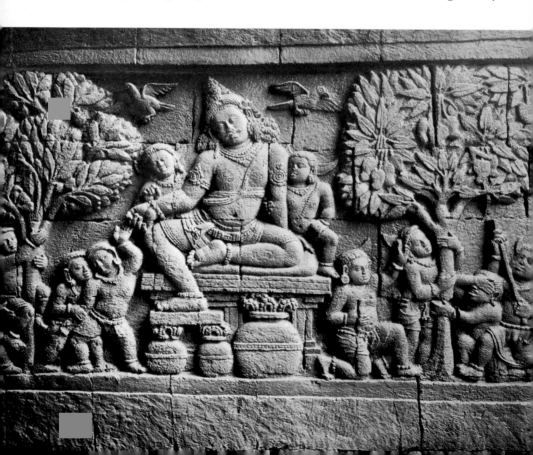

of the usual Javanese type. It is mounted on a high, broad plinth, which is approached on its north-western face by a staircase with re-curved balustrades. The exterior is in every way more ornate than on any shrines so far discussed. As well as floral diaper and scrolls, there are numerous figures in relief (*Ill. 179*) that represent Bodhisattvas, male and female deities, the subsidiary principles of this form of Buddhism. Cut into the fine ashlar masonry are many relief panels (*Ills. 177, 178*), each self-contained and placed with consummate aesthetic judgment, containing subjects and scenes from Buddhist literature. Some represent mythical ideas, like the wish-granting tree, others narratives of one sort or another from Buddhist legend. The principal images, however, were inside, set into the cell-chamber. Apparently there were originally seven huge stone icons; four seem to have gone from their niches – the two outermost Dhyāni Buddhas on each side. Thus the Vajradhātu series

◄ 178 (*left*) Chandi Mendut, bas-relief: Kuvera, on the north wall of an ante-chamber. Kuvera is the God of Wealth, the merchants' deity, and has sacks of gold under his feet and wish-granting trees beside him

179 (*right*) Chandi Mendut, Buddhist deity. The Bodhisattva of compassion holds a lotus flower

is incomplete. The centre Buddha (*Ill. 180*), however, who also represented the ultimate Buddha nature, and his two projections in the Garbhadhātu, Lokeshvara (*Ill. 181*) and Vajrapāṇi, are magnificently present. When the entire set was there the interior of Mendut must have been an awe-inspiring and spiritually moving place. It is so even now. The three great statues are seated on elaborate thrones, backed against the walls,

180 Chandi Mendut, Buddha. The great central icon which personifies the ultimate nature of enlightenment

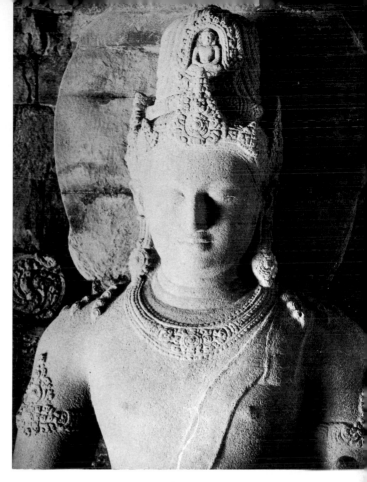

181 Chandi Mendut, Lokeshvara. This Bodhisattva is a personification of the Buddha's royal compassion. The superbly achieved continuity of surface can be seen very well

but the figures are virtually full-round. The central one, of the Buddha, is in a plain robe modelled close to the body; the other two wear crowns and jewels. It is a striking fact that the type and cutting of these figures is more reminiscent of contemporary work in the cave-temples of the western Deccan than of anything from other parts of India. These Mendut figures are conceived on that same monumental scale. It would not be correct to read (as some scholars have done) much more than a general expression of serenity into the faces of these images. But bliss and serenity, in their highest, most general terms, are the essential attributes of the divine, according to the thought of this tradition.

223

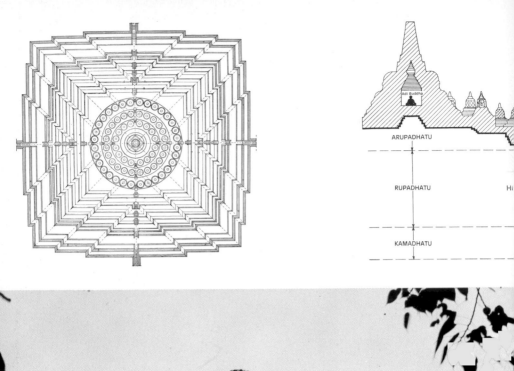

ARUPADHATU

RUPADHATU

Hi

KAMADHATU

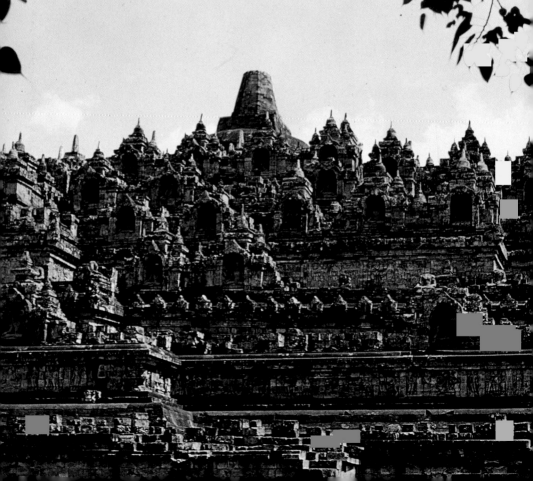

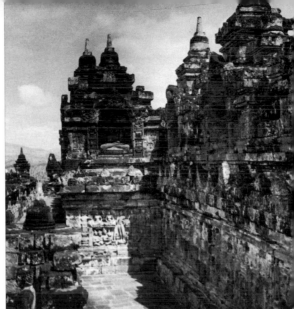

182 (*above left*) Borobudur, plan.
c. 800. The circular terraces crown
the square ones

183 (*above centre*) Borobudur,
section. This shows how the
bottom terrace has been added to
contain the outward thrust of the
artificial mountain, obscuring the
lowest range of reliefs

185 (*above right*) Borobudur,
view of a terrace. The pilgrim
perambulating these terraces could
read in images a comprehensive
summary of his religious doctrine

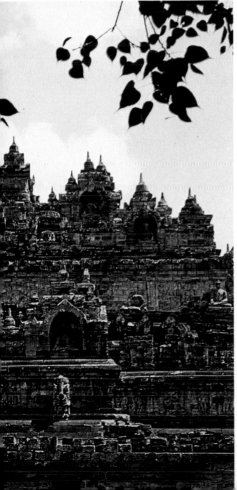

184 (*left*) Borobudur, general
view. This colossal Buddhist
temple-mountain was perhaps
the prototype for the Hindu
temple-mountains of the Khmers

225

On the west–east road from Chandi Mendut to Borobudur
stands a small, relatively plain temple called Chandi Pawon
(*Ill. 186*), dedicated to Kuvera, the god of wealth. It was not
accidental that in all Buddhist countries of the Indian circle, the
deity of wealth played an important rôle; for initially Buddhism
was a merchants' religion, spreading along the trade-routes of
the ancient world. Pawon was probably a kind of ante-room to
Borobudur, catering to the more worldly interests of pilgrims.
The outside bears extremely fine reliefs of female figures
within pillared frames of Indian type, and the roof bears tiers of
small stupas. Among the reliefs too are wish-granting trees sur-
rounded by pots of money, and bearded dwarfs over the
entrance pour out jewels from sacks.

186 Chandi Pawon, view from the rear. This little shrine was an annexe to
Borobudur, where pilgrims could pay their respects to the god of worldly
wealth

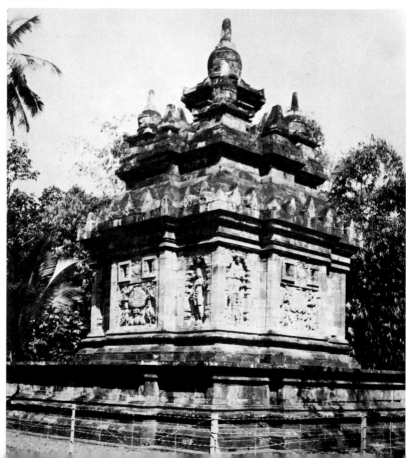

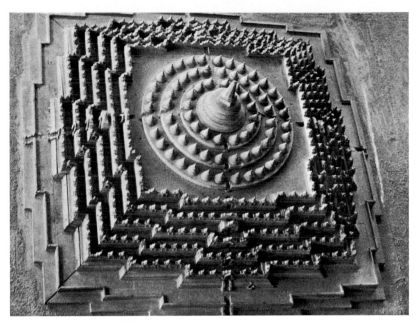

187 Borobudur, model

Borobudur (*Ill. 187*) is one of the most impressive monuments ever created by man. It is both a temple and a complete exposition of doctrine, designed as a whole, and completed as designed, with only one major afterthought. It seems to have provided a pattern for the temple-mountains of Angkor (*Ill. 183*), and it must have been in its own day one of the wonders of the Asiatic world. Built about AD 800, it probably fell into neglect by about 1000 and was overgrown. It was finely excavated and restored by the Dutch administration in 1907–11. Physically it now appears as a large, square plinth (the processional path) upon which stand five gradually diminishing terraces (*Ill. 182*). The plans of the squares are stepped-out twice to their central projection. On the sixth terrace stands a series of three circular diminishing terraces, crowned by a large circular stupa. Up the centre of each face, from top to bottom, runs a long staircase, none of the four taking precedence over the others as 'main entrance'. There are no internal cell-shrines.

In these respects Borobudur is a Buddhist stupa in the Indian sense. Each of the square terraces is enclosed by a high wall with pavilions and niches along the whole perimeter, which prevents the visitor on one level from seeing into any of the other levels (*Ill. 185*). All these terraces are lined with relief sculptures, the niches containing Buddha figures (*Ill. 187*). The top three circular terraces are open and unwalled, and support a total of seventy-two lesser stupas made of stone open latticework, inside each of which was a huge stone figure of the Buddha. The convex contour of the whole is steepest nearer the ground, flattening as it reaches the summit (*Ill. 183*). The bottom plinth, the processional path, was the major afterthought. It is made of a massive heap of stone pressed up against the original bottom storey of the designed structure, so that it actually obscures an entire series of reliefs – a few of which have been uncovered today. The reason for this afterthought is most probably technical. It seems that the bottom storey, that with an almost vertical face, may have begun to bulge and spread under the pressure of the immense weight of earth and stone above. The plinth may therefore have been added to buttress the perimeter of the base, and prevent the whole structure from shifting disastrously. There are some who have suggested other reasons for its presence, one of them symbolic, but the engineering explanation is convincing enough.

The symbolic structure of the monument is as follows: The whole building represents a Buddhist transition from the lowest manifestations of reality at the base, up through a series of 'regions' or psychological states, towards the ultimate condition of spiritual enlightenment and release from corruption and error at the summit. At the same time, since the monument is a unity, it effectively proclaims the doctrine of the unity of the Cosmos in the light of Truth, and does not – as other religions may – banish 'the world, the flesh and the devil' to an eternally 'different', negative region. In this Buddhist doctrine not only is the entire creation redemptible, it has never been anything but redeemed, and the ordinary state of existence is, if

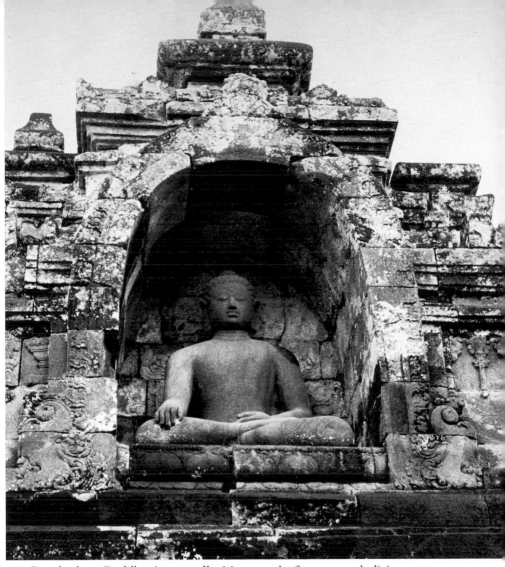

188 Borobudur, Buddha in a wall. Many such figures symbolizing projections of the single Buddha-nature preside over the terraces

only we have the eyes to see it, no different from the state of enlightened bliss. The difference between enlightenment and ordinary corrupt life is not a difference in the world, but in the eye and mind of each beholder. Someone who has reached the top of Borobudur should be a different person from the one

who started up. Thus the topmost terrace with its round stupa containing an unfinished and invisible image of the Buddha, symbolizes the ultimate spiritual truth; the seventy-two open-work stupas on the other circular terraces with their hardly visible internal Buddha forms symbolize the states of enlightenment not quite fully consummated (*Ill. 201*). Over the four sides of the square terraces preside a large number of niched figures of the Dhyāni Buddhas, in forms appropriate to the realms at the level of which they appear – as transcendent on the upper stages, as 'human' on the lower stages.

The usual way for a pilgrim to pay reverence to a Buddhist stupa is to walk around it, keeping it on his right hand. All the terraces of Borobudur have on their outward-facing walls a vast series of reliefs about three feet high, which would be read by the visitor in series from right to left. Between the reliefs are decorative scroll panels; and a hundred huge monster-head waterspouts carry off the tropical rainwater. The gates on the stairways between terraces are of the standard Indonesian type; they have a face of the horrific Kāla-monster in relief at the apex, vomiting scrolls which run down the jambs to terminate in out-turned heads of aquatic makara-monsters at the foot (*Ill. 189*). There may appear in the two spandrels of the arch a pair of attractive small figures of bearded sages opening curtains, as if to open for the visitor the next level of vision (*Ill. 194*). The reliefs of the lowest level of all (*Ill. 190*), those which were later hidden by the added processional path, are in many ways the most interesting. They are devoted to a whole series of scenes, taken from the Karmavibhanga text, which illustrate the casual workings of good and especially of bad deeds in successive reincarnations. They show, for example, how those who hunt, kill and cook living creatures such as tortoises and fish are themselves cooked in hells, or die as children in their next life. They show the matricide tormented by a demon in hell. They also show how inferior people waste their time at entertainments like idle music and juggling. It has been suggested that the obscuring plinth was added because it was not

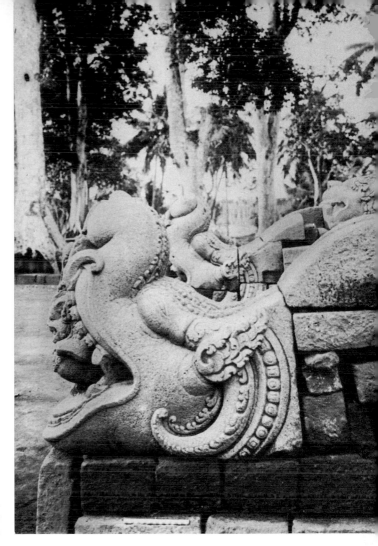

189 Borobudur, a makara terminal. These monster-heads terminate the stair balustrades

considered suitable that people should *see* these scenes, and that the place for them was underground. This is a most unlikely hypothesis, for these lowest scenes contain the most immediately valuable popular exposition of Buddhist morality.

It is easier to make vice look interesting than virtue, and the liveliness of the sculptures devoted to wickedness is in marked contrast to the progressive orderliness and – it must be admitted –

231

190 Borobudur, bas–relief showing the type of vessel that traded among the islands of the South Seas, and transported the Indian colonists. It has both outriggers and a complex sail system

191 Borobudur, bas–relief showing a religious discussion in the jewelled tranquillity of paradise

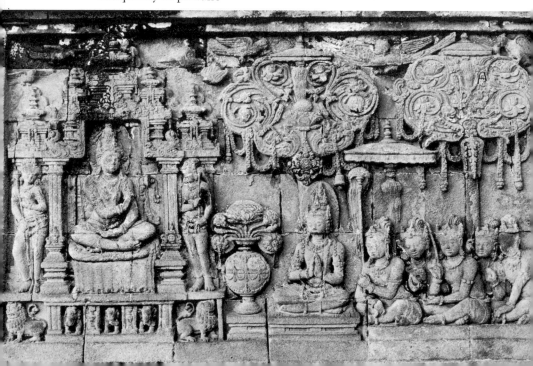

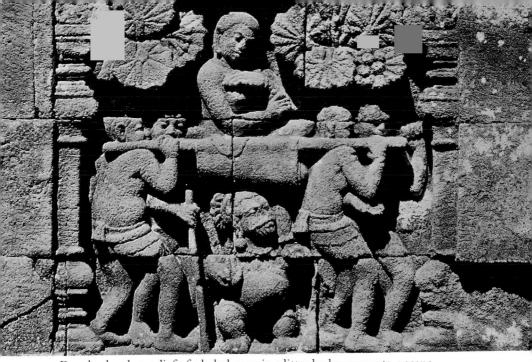

192 Borobudur, bas-relief of a lady borne in a litter by her servants, a scene from a Buddhist story showing everyday life

193 Borobudur, bas-relief of a king and queen receiving another lady at their court. Musicians holding different instruments squat beside the throne-dais

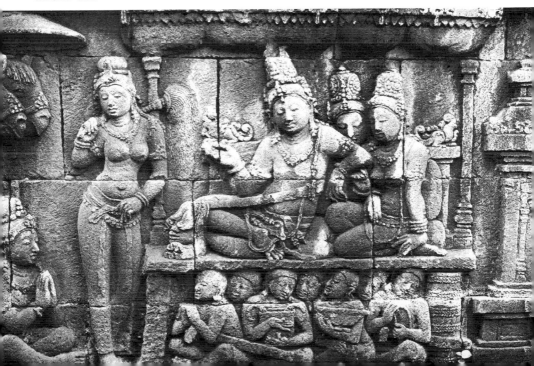

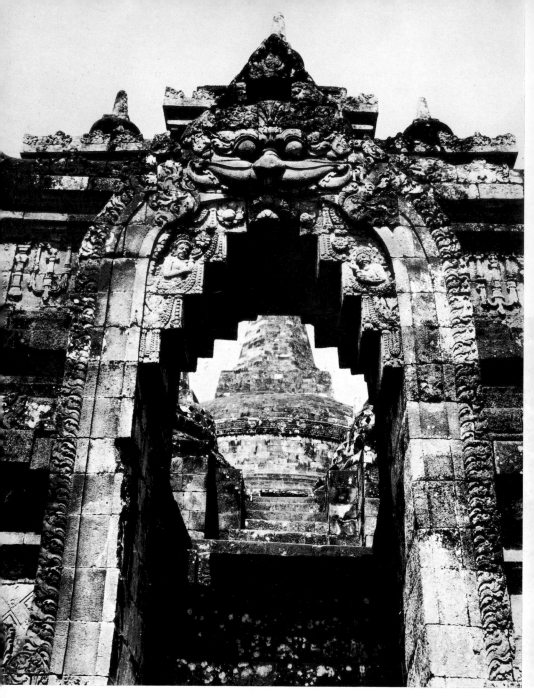

increasing monotony of the series above devoted to the glories
of the virtuous life. On the first terrace is a long series of scenes
devoted to the life of the Buddha and to stories of his earlier
incarnations called *Jātakas*. These (*Ills. 192, 195*) do still have
considerable vigour. On the terraces above (*Ill. 191*) are
illustrations to important Mahāyāna texts dealing with the self-
discovery and the education of the Bodhisattva, as a being
possessed by compassion for and devoted wholly to the salva-
tion of all creatures. The second gallery is especially notable for
its visions of paradise (relatively low in the Buddhist scale)

194 (*left*) Borobudur, a gateway from one terrace to another. Bearded
sages draw back jewel-curtains to reveal the next stage of the doctrine

195 Borobudur, bas-relief showing elephants and monkeys at play in the
forest

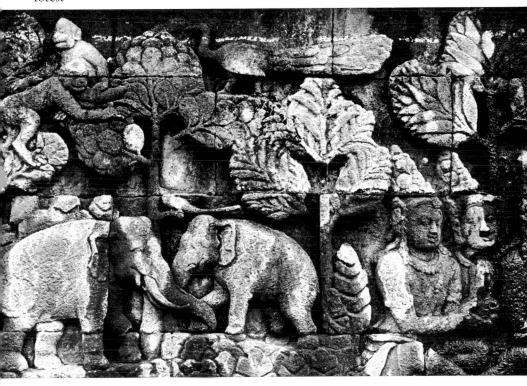

196 Buddha from Kota
Bangun, Borneo. Ninth
century, bronze, height 58 cm.
An unique large casting,
reminiscent of the Gupta style
of Indian bronze sculpture

198 (*above, far right*) Lamp from
eastern Java, Garuḍa carrying
a woman. Probably fifteenth
century, bronze, height 61 cm.
This type of three-dimensional
ornament symbolizes the
celestial regions. It may have
been the inspiration for similar
ornament in Thailand and
Burma

199 (*below, far right*) Priest's
bell. Bronze, height 18·5 cm.
The handle of this bell
symbolizes the masculine,
thunderbolt-like jewel of
Buddhist insight. The faces
indicate the royal power of the
doctrine, the sound of the bell
its ring of truth. The faces
recall both those on the 'Moon
of Bali' (*Ills. 5, 6*) and those on
the towers of the Bayon at
Angkor

197 Manjushri from
Ngemplaksemangan. Early
tenth century, silver, height
28 cm. One of the finest pieces
of art in precious metal from
the Eastern world

236

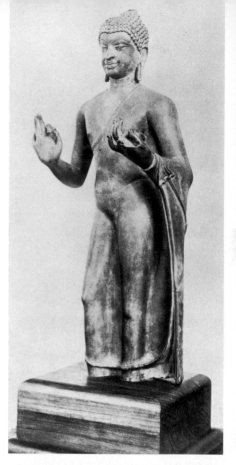

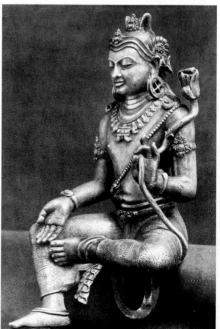

200 Buddha from central Java. Eighth century, bronze, height 19 cm. A miniature version of the kind of Buddha carved in stone at the summit of Borobudur

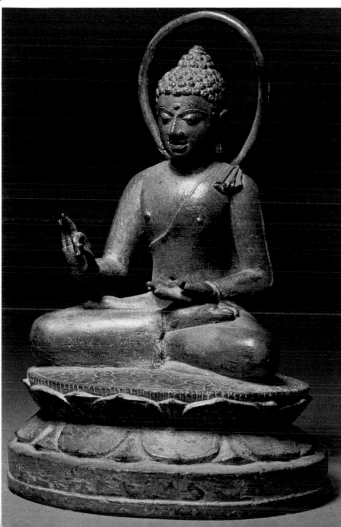

where personages gorgeously jewelled sit conversing or listening to the Truth under magnificently ornate pavilions, among trees whose foliage has turned into patterned scrolls from which hang fruit-like strings of gems (*Ill. 191*). The long-drawn-out approach to the summit, round terrace after terrace, is marked by the progressive stilling into a static order of the sculptural designs. The sensuous roundness of the forms of the figures is scarcely abated, but the emphasis upon horizontals and verticals, upon static formal enclosures and upon the repetition of figures and gestures becomes more and more

201 Borobudur, stupas on the circular terraces. View of the topmost terraces of Borobudur, showing how the openwork stupas contain Buddha figures

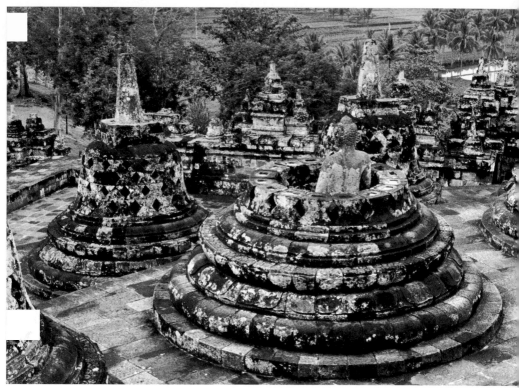

marked as one approaches the summit. There all movement disappears, and design submits entirely to the circle enclosing the stupa.

It hardly seems possible that Borobudur was the focus of a specific royal cult, as there is no provision at all for the performance of royal rituals. It must have been in some sense a monument for the whole people, forming the focus for their religion and life, and constituting a perpetual reminder of the doctrines of their religion.

In an art-style very close to that of the sculptures of Borobudur and Chandi Mendut, are a considerable number of bronzes, some small, some large. One fine large standing image comes from Kota Bangun in Borneo (*Ill. 196*); but most come from Java. Many small cult images of the Buddha and of Buddhist deities exist (*Ill. 197*); many show the Buddha seated inside an aureole (*Ill. 200*). They are very close in type to the early Pāla images of Indian Bihar, the homeland of Buddhism with which the Javanese must have maintained close touch. As small bronzes could easily be transported back home, it is likely that the Javanese would have been able to make far closer imitations of the Indian originals in their own small bronzes than they would in their larger works. It may well be that some of the small bronzes found in Java were actually made in India. A few small but extremely fine gold figurines of undoubted Javanese workmanship have also turned up. For all their small size they must rate as first-class works of art.

Not all the bronzes are purely figurative. Among the objects found are some extremely beautiful bells (*Ill. 199*), lamp handles (*Ill. 198*), and Vajra emblems. Their forms, although they may include figures, are mainly compounded of elements of the decorative repertoire – scrolled leaves, swags and bands of 'jewels', curvilinear stems and petal forms, sprouting shoots and so on. Flat trays of bronze with extremely beautiful incised designs of lotuses have been found too. These were used by the higher grade of monks to set out their bowl, bell and incense-burner.

Finally one bronze must be selected as a particularly splendid piece. It is the Avalokiteshvara from Tekaran, in Surakarta (*Ill. 202*), the largest bronze so far known from Indonesia, except for the imported Celebes Buddha. The bronze was entirely plated in silver and supported inside by an iron frame. The finish of the surface is superb; the design of the big loops of ornament echoes the broad rounded shapes of the volumes of the body and limbs. The finesse of the chasing of features and hair is extreme. It is one of the world's masterpieces of art.

To some extent one may feel that the history of Indonesian art after Borobudur can only represent something of an anti-climax. But there seems to have been no decline in the creative urge and the skill of the central Javanese artists. It is true that there was an increasing emphasis on decorative motifs in both architecture and sculpture, but the decoration is excellent, and is only offset by a slight weakening and generalization of the treatment of plastic volumes. Among the later art of central Java are a number of outstanding masterpieces. One of them is Chandi Kalasan (*Ills. 203, 204*).

Kalasan lies between Prambanam, where there is another major temple group, and Jogjakarta. It is only partly restored. Some earlier scholars have accepted that an inscription, dis-covered near Chandi Kalasan and dated A D 778, referring to the foundation of a Buddhist temple, actually refers to Kalasan, thus making it one of the few fixed dating points in Javanese art-history. Unfortunately the present Chandi Kalasan encloses substantial remains of far older structures, and there can be little doubt that it is of a date considerably later than Borobudur, probably about A D 850–70. Kalasan was a large square shrine on a plinth, with projecting porticos at the centre of each face. Only the southern one remains intact. The roof was surmounted by a high circular stupa, mounted on an octagonal drum, the faces of which bear reliefs of divinities. Surmounting each portico there was apparently a group of five small stupas, and at each disengaged corner of the main shrine another larger stupa. The horizontal mouldings at the base and architrave are finely

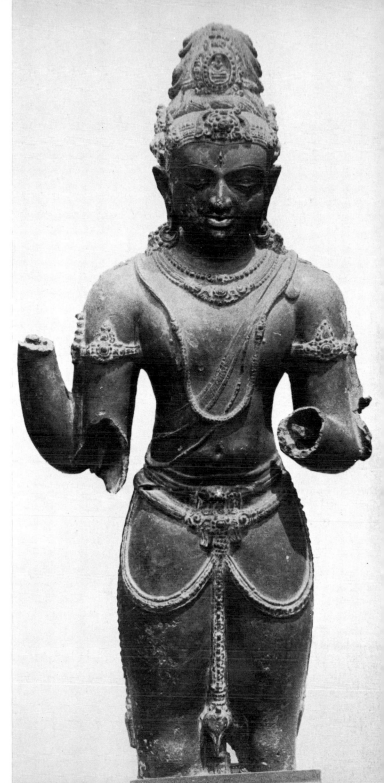

202 Avalokite-
shvara from
Tekaran. Ninth to
tenth century,
bronze, silver-
plated, height 83 cm.
A large and perfect
casting such as this
must have
demanded an
extraordinary
technical skill

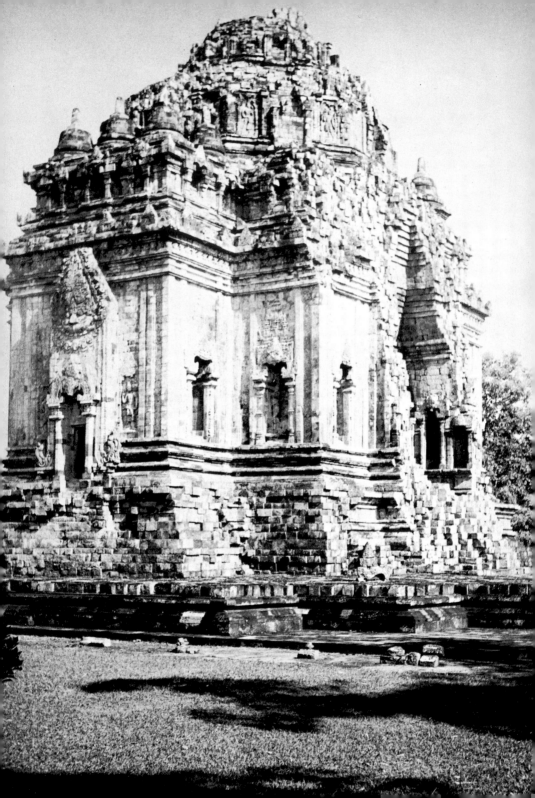

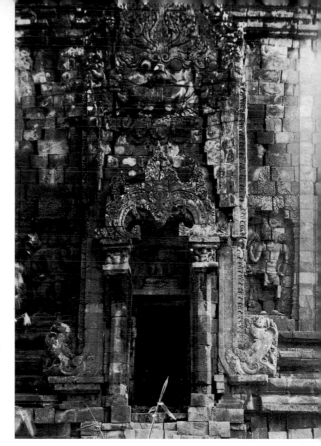

203 (*left*) Chandi Kalasan, view from south-east. Probably mid-ninth century

204 Chandi Kalasan, detail of south façade

Although the decoration is purely Indonesian, there are in this building suggestions of direct contact with south-eastern India

profiled. Each section of the exterior wall contains a niche – once meant for a figure sculpture (*Ill. 204*) – framed in a pair of engaged octagonal columns with profiled base, rings and capitals. Above, in relief, is the Kāla face bearing a towering pavilion-motif. Above the surviving portico, the Kāla is raised on to a splendid antefix-like plaque. The ornamental carving of the scroll-work, and the figure carving – which is strikingly reminiscent of south-east Indian contemporary work – are finely executed. It is worth mentioning that the resemblances between Javanese work and different types of Indian art must have some historical rationale. Unfortunately, knowledge of the details of the Shailendra history, and of the sequence of foreign contacts made by the dynasty, is inadequate for an historical explanation of these stylistic similarities.

243

Another ninth-century temple group, similar in pattern to Kalasan but far larger, is Chandi Sewu (*Ills. 205–7*). It is composed of a main shrine with all of its four porches extended and separated from it by a passage so that they form separate chapels. This complex is surrounded by smaller temples, only one of which has been restored. The main shrine is much collapsed; but

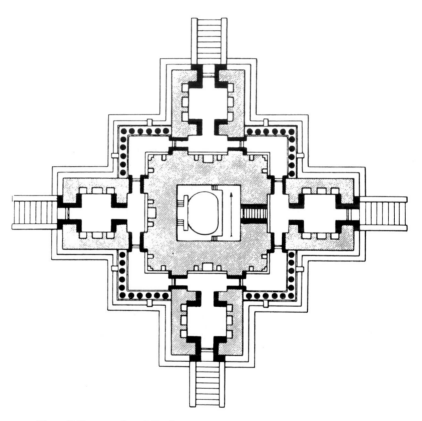

205 Chandi Sewu, plan. Ninth century

206 (*right*) Chandi Sewu, one of the minor temples ▶

The interesting plan of this complex makes one regret that only one of its chapels survives. It seems to have been a kind of condensation of the scheme of Borobudur

from one small surviving temple (*Ill. 206*) and the parts of the main shrine it is possible to estimate that the square shrine on its plinth, with two highly compressed square storeys above, was roofed by circles of small stupas mounted in tiers, surmounted by a terminal large stupa – in effect the general scheme of Borobudur compressed into the narrow scope of a shrine.

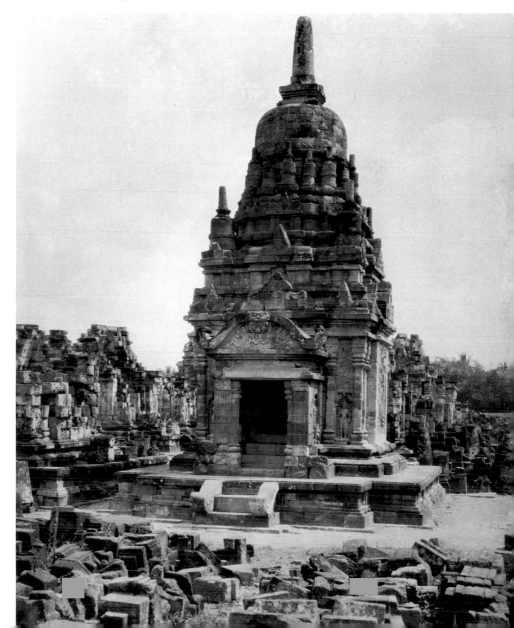

207 Chandi Sewu, one of the raksasa guardians. These colossal demons protected the temple from the intrusion of evil spirits

208 Chandi Sewu. One of the partly ruined shrines

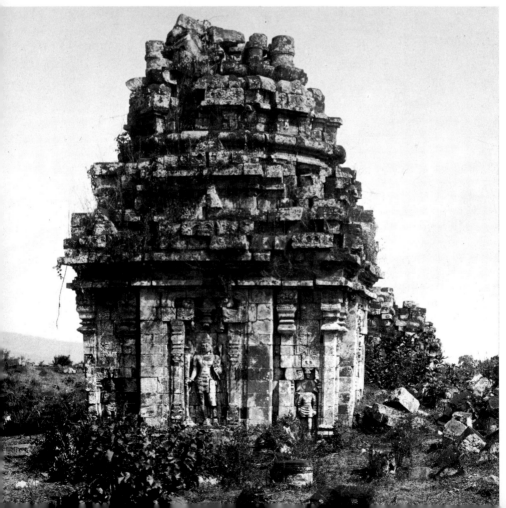

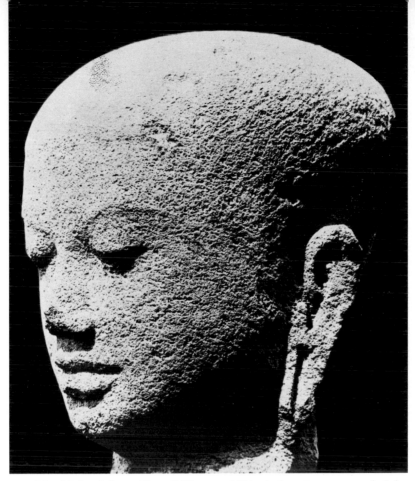

209 Monk's head from Chandi Plaosan. Mid-ninth century, stone, height 27 cm. This head captures the serenity characteristic of the spiritually advanced Buddhist monk

Sewu's sculpture (*Ill. 207*), especially the main Buddha icon, while it resembles Borobudur work in general, is far less skilful plastically, and appears lumpish and uncertain by comparison. Far more impressive are the sculptures from the ruined Chandi Plaosan. Here were some beautiful donor figures, and iconic images of Bodhisattvas. One head of a monk is justly famous for its blissful, self-contained, unworldly expression, achieved with delicate but subtle inflections of the surface of the rough stone (*Ill. 209*).

A variant type of ninth-century Buddhist shrine, where again the sculptures are of a high quality, is Chandi Sari (*Ills. 210, 211*). This is an interesting architectural invention. From the outside it appears as a large, rectangular three-storeyed block, with the main entrance piercing the centre of one of the longer sides. The third storey stands above a substantial architrave with horizontal mouldings and antefixes. Windows – two on each short side, three on each long – open into each storey though they are blind at the rear side. They are crowned by

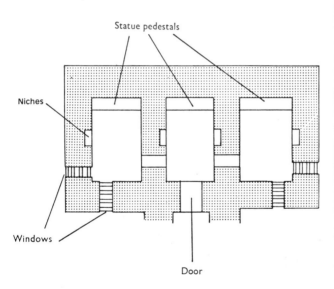

210 Chandi Sari, plan. Ninth century

211 Chandi Sari, view from the north-east

This is a unique type of building. Externally it resembles a house with three storeys and windows, although this pattern is not rationalized internally. Once again, stupas crown it, and it resembles a hollowed-out version of Borobudur

248

large antefix-like cartouches of ornamental carving based on curvilinear pavilions hung with strings of gems. The uppermost windows are hooded with the kirtimukha motif. The roof bears rows of small stupas, and perhaps there was once a central large stupa. Alongside each window-opening are pairs of figures representing heavenly beings.

Inside, Chandi Sari contains a processional corridor around three interior shrines, possibly for images of the Buddha and two Bodhisattvas, as at Chandi Mendut, but the images are gone.

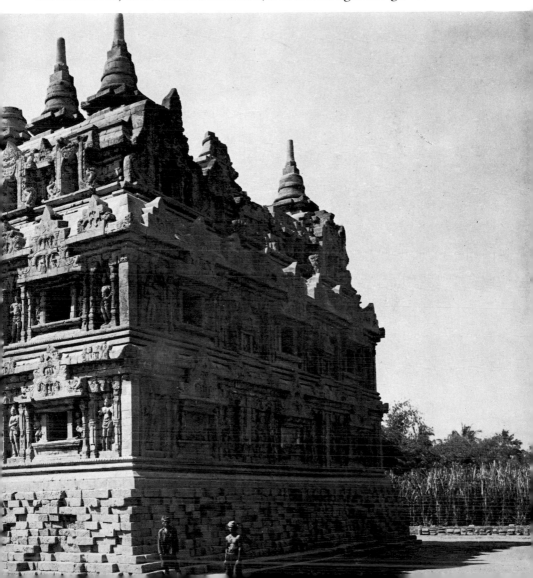

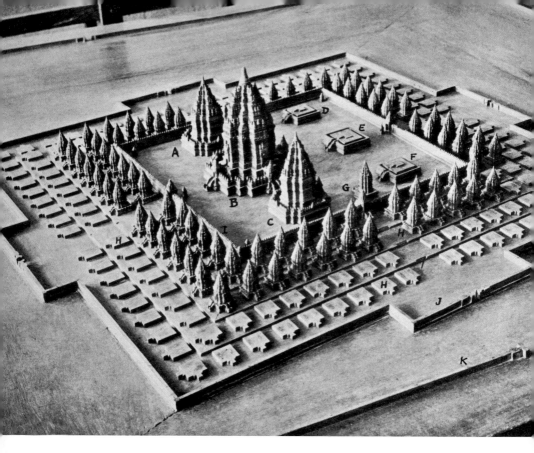

The last great monument of the Central Javanese period is indeed a colossal work, probably but not certainly built soon after 900, and before 930 when the kings retreated from central to eastern Java. It is not Buddhist, but Shaiva, and represents once more the shrine in the form of the cosmic mountain. It is called Lara Jonggrang at Prambanam (*Ills. 212–16*). There were originally no less than 232 temples incorporated into the design. The plan was centred on a square court with four gates containing the eight principal temples. The central one, the largest, about 120 feet high, was devoted to the icon of Shiva, and faces east. To north and south it is flanked by slightly smaller temples to the two other members of the Hindu trinity, Vishnu and Brahmā. Facing it is the usual pavilion containing a statue of

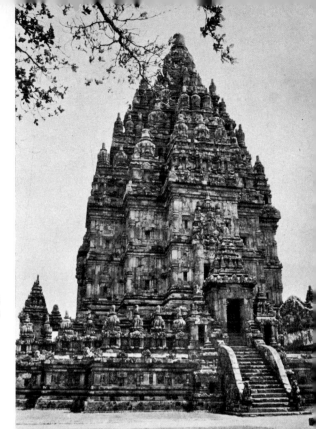

212 (*left*) Chandi Lara
Jonggrang, Prambanam, model

213 (*right*) Chandi Lara
Jonggrang, Temple of Shiva

This colossal temple complex is
Hindu; its three main shrines are
dedicated to the Hindu Trinity;
Vishnu, Brahmā, and the largest
to Shiva. Architectural forms
originally modified for Buddhist
use, are readapted to Hindu
building. Probably 900–30

Nandi, Shiva's bull-emblem. Flanking this, each facing the
Vishnu and Brahmā shrines, are shrines for two other 'forms' of
Shiva. At extreme north and south lie two still smaller shrines
whose purpose is unknown. The inner court is contained within
a second square, gated outer court, and between the walls are
serried in rows the 224 other small shrines, each originally about
thirty-five feet high. This complex was further enclosed far off-
centre in a large walled courtyard. Most of the temples are still
in ruins, after an earthquake in the sixteenth century, but the
main shrine, and a few smaller shrines, have been beautifully
restored by the Dutch. The smaller temples are all versions,
simplified and much reduced, of the design of the great central
shrine.

214 Chandi Lara Jonggrang, celestial beings from the Shiva temple. Under the hideous mask of Time three celestials stand in a welcoming group

This central Shiva shrine was once more conceived as a square cell with portico-projections on each face. But the porticos are structurally integral with the mass of the cell, and their projection is carried through all the way up each face of the pyramidal tower. This tower is constructed as six diminishing storeys, whose moulded architraves bear continuous rows of gadrooned fruit-shaped stupas, and is crowned by a larger stupa – an idea obviously derived from the great Buddhist monuments of central Java. The main volume of the cell shows a wall with two rows of niches suggesting two storeys of windows. The plinth on which this shrine stands has at each of the four approach stairs a gate-tower whose shape repeats that of the main shrine. The plinth is edged with the same type of stone stupas. The ornamental work around gates and niches is of good quality central

252

Javanese type. Originally, no doubt, all the niches on all the shrines contained sculptures of celestial beings (*Ill. 214*). But at present it is the balustrades and inset panels which abound with splendidly lively reliefs of deities (*Ill. 215*) and of scenes from the great Hindu classics, especially the *Rāmāyaṇa*. One series of the 'guardians of the directions' is especially beautiful in the manner in which ornamental motifs are integrated with the plastic forms of the bodies; both are derived from the same thematic motifs. A motif peculiar to Prambanam is the lion in an ornamental niche flanked by a pair of panels with ornate jewelled trees. The central icon of Shiva also survives (*Ill. 216*). The anthropomorphic image stands on the yoni-basin as the lingam usually does. It is perhaps characteristic that the plastic quality of this icon is markedly inferior to the extremely fine carving of the fabulous ornaments the figure wears.

215 (*left*) Chandi Lara Jonggrang, dancing goddess. This relief represents mystical female deities of Hindu Tantrik tradition

216 (*right*) Chandi Lara Jonggrang, Shiva from the Shiva temple. A central icon of the deity to whom the whole complex was dedicated

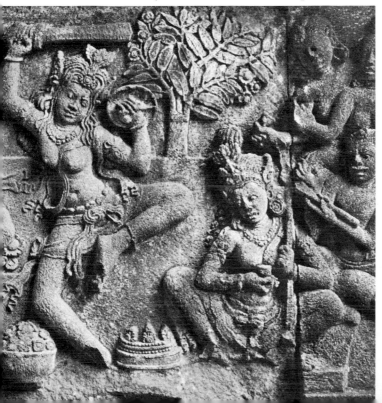
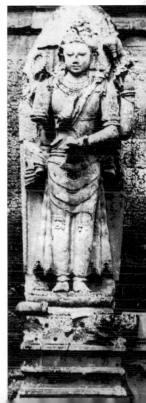

There is a particularly marked general tendency in the art of this whole period of five hundred years. It is for relief sculpture, the lesser sculpture and the ornament to evolve more and more away from the sensuous plastic order of the Central Javanese style, into the style of extravagant fantasy associated with the Wayang puppets of modern times. Here bodies and volume are more or less eliminated, everything is turned into linear sinuosities, and all complex forms into a proliferation of curlicues. The major iconic sculptures do continue the Central Javanese tradition, and among them are some outstanding masterpieces. Their style evolves in a similar direction, but without losing the mass of the volumes, whose sections are the product of elaborate three-dimensional linear curves. Fundamentally, however, eastern Javanese art is continuous with central Javanese traditions.

There are a very large number of monuments in eastern Java, many of them well restored, but there are few single structures impressive and planned throughout in the way in which Borobudur or Lara Jonggrang were planned. For example, around the strange natural mountain with tiered peaks called Mount Penanggungan there are eighty-one monuments of different kinds, most in ruins, prominent among them bathing-places. Penanggungan was identified by the people with the sacred Mount Meru, and its natural springs were believed to have a magical healing power and a mystical purifying capacity. One of the earliest east Javanese monuments is such a bathing-place, Jalatunda, built in the tenth century. It consists of a rectangular basin, over fifty feet long, cut into the hillside. The water sprang into it through a carving of Mount Meru, *via* a basin carved with heroic scenes from the *Mahābhārata*.

Another such bathing-place, of brick, which also has extensive ruined temples, is Belahan, supposed, in addition, to have been the burial-place of King Erlangga who probably died in 1049 (*Ill. 217*). One of the greatest of the east Javanese icons formed the central figure against the back wall of the tank (*Ill.*

254

217 Vishnu from Belahan, portrait statue of Erlangga. *c.* 1042, tufa, height 190 cm. This over-life-size sculpture probably represents the king in the guise of his patron deity Vishnu carried on his terrible vehicle Garuda

218 Belahan, goddess of northern niche of the Bathing Place. Eleventh century

219 Figure decorating a fountain from Mount Penanggungan. Tenth century, volcanic stone, height 60 cm

These goddesses of bounty pour out the waters of their fountains through breasts and jars

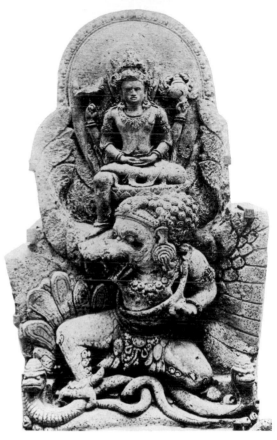

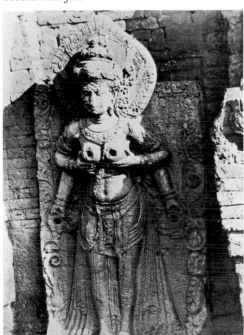

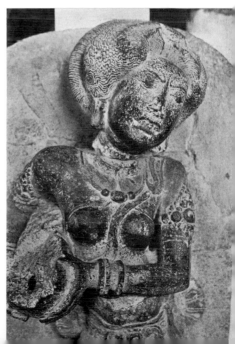

218). It shows the god Vishṇu seated at peace on the back of his tremendous, and violently dramatic vehicle, Garuḍa. It is carved of reddish tufa, and is sometimes said to be a self-dedication representing Erlangga himself in divine guise. Beside this image was a sculpture of a type associated with many of these sacred bathing sites. It is a relief of a four-armed goddess of abundance. Her two lower hands hold jars pierced with holes; her two upper hands squeeze her breasts which are also pierced. Through these holes the sacred water flowed into the basin. Many variants of this idea are associated with the springs of Mount Penanggungan (*Ill. 219*). On Bali the same idea is carried out at the Goa Gadjah, at Bedulu, in a spring-fed tank below a cave, where several such pierced figures spout water from their jars. The cave, surmounted by a kirtimukha face, perhaps also meant as the spirit of the site, is carved and rusticated to represent 'the mountain'.

In both Java and Bali there are a number of rock-face carvings from about this period. In Java the Selamangleng, an eleventh-century hermit's cave, is cut into a large rock at the foot of the Wadjak mountains. It is surmounted again by a huge kirtimukha head, and decorated with suitable reliefs representing the famous story of Arjuna's penance from the *Mahābhārata*. On Bali a series of rock-face reliefs at Yeh Pulu near Bedulu (*Ill. 220*) represent unidentified scenes. They are probably later than the series of eleventh-century reliefs representing chandis cut on to a rock-face at Gunung Kawi, Tampaksiring (*Ill. 221*). They are associated with a cave complex, and are called the 'Royal Tombs' on the assumption that the five chandis are a memorial to a king and his four chief wives.

There are two monuments dating from the early and middle thirteenth century that give a clear idea of the east Javanese conception of the chandi-temple. These are Chandi Sawentar (early thirteenth century) and Chandi Kidal (mid-thirteenth century; *Ill. 223*). The pattern of these temples is very similar, and since Kidal is by far the more complete, it is the better

220 Yeh Pulu, Bali, reliefs. One of the sacred fountain-sites excavated on Bali

221 Gunung Kawi, Tampaksiring. A series of cliff-cut memorials to members of the royal family of east Java. Eleventh century

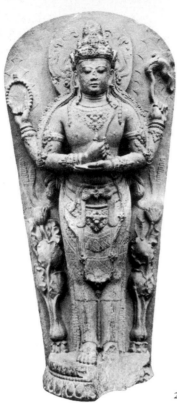

222 Chandi Kidal, Shiva

example. The nucleus of the building is a square cell with slightly projecting porticos hooded by a kirtimukha head. But the cell itself is dwarfed both by the massive moulded plinth upon which it stands, and by the huge tower with which it is surmounted. This stands above an architrave stepped far out on tiered mouldings. It is no longer composed of diminishing tiers, but is conceived as a massive pyramidal obelisk composed of double bands of ornament spaced by stumpy pilasters and bands of recessed panels. Its ornamental figure of Garuḍa carrying a flask of the nectar of immortality can be compared with the dramatic Garuḍa of Belahan. At present Kidal lacks its icon, but in Amsterdam there is a fine Shiva statue framed in a petal-shaped halo, which is supposed to have come from Kidal (*Ill. 222*). It may well be a post-mortem image of King Anūshapati of the

Singhasāri dynasty in the guise of Shiva. The hands make a gesture of mystical significance, and the lotus flowers springing from their corms on either side of his feet, carved in full relief, hint at a later feature of certain cult statues.

To this period belong two major Javanese sculptural master-pieces, which no longer have any architectural context. The first is an enormous icon of Ganesha, the elephant-headed god of wealth (*Ill. 225*). It was found in a village garden at Bara, Blitar. The stout deity sits compact. In true Javanese style horizontals and verticals are equally emphasized. His limbs are undercut masses silhouetted by shadow. His long eyelids curve. His crown and jewelled armlets are big and prominent. Over his knees fall heavy lappets of carved brocade, almost hiding the band of skulls upon his throne. Wealth reposes upon death. The back of this image is more impressive still, for behind the massive

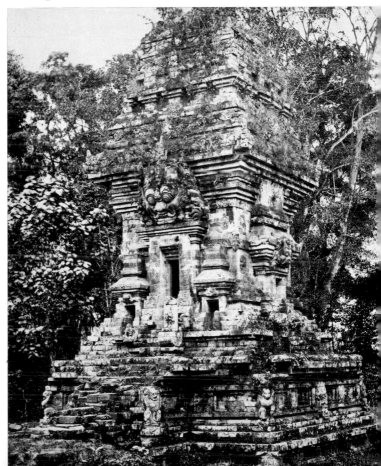

223 Chandi Kidal. Mid-thirteenth century. A fully developed east Javanese tower shrine with its weighty architrave

elephant's head and ears is carved a superb example of the terrifying kirtimukha face, the tusked and glaring hideous image of devouring time. The other side of wealth is death.

The second of these great sculptural masterpieces is a Buddhist image, taken from the ruined complex of temples and buildings at Singasari (*Ill. 224*). It is a seated female image, with a high crown and many jewels, backed by an arcade-like aureole. It, too, may be an image of a queen. From the teaching gesture that the hands make, however, and from the book supported on a lotus flower springing up by her shoulder, we know that this represents the Buddhist goddess who personifies transcendent Wisdom, Prajñā-Pāramitā. Under her jewels the forms of her body, the absolutely equanimous quality of the design and the totally tranquil expression of the face, make this sculpture one of the most successful images of the blissful peace of wisdom ever created.

There are a number of other fine images from Singasari, but they do not all belong to the same period. The earlier examples include a fine relief of a totally calm goddess Durgā slaying the buffalo-demon (*Ill. 226*). Another is a splendid Ganesha seated on a throne of skulls. Both of these images wear garments, the elaborate woven patterns of which are carved in the surface of the stone. Perhaps slightly later are the images of a naked dancing Shiva, in his terrible form, garlanded with skulls, and of a corpulent sage, Agastya, with more of the beautiful high-relief lotus flowers by his side. A fat, lumpish, free-standing guardian colossus, with glaring face, links older central Javanese shrine guardians with the hideous monsters still made for Balinese shrines. Two further large images, probably of the fourteenth century, display a massive curvilinear suavity. One is of a Shaiva sage (*Ill. 227*), the other of the four-headed deity Brahmā, himself bearded like a Brahmin.

The central shrine at Singasari (*Ill. 228*), which has been restored, is a majestic version of the type represented at Kidal, built about 1300 to commemorate a king who may have died as a consequence of a Tantrik ritual orgy. The interesting thing

224 Prajñā–Pāramitā from
Singasari. Thirteenth century,
volcanic stone, height 126 cm.
The goddess personifying Buddhist
wisdom, showing the total
serenity which wisdom brings

225 Ganesha of Bara, Blitar. 1239,
height 150 cm. When this
elephant-headed god of wealth
turns his back on you he shows
the face of Devouring Time

226 Durgā slaying a buffalo from
Singasari. Thirteenth century,
volcanic stone, height 157 cm.
The goddess here represents the
crystallization of the joined
powers of all the Hindu gods

227 The seer Tṛṇaviṇdu. Probably
mid-fourteenth century, height
153 cm. The well-fed Brahmin
sage who was one of the most
renowned devotees of Shiva

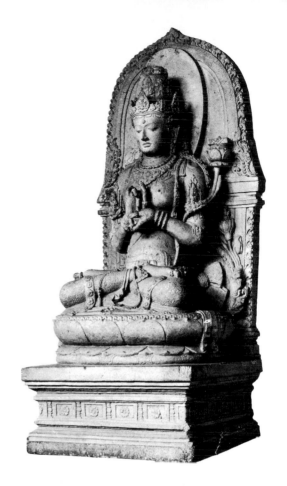

about this temple is that, whereas in all earlier temples the central volume of the building remained the principal cell in which the image was housed, as it always did in the Indian prototypes, here the *actual* main cell is in what appears to be the plinth, and what appears to be the cell has been assimilated as a part of the roofing tower. A shifting of the horizontal bands of moulding has taken place, and we are clearly presented here with a redeployment of old architectural conceptions made possible, no doubt, by a loss of direct contact with India and Indian custom. The result is superb. The legend concerning the temple's origin is interesting, in that it indicates the extent to

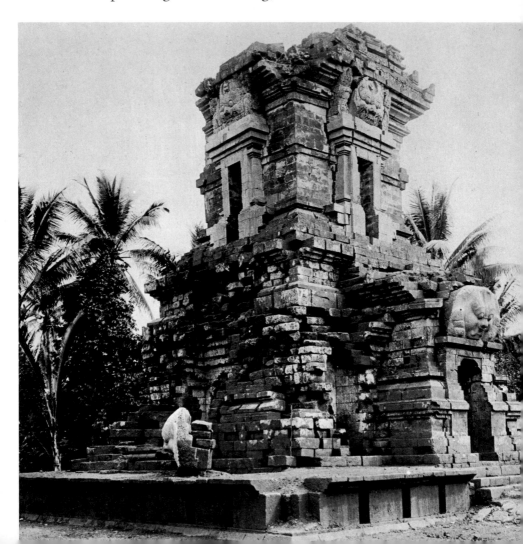

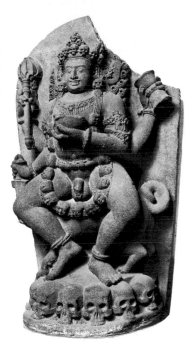

229 Chakra-chakra Bhairava from Singasari. Thirteenth century, volcanic stone, height 167 cm. Shiva as the phallic Lord of Death

◀ 228 (*left*) Chandi Singasari. *c.* 1300. Shrine dedicated to a religion which blended Hinduism and Buddhism in a Tantrik cult

which Tantrik forms of religion, intimately blending elements from both Hinduism and Buddhism, had come to be practised. The iconography of most of the great later chandis of eastern Java is a Tantrik compound of Buddhist and Hindu ingredients (*Ill. 229*). It should, however, be mentioned that pure forms of Buddhist architecture were still practised, for two ruinous normal stupas are known: one, Chandi Sumberawan, by another ritual bathing tank near Singasari; another, Chandi Dadi, in Sumberawan.

The later shrines of the chandis of eastern Java follow virtually the same pattern as Chandi Kidal, with variations. The outstanding feature is always the massive, stepped-out, obelisk-like roof, though not all are restored completely. There is a long series known, ranging through the whole fourteenth and early fifteenth century, some Hindu, some Buddhist. A few of outstanding architectural interest will be singled out, and then the style and development of the relief sculpture with which all of them are ornamented will be discussed.

263

230 Plan of Chandi Djago. *c.* 1270–80. 231 (*below*) Chandi Djago

This whole temple was dedicated to an orgiastic, 'left-handed' form of Buddhism

Chandi Djago near Malang (*Ills. 230–1*) is an important Buddhist structure, lacking the upper part of its cell and the whole tower. It was probably built between about 1270 and 1280, as a funerary monument to King Vishṇuvardhaṇa of the Singhasāri dynasty. The idiosyncrasy of this monument consists in the placing of the cell-shrine at the back edge of a pair of superimposed plinths, thus offering a magnificent approach stairway, and giving the whole monument a firm orientation north-westward – towards the region of the dead. The plinths are beautifully moulded at their lips, and bear long continuous bands of figure-relief (*Ill. 232*), which have to be read, incidentally, widdershins; that is, walking anti-clockwise round the monument. There was originally a large group of Tantrik Buddhist icons inside, surrounding a huge figure of Amoghapāsha, the eight-armed form of the Bodhisattva Avalokiteshvara-Lokeshvara.

232 Chandi Djago, reliefs, probably representing a legend of a visitor to the worlds of the dead

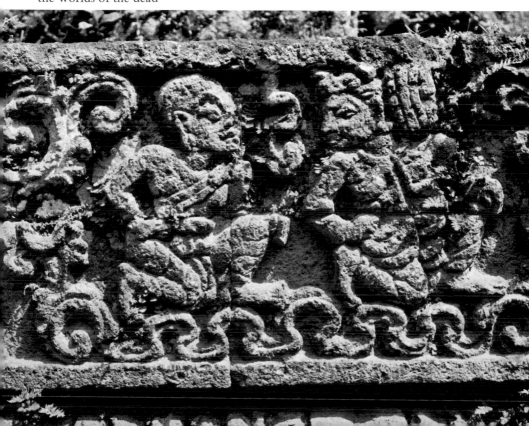

Chandi Djabung (*Ill. 233*), east of Kraksaan, is a brick shrine the cell and moulded architraves of which are not square but circular in plan. The four niches have a pair of block-like projecting snake-heads below the base of their jambs, and the whole ornament, especially the kirtimukha faces over the niches, is markedly theatrical and barbaric. Chandi Tikus is a mid-fourteenth-century bathing-place where there is an assemblage of small brick shrines. But Chandi Panataran, at Blitar (*Ills. 234–6*), is a large complex of shrines which anticipates in its layout that of modern wooden temples in Bali. Its main buildings were probably built between 1320 and 1370, since a lintel of the main shrine is dated 1323, two of the guardian figures on

233 Chandi Djabung. Mid-fourteenth century

266

234 Plan of Chandi
Panataran, at Blitar.
Fourteenth century

235 (*right*) Chandi
Panataran, The Dated
Temple

The shrine of this temple
occupies the rear of the
series of courtyards, near
the mountain from which
the gods descend

one of the terraces of the main shrine are dated 1347, and one of
the smaller shrines (*Ill. 235*) is dated 1369. The main shrine,
which is conventionally east Javanese, stands in a rear courtyard
on three broad plinths, surrounded by four smaller shrines. In
Balinese temples the main shrine stands at the rear of the
enclosures, nearest to the mountains from whence the gods
descend into the shrine. It is reasonable to suppose that the placing
of Chandis Djago and Panataran follows the same pattern. At
Panataran a pair of extra courtyards, side by side, stand before
the entrance to the court of the main shrine (*Ill. 236*).

267

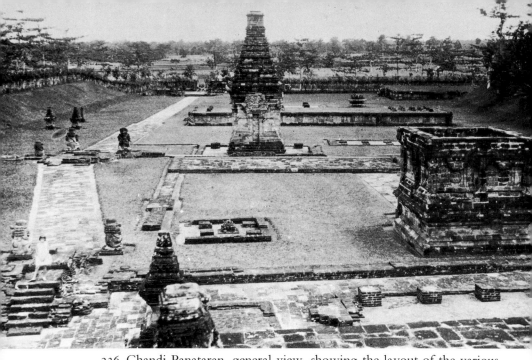

236 Chandi Panataran, general view, showing the layout of the various temple buildings in their courtyards

237 Chandi Panataran, Kṛishṇāyana scene. These reliefs show the increasing stylization of the figures towards the Wayang stereotypes

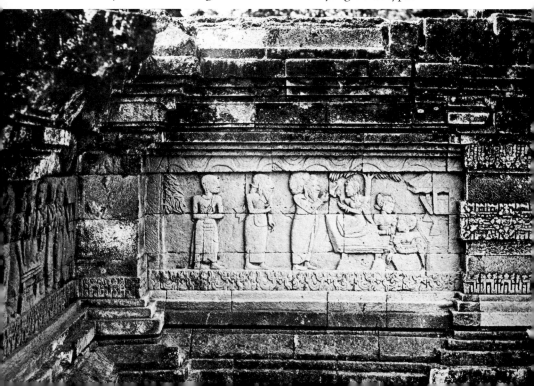

At Panataran there are, too, a number of stone pedestals in the courts designed to support wooden buildings, closely suggesting the layout of buildings in Balinese temples. One of the stone temples, now roofless, but originally roofed probably with wood, is the Nāga or snake temple. The whole exterior is carved with celestials who hold bells and who support the swagged bodies of snakes. It is said by the modern Balinese that the Nāga temple was used as a depository for the sacred possessions of the shrine's deity, such as copperplate inscriptions, images and precious offerings. Possibly, too, holy water may have been ritually prepared inside this image of Mount Meru. The shrines and plinths of Panataran again bear bands of narrative reliefs from various Hindu legends (*Ill. 237*); there are massively and crudely cut spirit-guardian figures at various points; and much in evidence is the characteristic east Javanese ornament in the form of a downward-pointing triangle containing relief ornament, laid over a moulding as if it were a hanging flap of fabric.

A further whole series of lesser chandis was made before the coming of Islam in the fifteenth century, all following the same pattern of court and tower. The main point of distinction between them lies in the style of the relief ornament, and in the fact that panels came to be favoured over bands of figure relief. The ornamental style followed the trends of the figural style. In the beautiful reliefs of Chandi Djawi, about 1300, the beginnings are found of the tendency towards linear stylization. The slender figures which populate the scenes are isolated against the ground in formalized postures, and around them the area is filled with subsidiary figures and natural scenery in a two-dimensional spread. There are, however, occasional glimpses of figures overlapping, or of a cottage cut off by a tree. The principle of separating objects each within its own complete contours is becoming fully established.

The further evolution of this linear method appears in the reliefs of Chandi Djago (*Ill. 238*), where the figures lose their substance in favour of the ornamental elements. This progressed

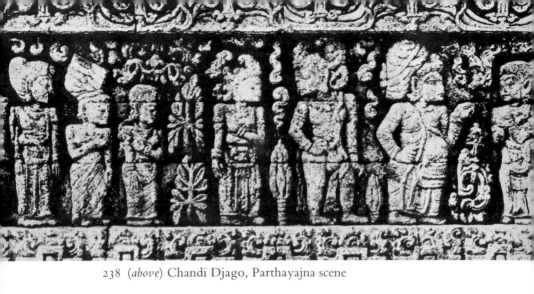

238 (*above*) Chandi Djago, Parthayajna scene

239 (*below*) Chandi Surawana, the plinth. Fourteenth century

240 (*right*) Chandi Surawana, bas-relief. The figures of the relief, representing the legend of Arjuna, resemble puppets in their posture and arrangement

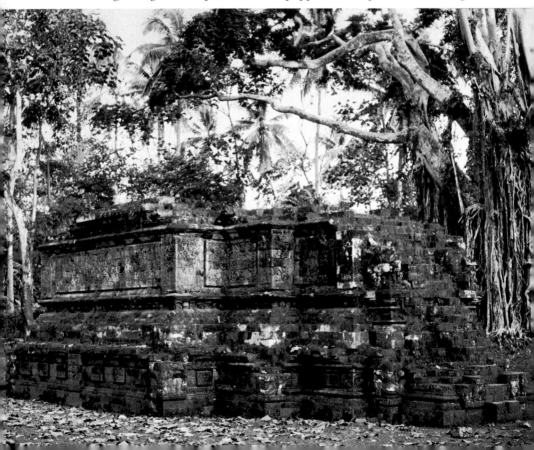

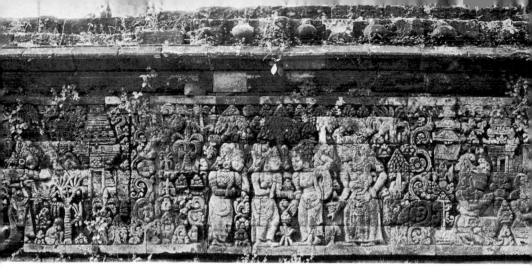

further in the reliefs of Chandi Panataran (*Ill. 237*), where all the natural elements are reduced to a curlicue or scroll formula. And at Chandi Surawana (*Ill. 239*), dating from the end of the fourteenth century, the reliefs have become pure Wayang puppet stereotypes. The figures have adopted the stiff profile stance that presents both shoulders (*Ill. 240*), while the trees and houses resemble the stereotype silhouette cut-outs of leather used in puppetry of the immensely popular Wayang (*Ills. 241, 242*) which has survived to the present day. In Bali a grotesque excess of decoration often spoils the purely aesthetic effect of temple architecture (*Ill. 244*).

Interestingly enough, it seems that alongside this relief narrative style – which may have existed in pictorial art as well – the tradition of iconic sculpture in deep relief survived with a life and quality of its own. It retained its vivid sense of mass, although its surfaces became increasingly smooth, linear, and stylized. There are exceptionally charming pieces, notably the couple – man and wife – from Djebuk, Tulung Agung (*Ill. 243*); and the queen from the same place, whose whole back is converted into a thorough-carved stand of lotus flowers, buds and leaves. The same plastic tradition, escaping submission to the Wayang formula, seems to have produced the few beautiful small terracotta figures which formed part of the revetment of

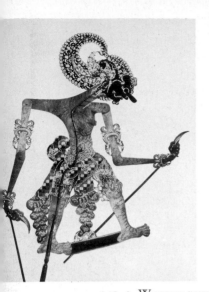
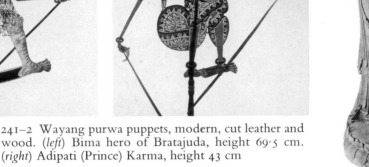
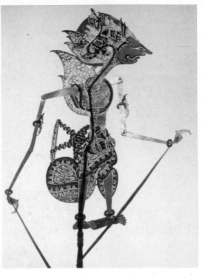

241–2 Wayang purwa puppets, modern, cut leather and wood. (*left*) Bima hero of Bratajuda, height 69·5 cm. (*right*) Adipati (Prince) Karma, height 43 cm

the capital city of Majapahit. Notable instances come from Trawulan (*Ills. 245, 246*). The many small bronzes of Hindu scenes are, however, far more under the Wayang influence, three-dimensional though they may be. Curlicues proliferate, and the plasticity of bodies is virtually disregarded.

RECENT TIMES

It might be well to describe briefly the Wayang and its puppets which can be called almost an addiction among the Indonesian peoples during recent centuries. Presentation of the plays of the Wayang is not mere entertainment, nor an act of solemn piety. It is the presentation in dramatic form, accompanied by the music of the *gamelan*, the Indonesian orchestra, of ideas and images which satisfy a deep emotional and ritual necessity for these peoples. A performance is a kind of communal mystical meditation, and takes place in the dark. The divine personalities of the *Rāmāyaṇa* and *Mahābhārata*, whose Indian origins are long forgotten, come down to take possession of the puppets

272

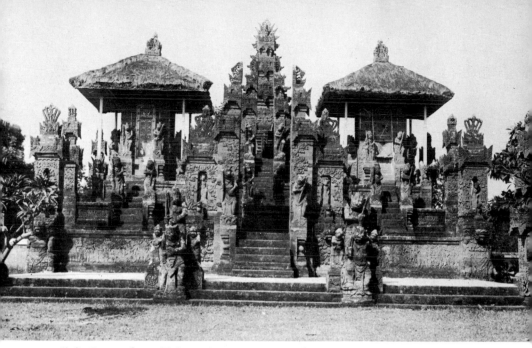

243 (*left*) Queen from Tulung Agung. Fourteenth century, stone, height 160 cm.

244 (*above*) Pura Maduwe Karang, Kubutambahan. The extravagantly ornate gateway to a modern Balinese temple. Parts of the fabric may be a few centuries old, parts are modern

245 (*above* Head of Figurine from Trawulan. Terracotta, height 8·5 cm

246 (*right*) Figurine from Trawulan. Terracotta, height 37 cm

These charming fragments show that a lively secular tradition of sculpture must have existed alongside the hieratic art of the chandis

247 Betari Durgā puppet. Modern, cut leather and wood. This stylized figure represents the terrible goddess Durgā. As she would be supposed to take possession of her puppet during performance, the play was not simple theatre

248 Wayang purwa figure representing the tree of life, used as an interval sign during wayang performance. Height 53 cm

and their puppeteers. The figures are made of either leather or wood, cut out into silhouettes (*Ills. 241, 242, 247*). A white cloth screen is stretched over a wooden frame, and a lamp hangs behind it. The spectators face the screen. Puppeteers, who sit below the edge of the cloth and behind it, manipulate the puppets by means of slender rods attached to the wrists of the jointed arms, so that the shadows are clearly thrown on to the cloth screen. A chest stands nearby containing many puppets and stage properties (*Ill. 248*) made in the same way, such as chariots, temples and so on. They are all painted in brilliant colours with gold-leaf, despite the fact that they are seen by only a few honoured guests, while the black shadows alone are seen by the public. In one of the many Wayang plays there are thirty-seven principal characters.

The puppets are cut out by using master stencils, with special chisels and knives, and mounted on bamboo handles. The stylization of the pointed faces, hair and garments is extreme. At bottom its purpose may be partly to make the direction of

274

the shadow's action unequivocally clear, but the true purpose of such extreme formalization must be to symbolize the divinity and trans-human status of the images. That this is so is confirmed by the fact that Wayang plays are also performed by human dancers in temple compounds, wearing elaborate ornamental costume; and masks stylized in a similar fashion are worn in other dance-dramas in Bali. The dancers are always recognized as being possessed by the divine personality whose rôle they are acting. These masks can be fine works of art.

Islam in Indonesia made use of the repertoire of traditional ornament for its mosques and tombs, but in conformity with a puritan Moslem custom, the representation of living creatures was excluded. The gates of the sixteenth-century mosque at Sendangduwur, Badjanegara (*Ill. 250*) show a splendid example of this adaptation. The 'wings' of the old Hindu Garuda, vehicle of the high god Vishnu, frame the gate. Above the lintel the tree-clad mountain-forms recall the imagery of the cosmic Meru, and the fantastic snakes – Garuda's traditional victims – hood the jambs. Tombs, such as that of Ratu Ibu at Air Mata (*Ill. 249*) on the island of Madura, employ elaborate but abstract variants of the scroll-filled antefixes of older architecture, and of the petal-shaped aureoles of the great icons.

In conclusion, the revival of art that has been attempted in modern Indonesia must be mentioned. We must leave out of account the Balinese tourist-trade woodwork which is seen everywhere. There has been government support for reviving old crafts, such as silver-work, along traditional lines. A number of artists like the Balinese Dewa Gde Soberat, have adapted westernized figure-drawing to their own decorative compositions. The best-known painter of modern Indonesia is the Javanese, Affandi (*Ill. 251*). He uses oils to execute pictures of Indonesian subjects in a freely slashing expressionist manner, with vivid colour. The strokes, however violent they seem, are nevertheless conditioned by the sweet sinuosity of Javanese tradition. He appears to be, as yet, the only artist of Southeast Asia to attain a personal world-wide recognition.

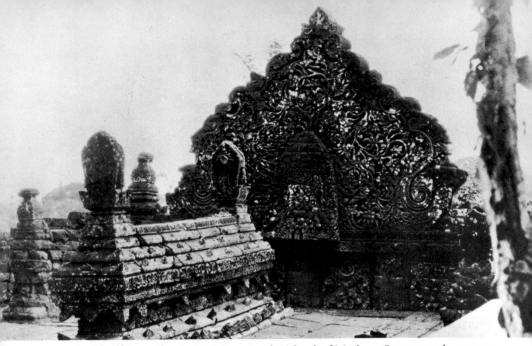

249 Tomb of Ratu Ibu at Air Mata, on the island of Madura. Seventeenth century

250 Sendangduwur, Badjanegara, gateway B. Sixteenth century. The gateway to this mosque adapts an image of the wings of Garuḍa, who in Hindu mythology carried the divine royal prototype Vishnu on his back

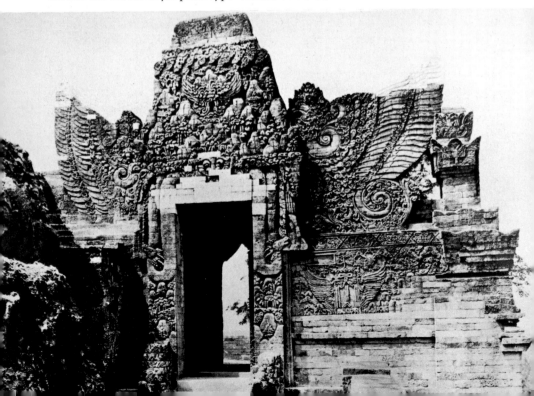

251 Self-portrait by Affandi, modern Indonesia's best-known painter,
1947, 61·5 by 53·5 cm

Select Bibliography

KEY TO ABBREVIATIONS

A.A.	Arts Asiatiques, Musée Guimet, Paris.
A.A.S.	Artibus Asiae, Ascona.
Ann. Bild. I.A.	Bibliography (Annual) of Indian Archaeology.
ASIAR	Archaeological Survey of India, Annual Report.
B.A.V.H.	Bulletin des Amis du Vieux Hué, Hué.
B.C.A.I.	Bulletin de la Commission archéologique de l'Indochine, Paris.
B.E.F.E.O.	Bulletin de l'école française de l'extrême-Orient.
B.S.E.I.	Bulletin de la Société des Etudes indochinoises, Saigon.
E.F.E.O.	l'Ecole française d'Extrême-Orient, Hanoi, Saigon, then Paris.
J.A.	Journal asiatique, Société asiatique, Paris.
JBRS	Journal of the Burma Research Society.
J.S.S.	Journal of the Siam Society, Bangkok.
Mem. ASI	Memoirs of the Archaeological Survey of India.
O.V.	Oudheidkundig Verslag van de Oudheidkundige Dienst In Ned.-Indie (Indonesie). 1912–1949. Continued as: Laporan tahunan Dinas Purbakala. 1950.
R.A.A.	Revue des Arts asiatiques, Musée Guimet, Paris.
T.B.G.	Tijdschrift voor Indische Taal-, Land- en Volkenkunde, uitgegeven door (de Lembaga Kebudajaan Indonesia) (Koninklijk Bataviassch Genootschap van Kunsten en Wetenschappen).

General

Brown, Roxana M., *The Ceramics of South-East Asia, Their Dating and Identification*, Singapore 1988.

Coedès, G., *Les Etats hindouisés d'Indochine et d'Indonésie*, Histoire du Monde, vol. VIII, Paris 1948. Trans.: *The Indianized States of South-East Asia* (ed. W. Vella), Honolulu 1968.

Embree, J.F., and L.O. Dotson, *Bibliography of the Peoples and Cultures of Mainland South-East Asia*, New Haven 1950.

Frédéric, L., *The Temples and Sculpture of Southeast Asia*, London 1965.

Guy, John, *Oriental Trade Ceramics in South-East Asia, Ninth to Sixteenth Centuries*, Singapore 1986.

Hall, D.G.E., *A History of South-East Asia*, London 1955.

Majumdar, R.C., *Hindu Colonies in the Far-East*, Calcutta 1944.

Smith, R.B., and W. Watson, *Early South-East Asia*, New York 1979.

Indochina

Boisselier, J., *La Statuaire khmère et son évolution*, Paris and Saigon 1955.

Boisselier, J., *Note sur deux bouddhas parés*

278

des galeries d'Angkor Vat, B.S.E.I. vol. xxv, Saigon 1950.

Bosch, F.D.K., *Le Temple d'Angkor Vat*, B.E.F.E.O. xxxii, Hanoi 1932.

Briggs, L.P., *The Ancient Khmer Empire*, Philadelphia 1951.

Claëys, J.Y., *Introduction à l'Étude de l'Annam et du Champa*, Hanoi 1934.

Coedès, G., *Les États hindouisés d'Indochine et d'Indonésie*, Histoire du Monde, vol. viii, Paris 1948.

Coedès, G., *Le Culte de la Royauté divinisée. . .*, Série Orientale, Conference, vol. v, Rome 1952.

Coedès, G., *Les Bas-reliefs d'Angkor Vat*, B.C.A.I., Paris 1911.

Coedès, G., *Seconde Etude sur les bas-reliefs d'Angkor Vat*, B.E.F.E.O. xiii, Hanoi 1913.

Coedès, G., *Pour mieux comprendre Angkor*, Paris 1947. Trans.: *Angkor* (Engl. edn), Hong Kong 1975.

Coral Rémusat, G. de, *L'Art khmer, les grandes étapes de son évolution*, Paris 1940.

Coral Rémusat, G. de, *Influences javanaises dans l'art de Rolûos*, J.A., Paris 1933.

Deydier, H., *Études d'iconographie bouddhique et brahmanique*, B.E.F.E.O. xlvi, Hanoi 1954.

Dupont, P., *La Statuaire pré-angkorienne*, Ascona 1955.

Dupont, P., *Les Buddhas dits d'Amaravati en Asie du Sud-Est*, B.E.F.E.O. xlix, Paris 1959.

Dupont, P., *Visnu mitrés de l'Indochine occidentale*, B.E.F.E.O. xli, Hanoi 1941.

Dupont, P., *Les Linteaux khmers du VIIIe siècle*, A.A.S. xv, Ascona 1952.

Dupont, P., *Art de Dvaravati et art khmer . . .*, R.A.A. vol. ix, Paris 1935.

Dupont, P., *L'Art du Kulên et les débuts de la statuaire angkorienne*, B.E.F.E.O. xxxvi, Hanoi 1936.

Dupont, P., *Les Apports chinois dans le style bouddhique de Dong duong*, B.E.F.E.O. xliv, Hanoi 1947–50.

Dupont, P., *Les Monuments du Phnom Kulên: le Prasat Neak Ta*, B.E.F.E.O. xxxviii, Hanoi 1938.

Finot, L., Goloubew, V., Coedès, G., *Le Temple d'Angkor Vat*, Paris 1929–32, 7 vols.

Finot, L., Parmentier, H., Marchal, H., *Le Temple d'Isvarapura*, Paris 1926.

Finot, L., *Les Bas-reliefs de Baphuon*, B.C.A.I., Paris 1910.

Finot, L., *Lokesvara en Indochine*, *Études Asiatiques. . .*, B.E.F.E.O., vol. i, Hanoi 1925.

Giteau, M., *Khmer Sculpture and the Angkor Civilization*, Fribourg 1965; London 1965.

Glaize, M., *Les Monuments du Groupe d'Angkor*, Guide, Saigon 1948.

Groslier, B.P., *Angkor, Hommes et Pierres*, Paris 1962; London 1957; Cologne 1958.

Groslier, B.P., *Indo China: art in the melting pot of races*, Baden-Baden, London 1962.

Groslier, G., *Les Arts indigènes au Cambodge*, Hanoi 1931.

Groslier, G., *Les Collections khmères du Musée Albert Sarraut à Phnom Penh*, Paris 1931.

Heine-Geldern, R. von, *Weltbild und Bauform in Südostasien*, Wiener Beiträge Kunst- und Kulturgeschichte Asiens, 4, Vienna 1930.

Leroi-Gourhan, A., and Poirier, J., *Ethnologie de l'Union française*, vol. ii, Paris 1953.

Lunet de Lajonquière, *Inventaire descriptif des Monuments du Cambodge*, Paris 1902–11, 3 vols.

MacDonald, Rt Hon. M., *Angkor*, Jonathan Cape, London 1958.

Malleret, L., *L'Archéologie du delta du Mékong*, Paris 1959–60.

Mercier, R., and Parmentier, H., *Éléments anciens d'architecture au Nord-Viet-Nam*, B.E.F.E.O. XLV, Hanoi 1952.
Parmentier, H., *L'Art khmer primitif*, Paris 1927.
Parmentier, H., *L'Art khmer classique*, Paris 1939.
Parmentier, H., *L'Art présumé du Founan*, B.E.F.E.O. XXXII, Hanoi 1932.

Champa

Bernanose, M., *Les Arts décoratifs au Tonkin*, Paris 1922.
Bezacier, L., *L'Art vietnamien*, Paris 1954.
Bezacier, L., *Relevé des Monuments anciens du Nord-Vietnam*, Paris 1959.
Cadière, L., *L'Art à Hué*, B.A.V.H. VI, Hué 1919.
Hejzlar, J., *The Art of Vietnam*, London 1973.
Huard, P., and Durand, M., *Connaissance du Viet-Nam*, Paris 1954.
Nguyen-van-Huyen, *La Civilisation annamite*, Hanoi 1944.
Parmentier, H., *Les sculptures chames au Musée de Tourane*, Paris and Brussels 1922.
Stern, P., *L'art du Champa et son évolution*, Toulouse 1942.

Siam and Laos

Beamish, T., *The Arts of Malaya*, Singapore 1957.
Bhirasri, S., *Thai-Mon Bronzes*, Bangkok 1957.
Bhirasri, S., *The Origin and Evolution of Thai Murals*, Bangkok 1959.
Boribal Buribhand, L., and Griswold, A.B., *Sculptures of Peninsular Siam in the Ayuthya Period*, J.S.S. vol. XXXVIII, Bangkok 1950.
Chapin, H.B., *Yunnanese Images of Avalokitesvara*, Harvard Jour. of Asiat. Stud., vol. 8, Harvard 1944.

Claëys, J.Y., *L'Archéologie du Siam*, B.E.F.E.O. XXXI, Hanoi 1931.
Coedès, G., *L'art siamois de Sukhodaya*, A.A. vol. I, Paris 1954.
Coedès, G., *Les Collections archéologiques du Musée national de Bangkok*, Paris and Brussels 1924.
Diskul, M.C. Subhadradis, *Ayudhya Art*, Bangkok 1956.
Diskul, M.C. Subhadradis, *Art in Thailand*, Bangkok 1972.
Diskul, M.C. Subhadradis, *The Art of Srivijaya*, Oxford 1980.
Dupont, P., *L'Archéologie mône de Dvaravati*, Paris 1959.
Griswold, A.B., *The Buddhas of Sukhodaya*, Archives of the Chinese Society of America, vol. VII, 1953.
Griswold, A.B., *Dated Buddha images of Northern Siam*, Ascona 1957.
Le May, R., *A Concise History of Buddhist Art in Siam*, Cambridge 1938. 2nd edn: Vermont 1963.
Mus, P., *Le Buddha paré*, B.E.F.E.O. XXVIII, Hanoi 1928.
Paranavitana, S., *Religious Intercourse between Ceylon and Siam*, Jour. R. As. Soc., Ceylon Br., vol. XXXII, Colombo 1932.
Parmentier, H., *L'Art du Laos*, Paris 1954.
Salmony, A., *La Sculpture du Siam*, Paris 1925.
Spinks, C.N., *Siamese Pottery in Indonesia*, Bangkok 1959.
Stratton, C., and M. Scott, *The Art of Sukhothai*, Kuala Lumpur 1981.
Subhadradis Diskul, *see* Diskul.

Burma

Aung Thaw, *Historical Sites in Burma*, Rangoon 1972.
Aung, U Htin, *The Thirty-Seven Lords*, JBRS XXXIX/I.
Duroiselle, C., *The Ananda Temple at Pagan*, Mem. ASI, no. 56, Delhi 1937.

Duroiselle, C., *The Art of Burma and Tantric Buddhism*, ASIAR, 1915–16.

Duroiselle, C., *Excavations at Halin, Hmawza, and Pagan*, ASIAR, 1926–7, 1927 8, 1928–9, 1929–30.

Duroiselle, C., *Excavations in Pegu District*, ASIAR, 1913–14, 1914–15.

Duroiselle, C., *Exploration in Burma*, ASIAR, 1935–6, 1936–7.

Duroiselle, C., Blagden, C.O., Mya, Taw Sein Ko, etc., *Epigraphia Birmanica*, 4 vols, Rangoon 1919–36.

Fielding-Hall, H., *The Soul of a People*, London, 1907.

Griswold, A.B., *Some Iconographical Peculiarities in Siam and Burma*, R.C. Majumdar Felicitation Volume.

Hall, D.G.E., *Burma*, London 1950.

Huber, E., *Les bas-reliefs du temple d'Ananda à Pagan*, B.E.F.E.O. XI.

Ko, Taw Sein, *Excavations at Hmawza, Pagan, Peikthano, Prome and Halin*, ASIAR, 1905–6, 1909–10, 1911–12, 1929–30.

Lowry, John, *Burmese Art*, Victoria and Albert Museum, London 1974.

Luce, G.H., *The Greater Temples of Pagan; The Smaller Temples of Pagan; Fukan-tu-lu; The Tan and the Ngai; Countries Neighbouring Burma; The Ancient Pyu; Economic Life of the Early Burman*, Burma Research Society, Fiftieth Anniversary Publications, no. 2, Rangoon 1960

Luce, G.H., *Old Burma – Early Pagan* (3 vols), New York 1969.

O'Connor, V.C. Scott, *Mandalay and other Cities of the Past in Burma*, London 1907.

Ray, N.-R., *Introduction to the Study of Theravāda Buddhism in Burma*, Calcutta 1946.

Ray, N.-R., *Sanskrit Buddhism in Burma*, Calcutta 1936.

Report of the Director, Archaeological Survey of Burma, 1959.

Report of the Superintendent, Archaeological Survey of Burman, 1901 27.

Sinclair, W.B., *Monasteries of Pagan*, Burma Research Society, Fiftieth Anniversary Publications, no. 2, Rangoon 1960.

Temple, Sir R.C., *Notes on Antiquities in Rāmaññadesa*, Bombay 1892.

Temple, Sir R.C., *The Thirty-Seven Nats*, London 1906.

Tun, U Than, *Religion in Burma, A.D. 1000–1300; Religious Buildings of Burma A.D. 1000–1300; Mahākassapa and his Tradition; History of Burma, A.D. 1300–1400*, JBRS XLII/2.

Indonesia

Auboyer, J., *L'influence chinoise sur le paysage dans la peinture et dans la sculpture de l'Insulinde*. Revue Arts asiat. 9, 1935, 228–34.

Bernet Kempers, A.J., *The Bronzes of Nālandā and Hindu-Javanese Art*. Bijdr. K.I. 90, 1933, 1–88 (also published separately).

Bernet Kempers, A.J., *Ancient Indonesian Art*, Cambridge, Mass. 1959.

Bibliography (Annual) of Indian Archaeology. Kern Institute, Leyden, 1 (1926) – xv (1940–47).

Bodrogi, Tibor, *Art of Indonesia*, Connecticut 1972.

Bosch, F.D.K., *Een hypothese omtrent den oorsprong der Hindoe-Javaansche kunst*. Handelingen le Congres Taal-Land- en Volkenkunde van Java, 1919, 1921.

Brandes, J.L.A., *Insluimeren van het gevoel voor de symbolieke waarde van ornament*. T.B.G. 46, 1903, 97–107.

Brandes, J.L.A., *Beschrijving van de ruine bij de desa Toempang, genaamd Tjandi Djago, in de residentie Pasoeroean*, 1904.

Brandes, J.L.A., *Beschrijving van Tjandi Singasari en de wolkentooneelen van Panataran*, 1909.

Chatterjee, B.R., *India and Java*. Greater India Soc. Bull. 5, 1933.

Coedès, G., *Histoire ancienne des états hindouisés d'Extrême-Orient*, 1st ed. 1944, 2nd ed. 1948.

Combaz, G., *Masques et dragons en Asie*, Mélanges chin. et bouddh. 7, 1939–45.

Coomaraswamy, Ananda K., *History of Indian and Indonesian Art*, 1927.

Coral Rémusat, G. de, *Influences javanaises dans l'art de Rolûos*, J.A., Paris 1933.

Dumarcay, Jacques, *Borobodur* (ed. and trans. M. Smithies) 1978.

Erp, Th. van, *Hindu Monumental Art in Central Java*, Twentieth Century Impressions of Neth. India, 1909.

Erp, Th. van, *Het ornament in de Hindoebouwkunst op Midden-Java*. Verslag le Congres Oost. Gen. Ned., 1921.

Erp. Th. van, *Beschrijving van Barabudur, Bouwkundige beschrijving*, 1931.

Erp, Th. van, *Hindoe-Javaansche steenplastiek in het Stedelijk Museum te Amsterdam*, Maandbl. beeld. k. II, 1934, 259–72.

Goloubew, V., *L'âge du bronze au Tonkin et dans le Nord-Annam*, B.E.F.E.O. XXIX, 1929, 1–46.

Grousset, R., *L'art pāla et sena dans l'Inde extérieure*, Études d'orientalisme Linossier, 1932, 277–85.

Heine-Geldern, R. von, *Altjavanische Bronzen . . . Museum Wien*, 1925.

Heine-Geldern, R. von, *Weltbild und Bauform in Südostasien*, Wiener Beiträge Kunst- und Kulturgeschichte Asiens 4, Vienna 1930, 28–78.

Heine-Geldern, R. von, *Prehistoric Research in the Netherlands Indies*, Science and Scientists in the Netherlands Indies, 1945, 129–67.

Heine-Goldern, R. von, *Introduction, Indonesian Art. A loan exhibition from the Royal Indies Institute Amsterdam*, Baltimore Museum of Art, 1949.

Holt, Claire, *Art in Indonesia*, New York 1967.

Karlgren, B., *The Date of early Dong-so'n Culture*. Bull. Mus. Far East. Antiq. Stockholm 14, 1942, 1–28.

Kern, H., *Verspreide Geschriften*, I–XV, 1913–28. Register, 1929. Supplement, 1936.

Krom, N.J., *Inleiding tot de Hindoe-Javaansche kunst*, I–II, 1st ed. 1919; I–III, 2nd ed. 1923.

Krom, N.J., *Beschrijving van Barabudur, I: Archaeologische beschrijving*, 1920 – Aanvulling. II: *Bouwkundige beschrijving* (Van Erp), 1931, 82 pp.

Krom, N.J., *Het Oude Java en zijn kunst*, 1923, 2nd ed. 1943.

Krom, N.J., *Over het Ciwaisme van Midden-Java*, Meded. Kon. Ned. Akad. Wet., Lett. 58 B: 8, 1924.

Krom, N.J., *L'art javanais dans les Musées de Hollande et de Java*, Ars Asiatica VIII, 1926.

Krom, N.J., *Barabudur*, Archaeological Description, I–II, 1927.

Krom, N.J., *Antiquities of Palembang*, Ann. Bibl. I.A. 1931, 29–33.

Moens, J.L., *De Tjandi̇ Mendut*, T.B.G. 59, 1921, 529–600.

Moojen, P.A.J., *Kunst op Bali*, Inleidende studie tot de bouwkunst, 1926.

Mus, P., *Le Buddha paré*. B.E.F.E.O. XXVIII, 1928, 153–278.

Mus, P., *Barabudur. Esquisse d'une histoire du bouddhisme fondée sur la critique archéologique des textes*, 1935.

Nilakanta Sastri, K.A., *South Indian Influences in the Far East*, 1949.

Parmentier, H., *L'architecture interprétée dans les bas-reliefs anciens de Java*, B.E.F.E.O. VII, 1907, 1–60.

Parmentier, H., *Origine commune des architectures hindoues dans l'Inde et en Extrême-Orient*. Études asiatiques, E.F.E.O. II, 1925, 199–241.

Parmentier, H., *L'art architectural hindou dans l'inde et en Extrême-Orient*, 1948.

Pott, P.H., *Yoga en yantra in hunne beteekenis voor de Indische archaeologie*, 1946.

Schnitger, F.M., *Forgotten Kingdoms in Sumatra*, 1939.

Stern, Ph., *L'art javanais*, Histoire universelle des arts IV, 1939, 185–205.

Stutterheim, W.F., *Rama-Legenden und Rama-Reliefs in Indonesien*, 1925

Stutterheim, W.F., *Cultuurgeschiedenis van Java in beeld*, 1926; *Pictorial History of Civilization in Java*, 1927.

Stutterheim, W.F., *The meaning of the Hindu-Javanese Caṇḍi*, Jour. Amer. Or. Soc. 51, 1931, 1–15.

Stutterheim, W.F., *Indian Influences in Old-Balinese Art*, 1935.

Stutterheim, W.F., *Note on Śāktism in Java*, Acta Orientalia 17, 1939, 144–52.

Stutterheim, W.F., *Studies in Indonesian Archaeology*, 1956.

Tobi, A.C., *De Buddhistische bronzen in het Museum te Leiden*, O.V., 1930, 158–201.

Visser, H.F.E., *Art Treasures from the East*, 1954.

Vogel, J. Ph., *The Relation between the Art of India and Java* (A chapter from 'The Influences of Indian Art'), 1925.

Vogler, E.B., *De monsterkop . . . in de Hindoe-Javaansche bouwkunst*, 1949.

Wagner, F.A., *Indonesia; the art of an island group*, Baden Baden, London 1959.

With, K., *Brahmanische, buddhistische und eigenlebige Architektur und Plastik auf Java*, 1920; 2nd ed. (abridged) 1922.

Zimmer, H. *The Art of Indian Asia*, I–II, 1955.

Locations of Objects

Ashmolean Museum, Department of Eastern Art, Oxford 138, 139; British Museum, London (Courtesy the Trustees) 126, 130, 247; Depôt for the Preservation of Angkor, Siemreap 64; Collection of Baronne Didelot, Paris 27; Djakarta Museum 169, 172, 174, 175, 196, 197, 202, 209, 219, 227, 243; Dr and Mrs Samuel Eilenberg, New York 200; Musée Guimet, Paris 8, 9, 10, 16, 22, 23, 24, 30, 44, 63, 97, 98, 100; Gulbenkian Museum, University of Durham 140, 163, 164; Koninklijk Instituut voor de Tropen, Amsterdam 222; Madjakerta Museum 217; Museum Nasional, Jakarta 224; Museum of Asiatic Art, Amsterdam 135, 198, 199; National Museum, Bangkok 124, 128; National Museum, Hanoi 2, 3, 4, 26; National Museum, Phnom-Penh 7, 11, 12, 13, 14, 15, 17, 18, 19, 20, 21, 25, 28, 29, 56, 65, 81, 96, 99; Pra Sing, Luang Monastery, Chiengmai 129; Collection of Prince Chalermbol Yugala 127; Collection of Prince Piya Rangsit, Bangkok 133, 134; Rijksmuseum voor Volkenkunde, Leiden 226, 229; Tourane Museum 107, 110, 111, 113, 114, 115, 116, 117, 118, 121; Trawulan Museum 245, 246; Tropenmuseum, Amsterdam 241, 242, 248, 251; Victoria and Albert Museum, London 165, 166

Photographic Acknowledgments

Glossary

Apsaras: a girl in heaven who offers sexual delight to the pious or heroic dead.

Ari: the old, displaced priesthood of Burma, who were probably Mahāyāna, or Vajrayāna (q.v.).

Baray: an artificial reservoir or lake.

Bodhi Tree: the tree at Bodhgaya in India under which the Buddha sat whilst he gained ultimate enlighten-ment. The original tree was cut down in AD 600, but trees survive which were grown from cuttings.

Bodhisattva: a spiritual being conceived by Buddhism who has by his morality and meditation reached the status of full enlightenment, but who refuses to abandon all other beings to their suffering. From compassion he stays in the world to help.

Brahminism: the form of Hindu religion based on the pre-eminence and sacred role of the Brahmin caste – a spiritual *élite* by birth.

Buddha: a teacher who established the Buddhist religion and died 489 BC. The name means the 'awoken one', or the 'enlightened one'.

Cetiya: Burmese version of chaitya (q.v.).

Chaitya: a Buddhist structure of varied form which is consecrated to the cult of the Buddha and/or his saints.

Chandi: word used generally in Indonesia today for an old sacred shrine.

Gadrooned: decorated with long concave depressions in parallel series.

Gamelan: an Indonesian orchestra composed of carefully tuned percussion instruments, usually of metal.

Garuda: a mythical creature with wings, claws and beak, but otherwise may be anthropomorphic. Attacks snakes, and carries the god Vishnu.

Hinayāna: the form of 'low church' Buddhism based on texts in the Pali language, which tends to emphasize the every-man-for-himself aspect.

Kāla-monster: a creature with horrific face and gaping mouth, representing Devouring Time.

Kirtimukha: the 'face of Glory'. A name for the kāla-monster (q.v.).

Kratons: fortified villages in strategic positions, from which local princes ruled ancient Indonesia.

Krishna: an incarnation of the Indian high God Vishnu, about whom many charming tales are told, both heroic and erotic.

Lakshmī: the Indian goddess of good fortune and fertility; usually the wife of Vishnu.

Lingam: emblem of the male genital organ as divine symbol.

Mahābhārata: one of the old Indian epics, c. 600–200 BC.

Mahābodhi: the most sacred shrine of Buddhism, at Bodhgaya in India, where the Buddha gained enlightenment.

Mahāyāna: a form of Buddhism based on Sanskrit texts which emphasizes the role of the compassionate Bodhisattva (q.v.)

Makara: a mythical water-monster usually with a curly snout.

Nāga: a sacred, mythical snake, guardian of water supplies or treasure.

Nats: the nature spirits of the forest peoples of Southeast Asia.

Nirvāna: the blissful state of release from suffering, desire and reincarnation, which is the ultimate Buddhist goal.

Pāla: a dynasty ruling in Bihar and Bengal between c. AD 750 and 1196.

Rāmāyāna: one of the old Indian epics, c. 400–200 BC.

Sanskrit: the ancient language of India, used later as the language of literature and learning.

Sassanian: a dynasty ruling in Persia for several centuries after the birth of Christ.

Shaman: a professional magician who communicates with the spirits.

Shiva: the High God of Hinduism who is creator in the guise of the lingam, destroyer of the cosmos in his terrible form.

Stupa: a mound or dome, containing Buddhist relics or acting as a focus of the faith.

Sūtras: the sacred texts of Buddhism.

Tantrik Buddhism: a form employing personalizations to symbolize the categories of religious thought.

Temple-mountain: a temple which rises over and encloses a mound, symbolizing closeness to heaven and the gods.

Theravāda: a name for Hinayāna (q.v.) indicating its fundamentalist nature.

Torana: a gateway with elaborate lintels.

Tufa: a volcanic rock, of aerated texture.

Vajrayāna: Tantrik Buddhism (q.v.) focused on the cult of the Vajra, which symbolizes the highest truth as diamond, thunderbolt and phallus.

Vat: a shrine.

Wei: a Turkic dynasty ruling in North China c. 385–557 who were Buddhist and patronized Buddhist art.

Yoni: emblem of the female genital organ, as divine symbol.

Index

Page numbers in italics refer to illustrations